· Véronique Enginger ·

Fables & Fairy Tales
to Cross Stitch

French Charm for Your Stitchwork

Schiffer Publishing Ltd

4880 Lower Valley Road • Atglen, PA 19310

Copyright © 2018 by Schiffer Publishing, Ltd.

Originally published as *Fables, Contes et Comptines* © 2016 by Mango, a subsidiary of Fleurus Éditions, Paris. Translated from the French by Omicron Language Solutions, LLC.

Library of Congress Control Number: 2017951909

Cover design by Molly Shields
Production design by Danielle D. Farmer

Editorial director: Tatiana Delesalle
Editor: Mélanie Jean
Artistic director: Chloé Eve
Typesetting: Élise Bonhomme (Patrick Leleux PAO)
Patterns, creation, and instructions: Sylvie Blondeau
Production: Axelle Hosten
With thanks to Mélissa Lagrange for her valuable help and efficiency.
Type set in Honey Script/Archer/Thirsty Script/HipsterFontNormal

ISBN: 978-0-7643-5478-6
Printed in China

Published by Schiffer Publishing, Ltd.
4880 Lower Valley Road
Atglen, PA 19310
Phone: (610) 593-1777; Fax: (610) 593-2002
E-mail: Info@schifferbooks.com
Web: www.schifferbooks.com

For our complete selection of fine books on this and related subjects, please visit our website at www.schifferbooks.com. You may also write for a free catalog.

Schiffer Publishing's titles are available at special discounts for bulk purchases for sales promotions or premiums. Special editions, including personalized covers, corporate imprints, and excerpts, can be created in large quantities for special needs. For more information, contact the publisher.

We are always looking for people to write books on new and related subjects. If you have an idea for a book, please contact us at proposals@schifferbooks.com.

Other Schiffer Books on Related Subjects:

Inspiration Kantha: Creative Stitchery and Quilting with Asia's Ancient Technique, Anna Hergert, ISBN 978-0-7643-5357-4

The Art of Weaving a Life: A Framework to Expand and Strengthen Your Personal Vision, Susan Barrett Merrill, ISBN 978-0-7643-5264-5

The Little Guide to Mastering Your Sewing Machine: All the Sewing Basics, Plus 15 Step-by-Step Projects, Sylvie Blondeau, ISBN 978-0-7643-4970-6

Acknowledgments

The editor wishes to thank DMC for supplying the fabrics used for the embroideries shown. www.dmc.com

Sylvie Blondeau would like to warmly thank Séverine at Mercerie Chérie for her marvelous materials and her adorable needlework notions and products, used for making the objects in this book. www.merceriecherie.fr

Once upon a time . . .

Wily foxes, big bad wolves and hungry ogres, princesses in distress, and enchanted worlds . . . dive into the magic world of fables and fairy tales.

We listened to them as kids, they appeared in our dreams, and even if they frightened us sometimes, one thing is certain: they helped us to grow up. By fighting wicked witches, escaping from the traps they laid, or even being fooled sometimes, the characters and their extraordinary adventures gave us the keys for taking our first steps toward growing up.

In these pages, you'll find the stories that you loved so much as a child transformed into lovely embroidery art. And I'll introduce you to some of my favorite French nursery rhymes, too, another wonderful source of stitching inspiration.

You can display your stitchwork by making the charming projects shown throughout the book. (See the back of the book for the instructions and patterns.) Whatever you choose to make, enjoy choosing your favorite characters and scenes, and the ones that the children in your life love most!

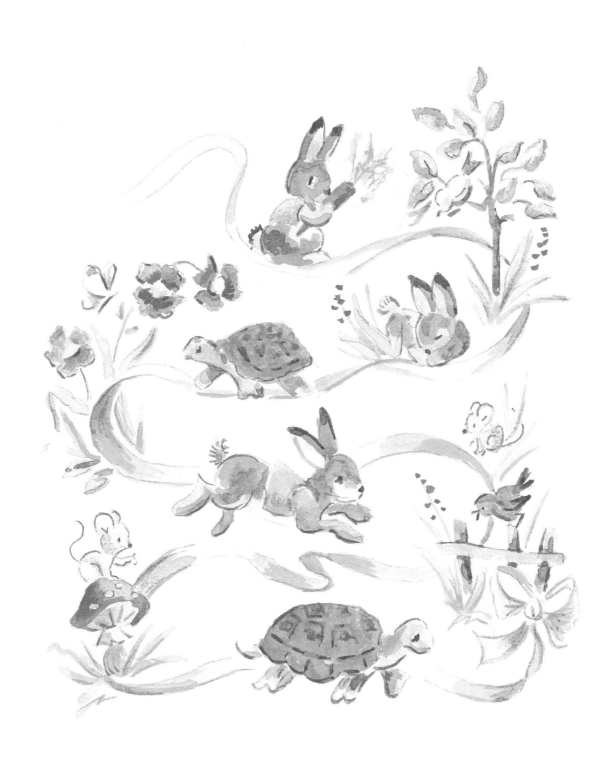

Contents

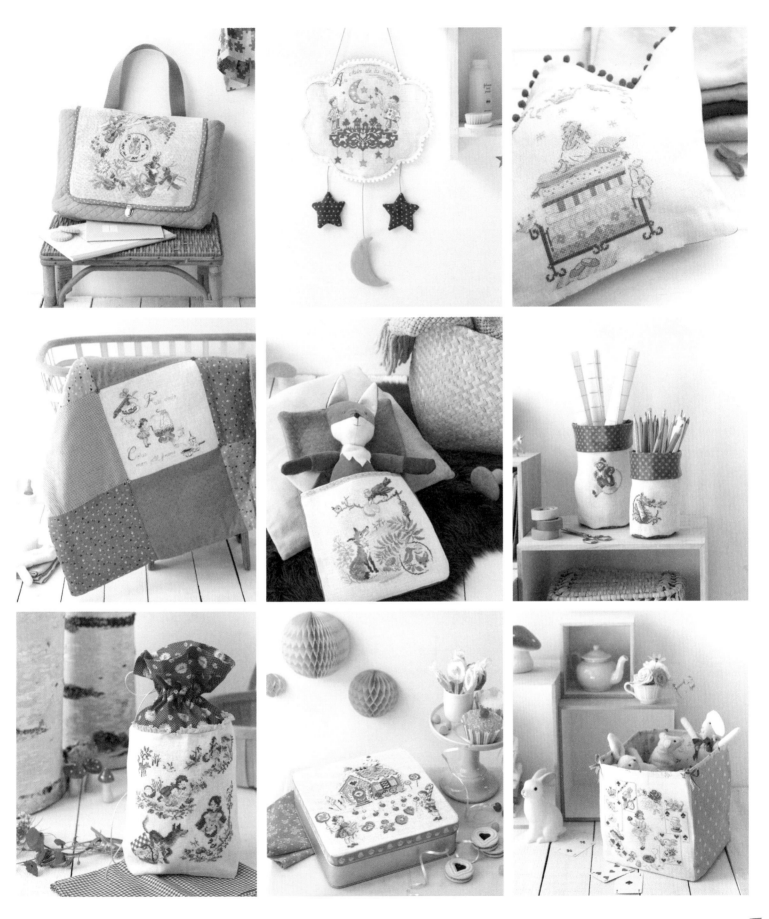

FABLES

For many of us, these short stories, always with a moral at the end, have shaped the adults we've become. Return to childhood by making some designs that honor your favorite fables!

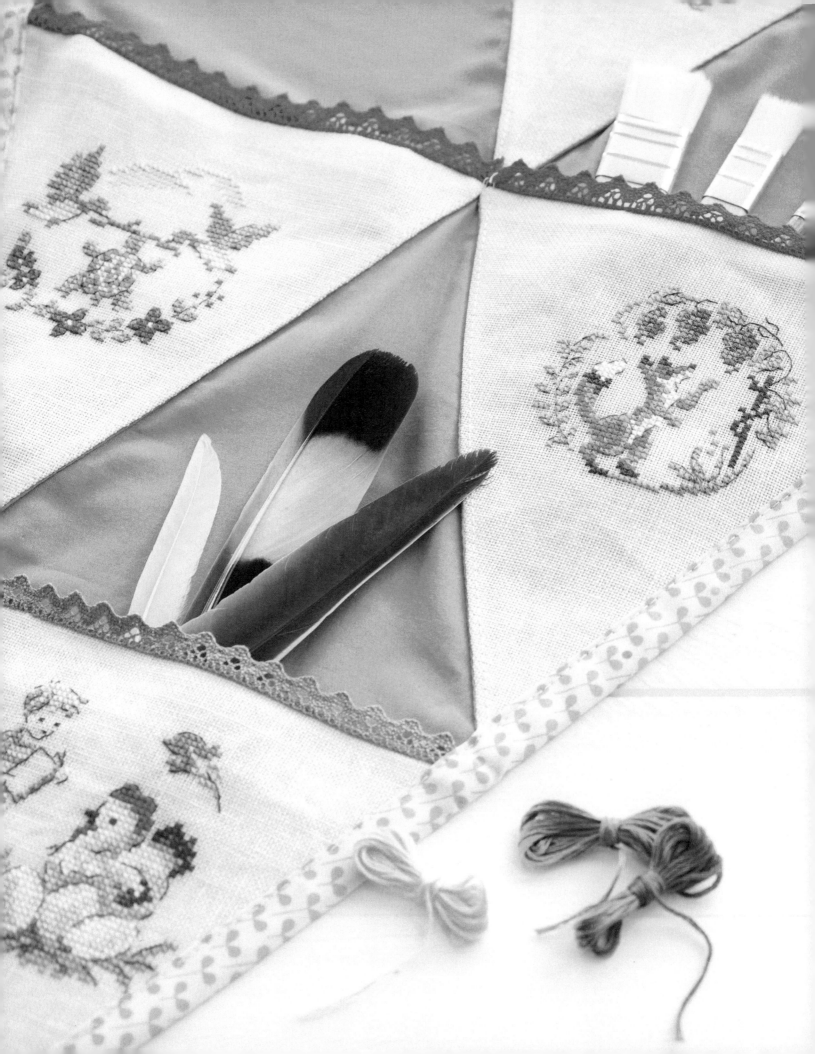

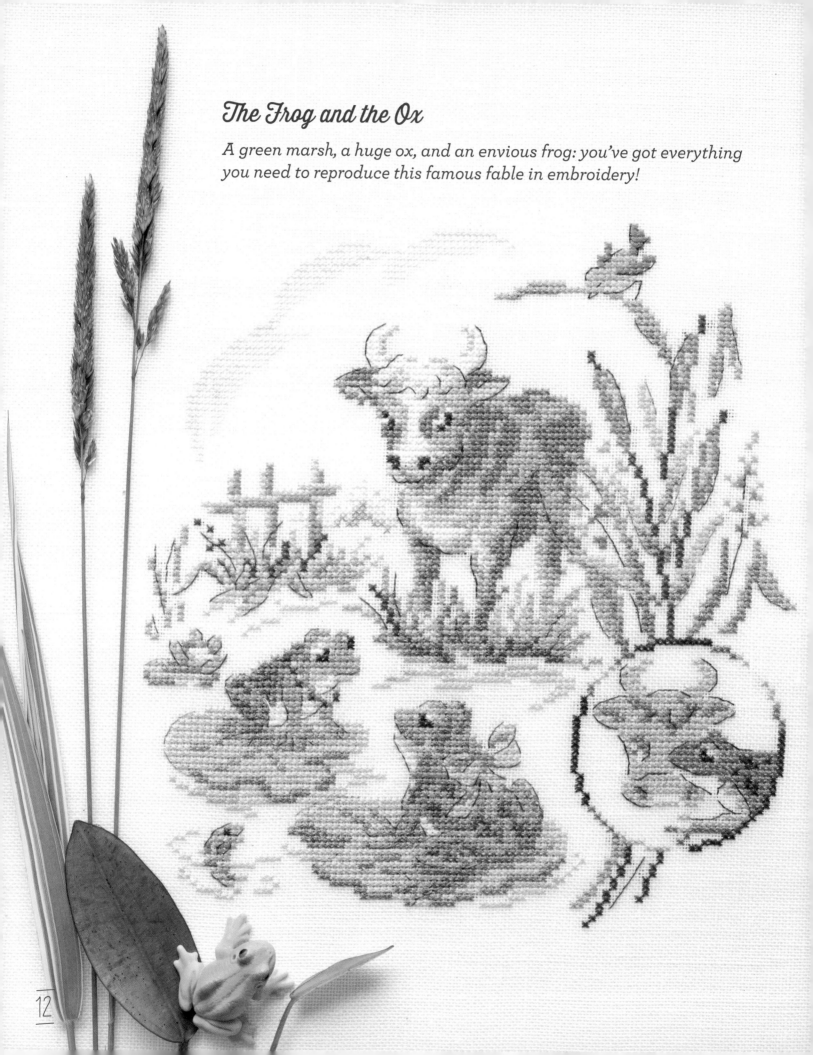

The Frog and the Ox

A green marsh, a huge ox, and an envious frog: you've got everything you need to reproduce this famous fable in embroidery!

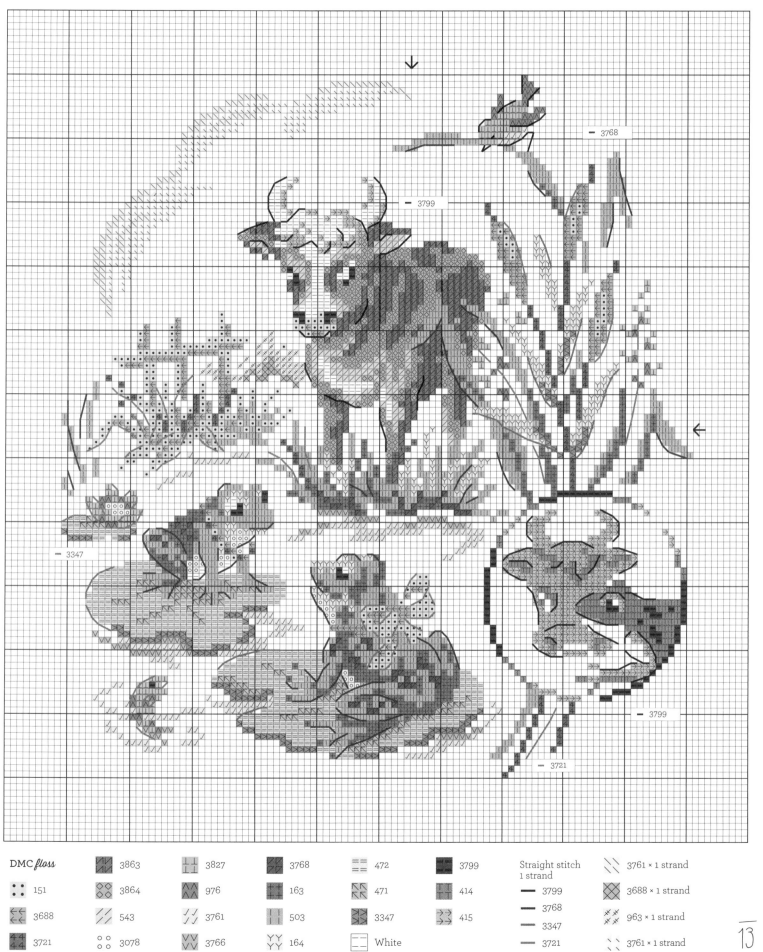

— 3768

— 3799

— 3347

— 3799

— 3721

DMC *floss*

	3863		3827		3768		472		3799	Straight stitch 1 strand		3761 × 1 strand
	151		3864		976		163		414	— 3799		3688 × 1 strand
	3688		543		3761		503		3347	— 3768		963 × 1 strand
	3721		3078		3766		164		415	— 3347		3761 × 1 strand
								White	— 3721			

The Ant and the Grasshopper

A trusty accessory with whimsy, this charming fabric totebag will follow your school-aged kid everywhere! It also makes a great tote for baby essentials.

Instructions on page 126.

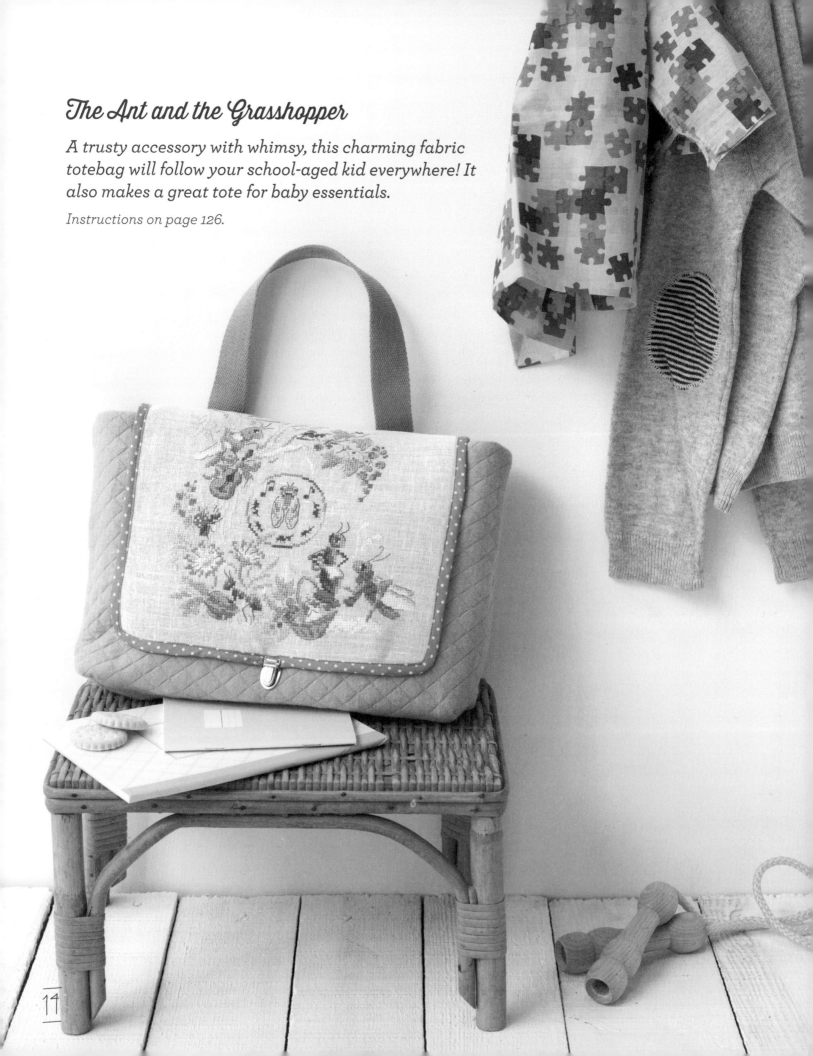

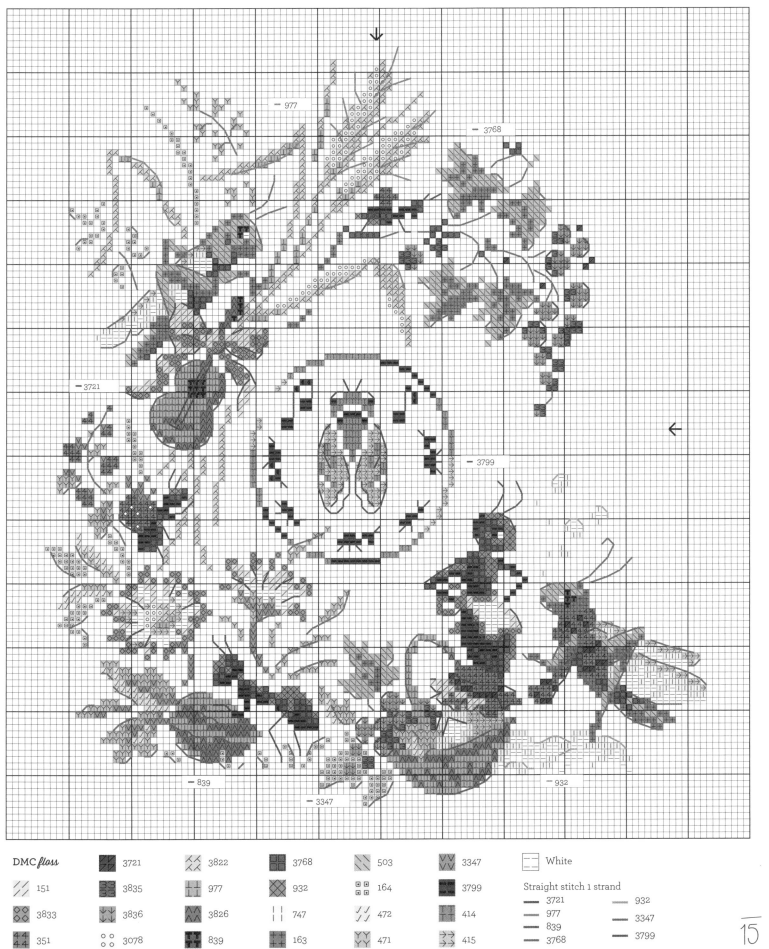

DMC floss

⫽ 151	3721	⤬⤬ 3822	3768	503	ⱽⱽ 3347
⬦⬦ 3833	3835	977	⤬ 932	⊡⊡ 164	3799
4 4 4 4 351	⬇⬇ 3836	3826	∣∣ 747	⫽⫽ 472	414
	∘∘ 3078	839	163	ⱽⱽ 471	→→ →→ 415

White

Straight stitch 1 strand
- 3721
- 977
- 839
- 3768

- 932
- 3347
- 3799

The Fox and the Stork

Reach for your needles! Just as if you were the frustrated stork, puncture the calculating fox's pride.

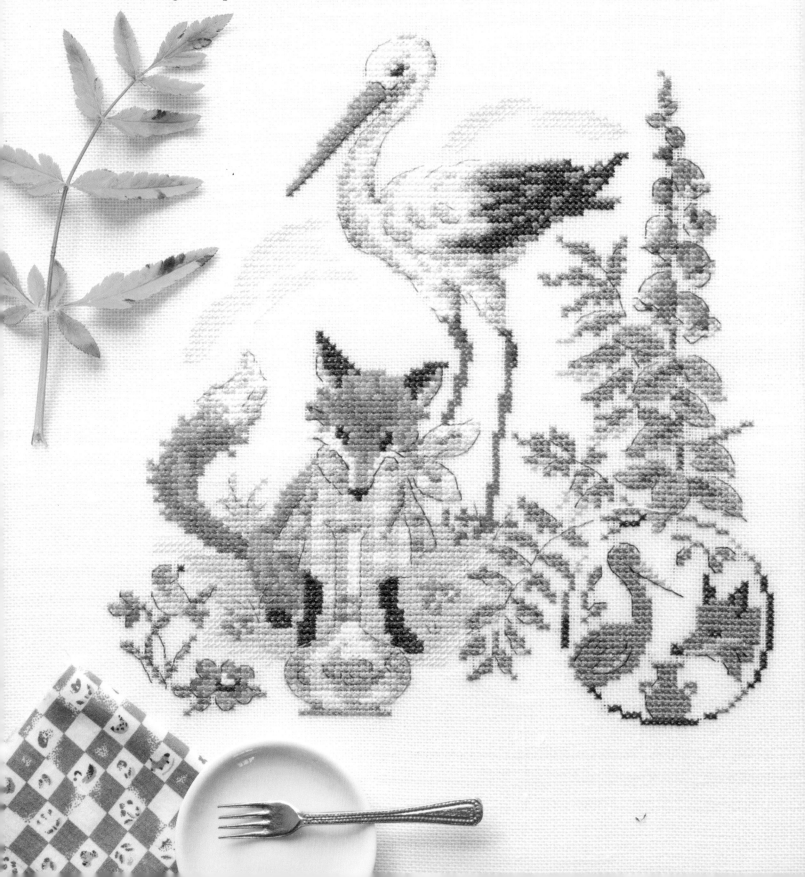

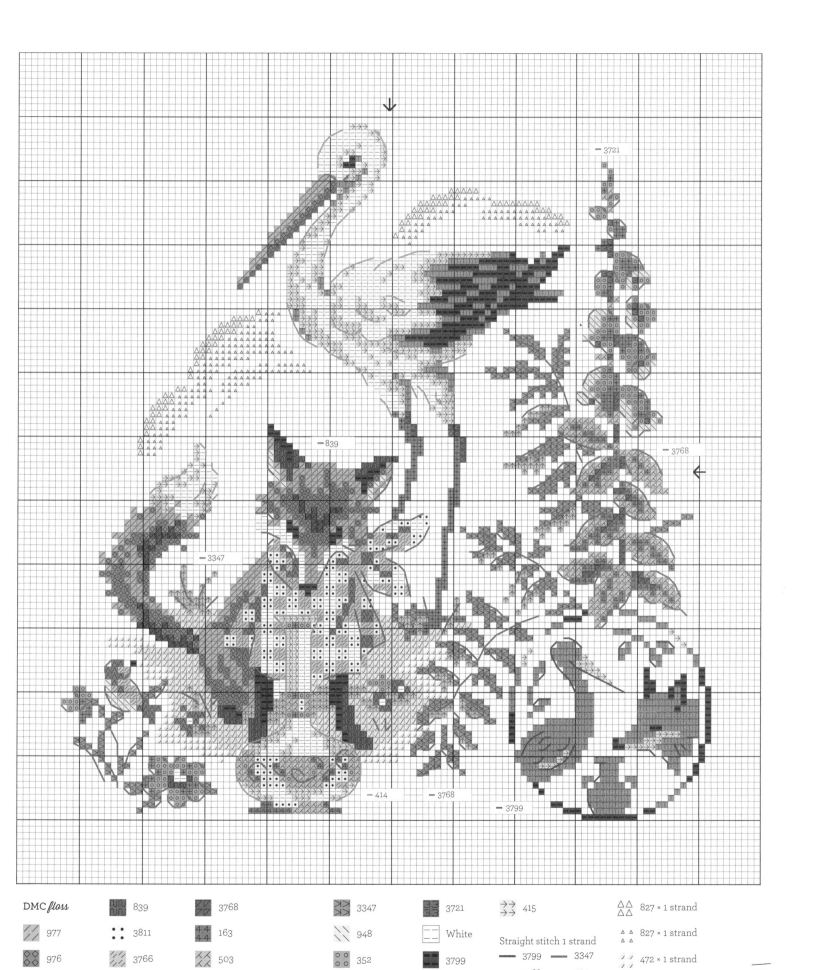

DMC *floss*										
	839		3768		3347		3721	415		827 × 1 strand
977	3811		163		948		White	Straight stitch 1 strand		827 × 1 strand
976	3766		503		352		3799	3799	3347	472 × 1 strand
3826	3810		472		351		414	3768	414	
								839	3721	

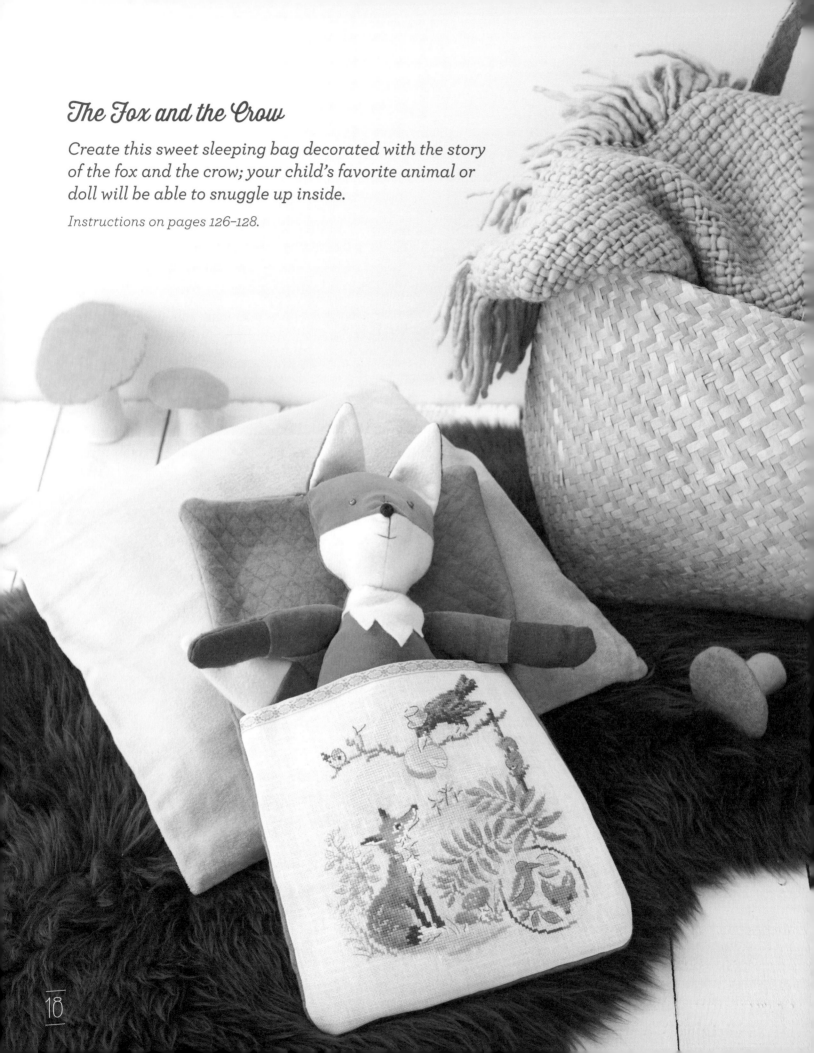

The Fox and the Crow

Create this sweet sleeping bag decorated with the story of the fox and the crow; your child's favorite animal or doll will be able to snuggle up inside.

Instructions on pages 126–128.

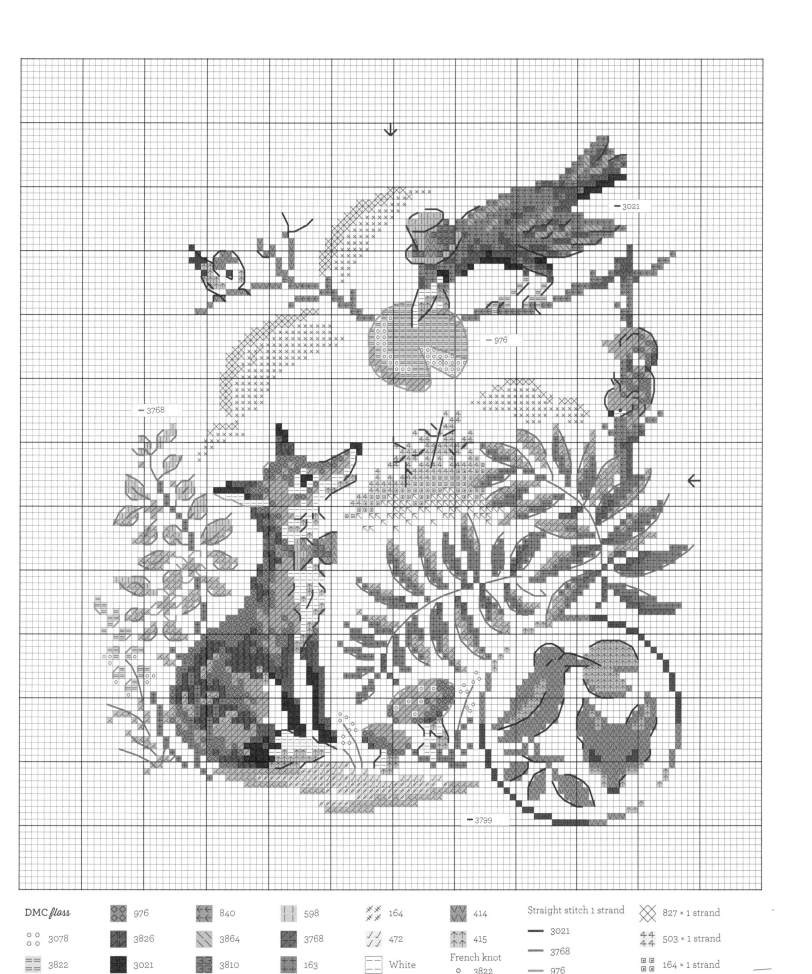

DMC *floss*

976	840	598	164	414
3078	3826	3864	472	415
3822	3021	3810	163	White
977	839	3766	503	3799
3768	3826	3768		

Straight stitch 1 strand
— 3021
— 3768
— 976
— 3799

French knot
○ 3822
● 3021

827 × 1 strand
503 × 1 strand
164 × 1 strand
472 × 1 strand

The Milkmaid and Her Pail

Just like the milkmaid, daydream for a while about cow and calf and pig ... But be careful not to let your hard work come to nothing!

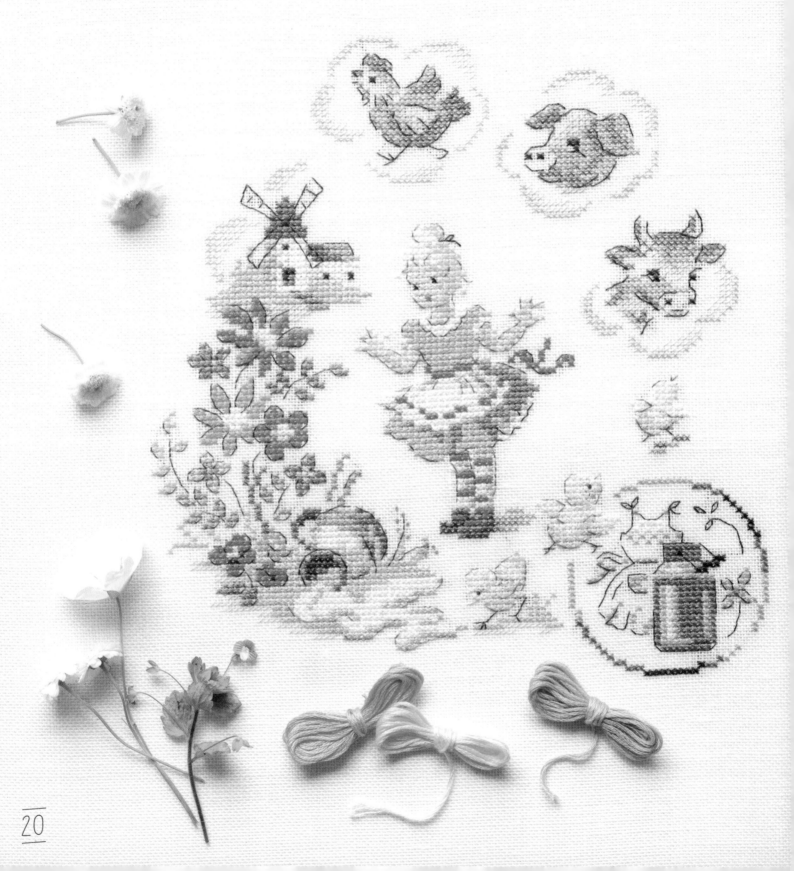

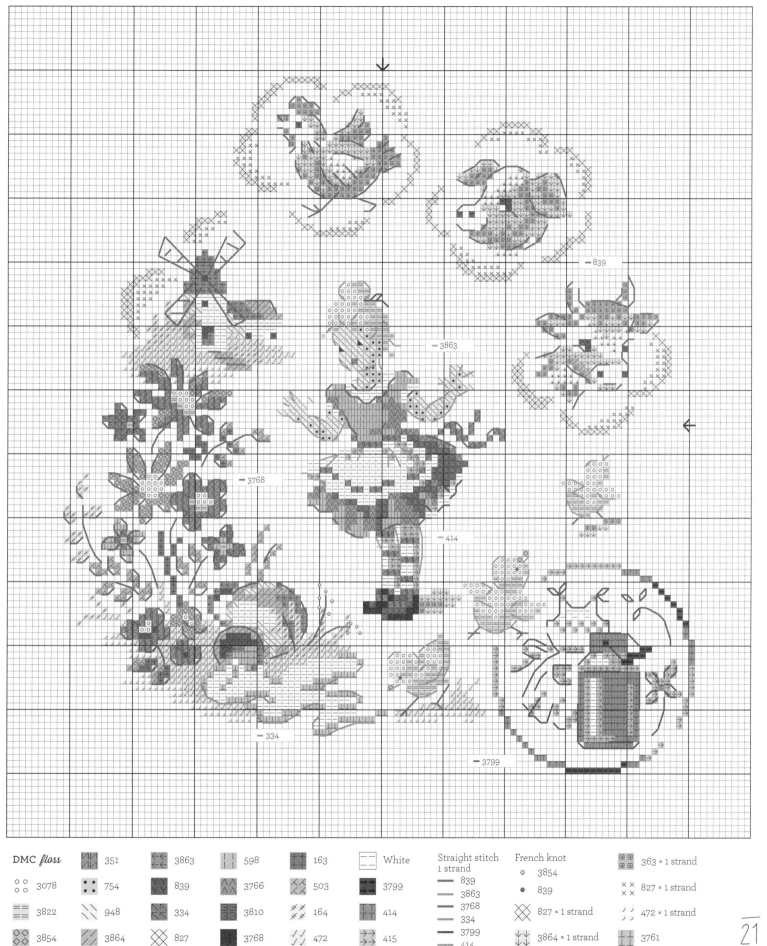

DMC *floss*

	351		3863		598		163		White	Straight stitch 1 strand	French knot		363 × 1 strand
3078	754		839		3766		503		3799	839	3854		827 × 1 strand
3822	948		334		3810	164		414	3863 3768	839		472 × 1 strand	
3854	3864	827		3768		472	415		334 3799 414	827 × 1 strand 3864 × 1 strand		3761	

The Wolf and the Lamb

Don't be fooled by the calm appearance of the river, or by the heady scent of wildflowers; hidden behind this soothing scene is an angry wolf with sharp teeth.

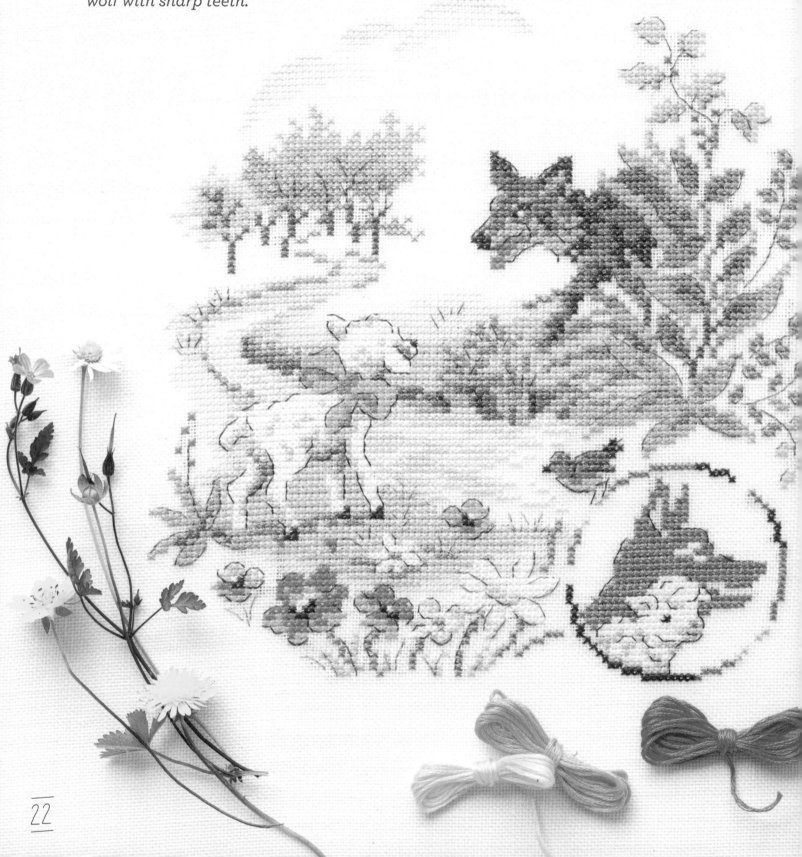

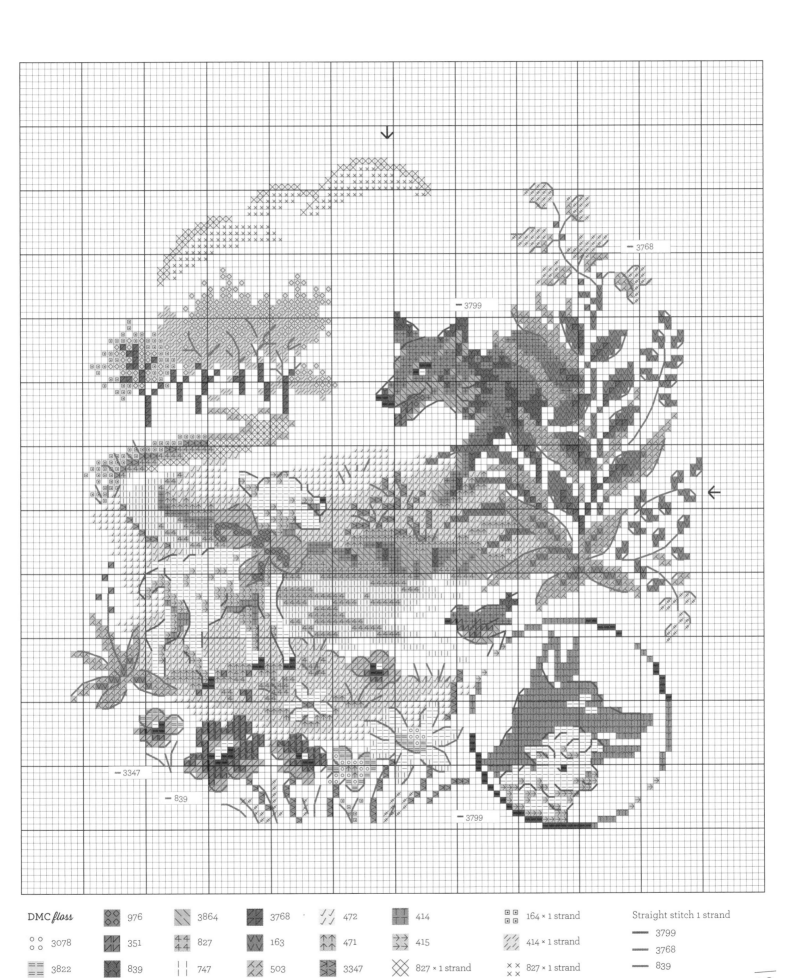

DMC *floss*

976	3864	3768	472	414	164 × 1 strand	Straight stitch 1 strand	
3078	351	827	163	471	414 × 1 strand	3799	
3822	839	747	503	415	827 × 1 strand	3768	
3854	840	White	164	3347	503 × 1 strand	839	
				3799	827 × 1 strand	3347	
					472 × 1 strand		

3768

3799

3347

839

3799

23

The Fisherman and the Little Fish

In the calm waters, a fish tries to save itself from a hungry fisherman. A nice try, but under your needle and thread, the poor little fish is going to be eaten!

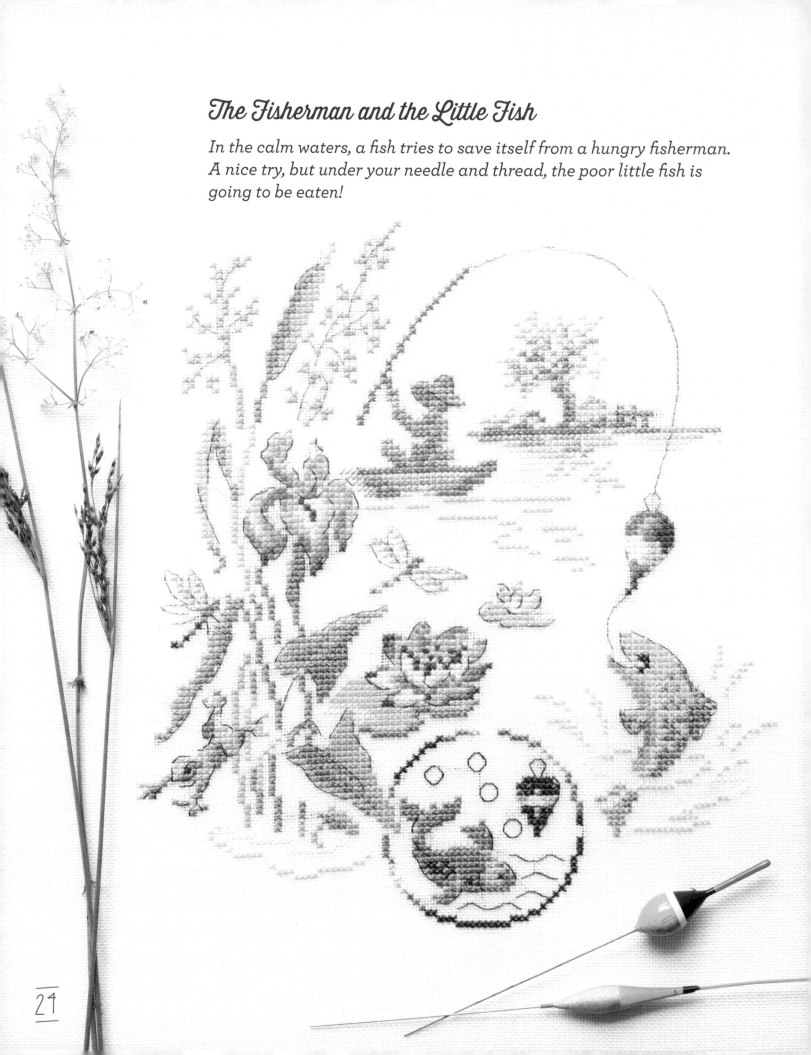

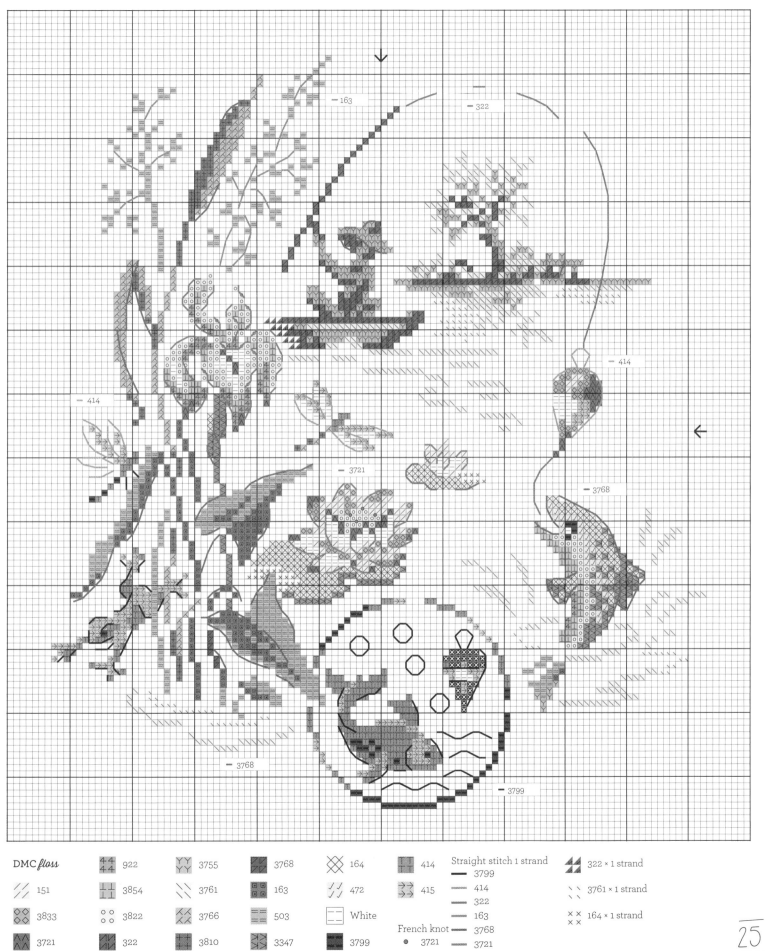

The City Mouse and the Country Mouse

Join the feast with these two friends by embroidering the joyous meeting.

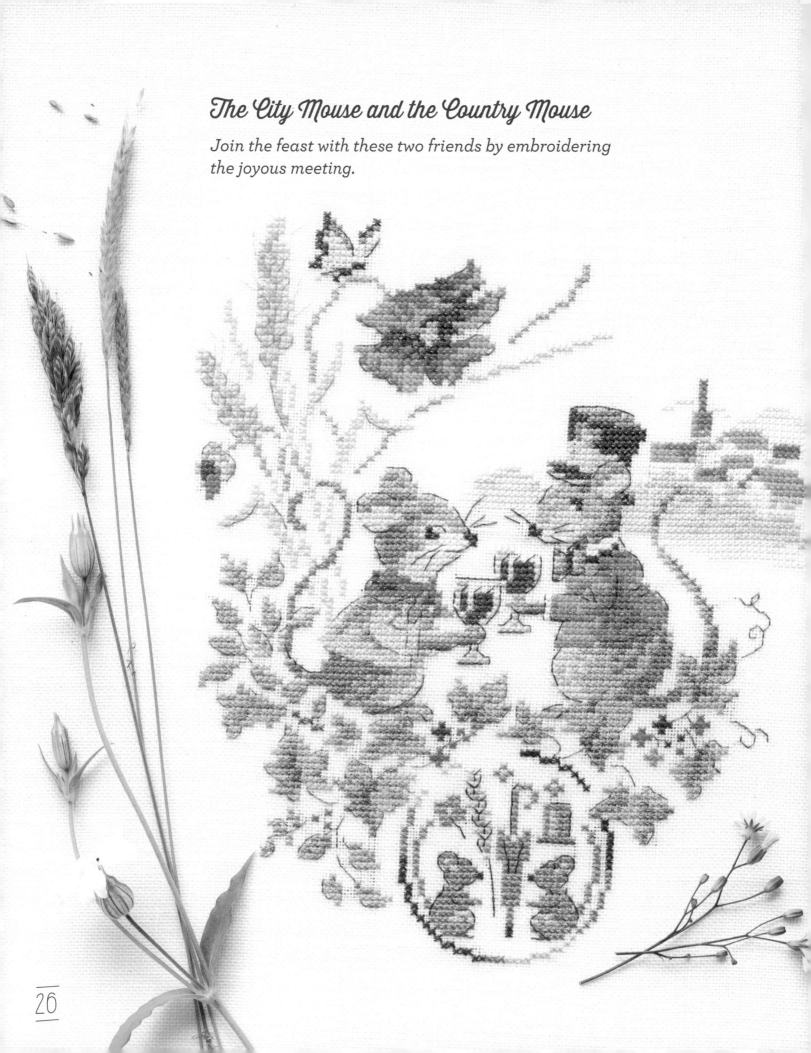

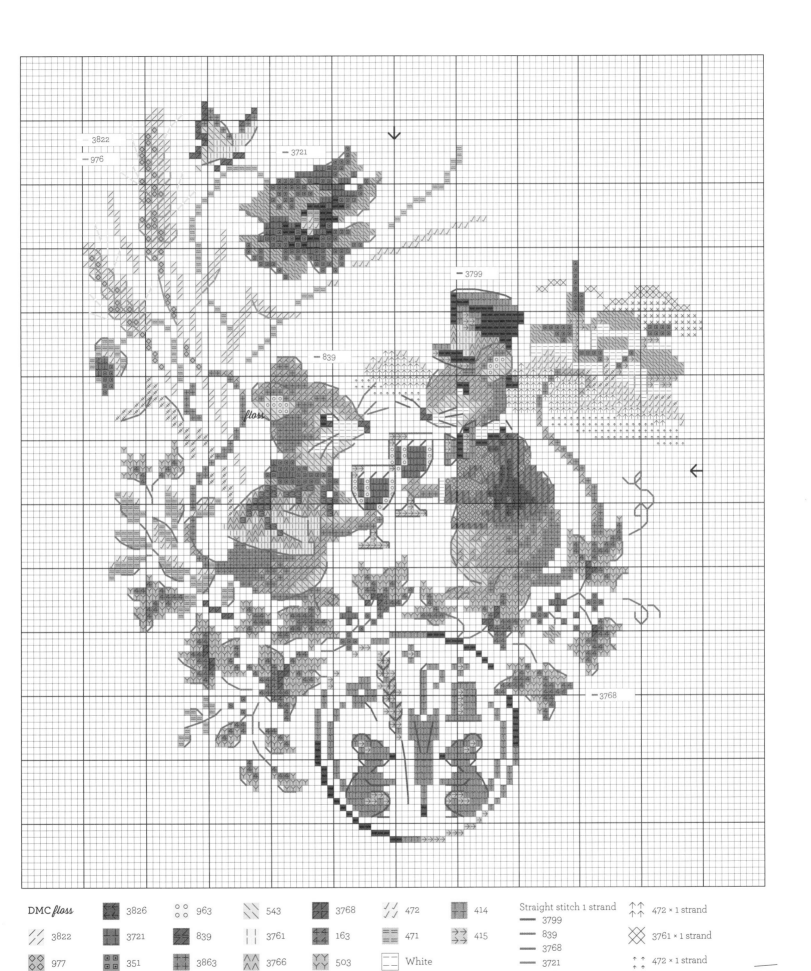

DMC *floss*						
▨ 3826	⁰⁰ 963	⁄⁄ 543	▨ 3768	⁄⁄ 472	▨ 414	**Straight stitch 1 strand**
⁄⁄ 3822	▦ 3721	▦ 839	‖ 3761	⁴⁴ 163	⁺⁺ 471	── 3799
⁰⁰ 977	▦ 351	▦ 3863	⋀⋀ 3766	⋁⋁ 503	□ White	── 839
⋈ 976	⁄⁄ 352	⋈ 3864	≋ 3810	⁺⁺ 164	▨ 3799	── 3768
						── 3721
						── 976
						── 3822

↑↑↑ 472 × 1 strand
⨂ 3761 × 1 strand
↑↑ 472 × 1 strand
×× 3761 × 1 strand

In-chart labels: — 3822, — 976, — 3721, — 3799, — 839, — 3768, *floss*

The Tortoise and the Hare

Stitch by stitch! Adopt a "slow and steady" attitude for this design, because as the old proverb says, it wins the race.

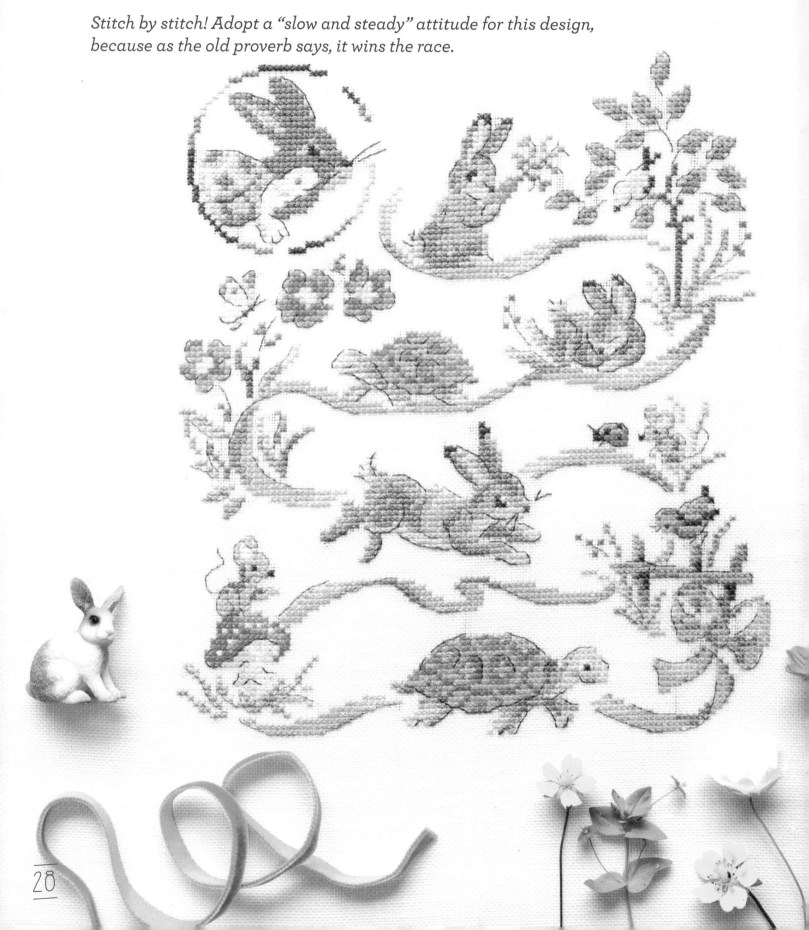

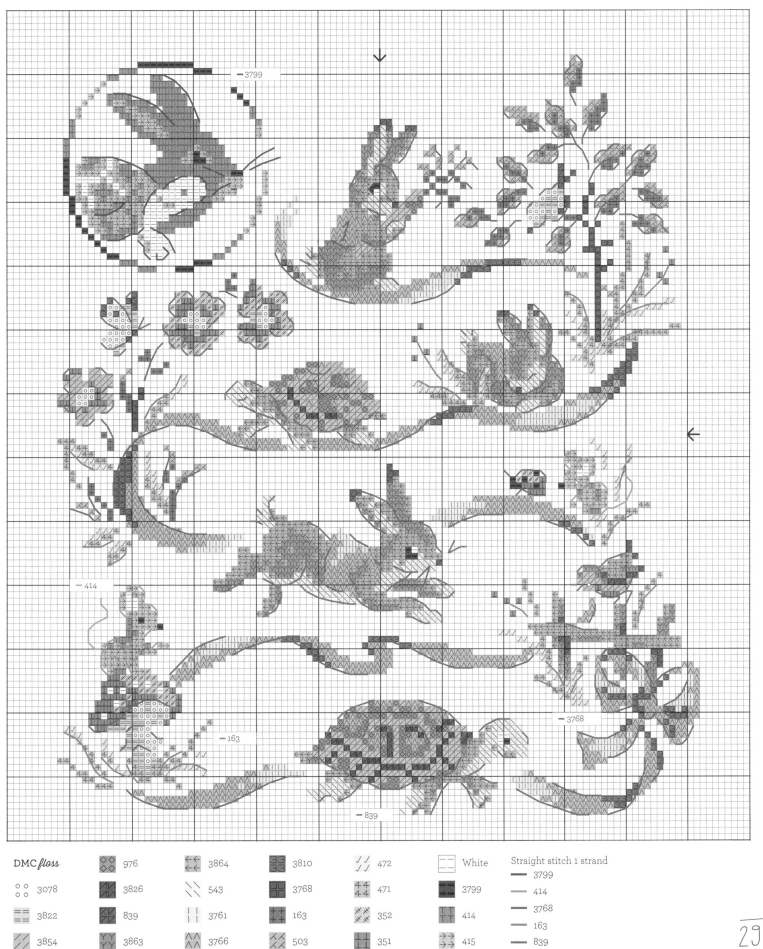

DMC floss										Straight stitch 1 strand
	976		3864		3810		472		White	3799
3078	3826		543		3768		471		3799	414
3822	839		3761		163		352		414	3768
3854	3863		3766		503		351		415	163
										839

29

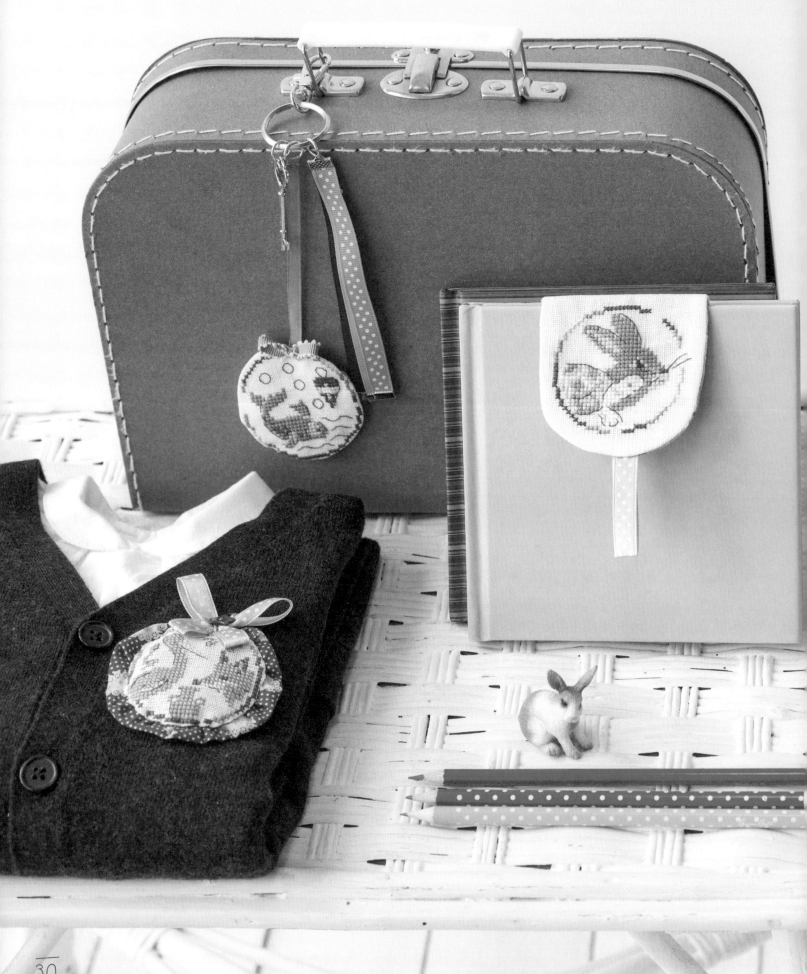

Taking the Fables Along

You know them all by heart; you listened to them when you were a child. Why not use your favorite fables to decorate a bookmark, a pin to wear, and a pretty key ring? Do it by using the miniature monochrome motifs that are hidden within each of the preceding designs.

Instructions on pages 128-129.

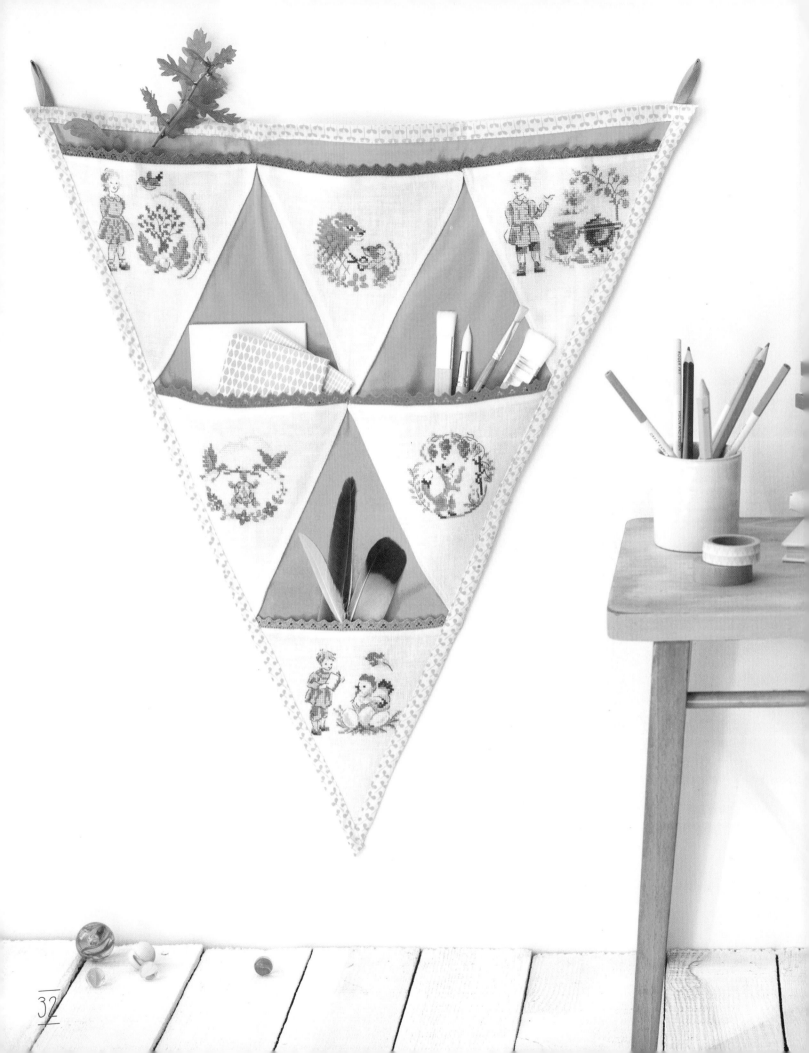

Storage Pouch Pennant

Decorated with your creations, this storage pouch in the shape of a pennant is ideal for storing the keys, change, and subway tokens that clutter up your purse!

Instructions on page 129.

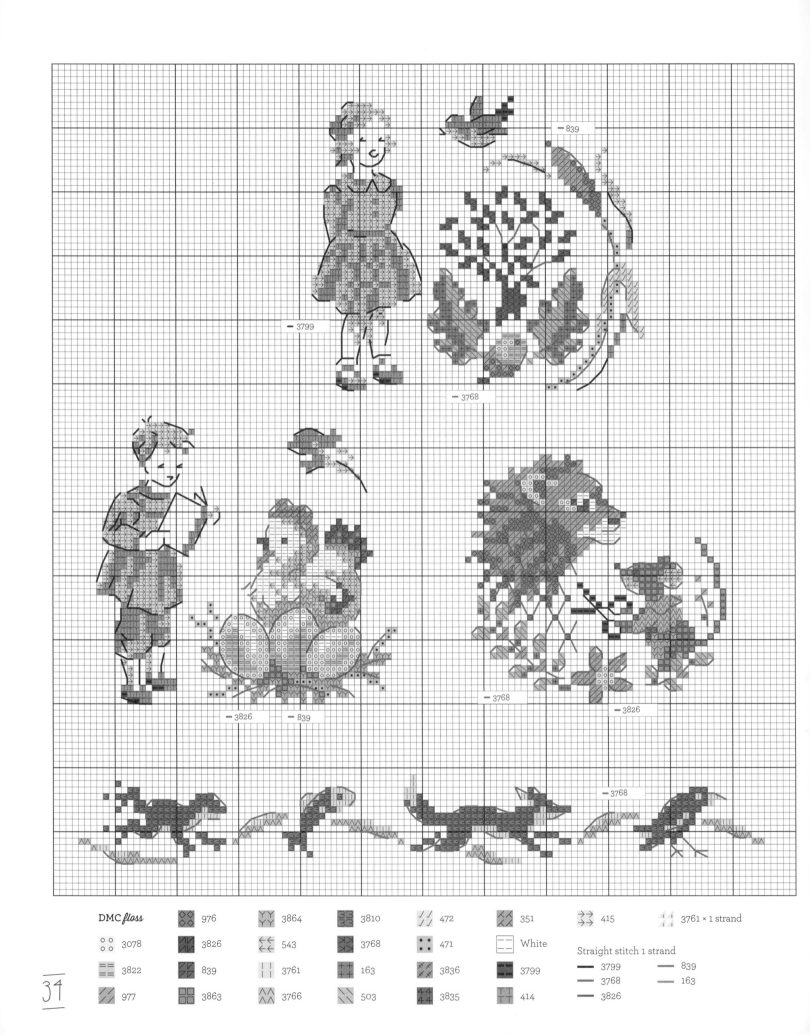

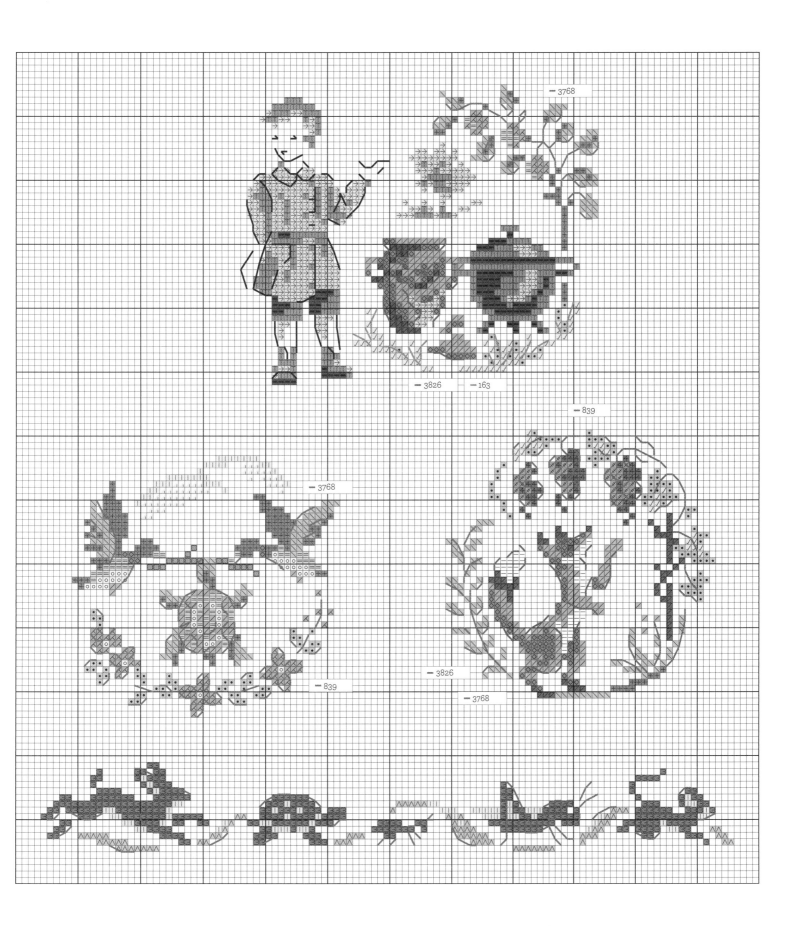

FAIRY
TALES

A haven for the imagination, fairy tales fill our spirits with magic. Monsters and witches rub shoulders with fairies and princesses. Re-read and relive these fairy tales through your embroidery . . .

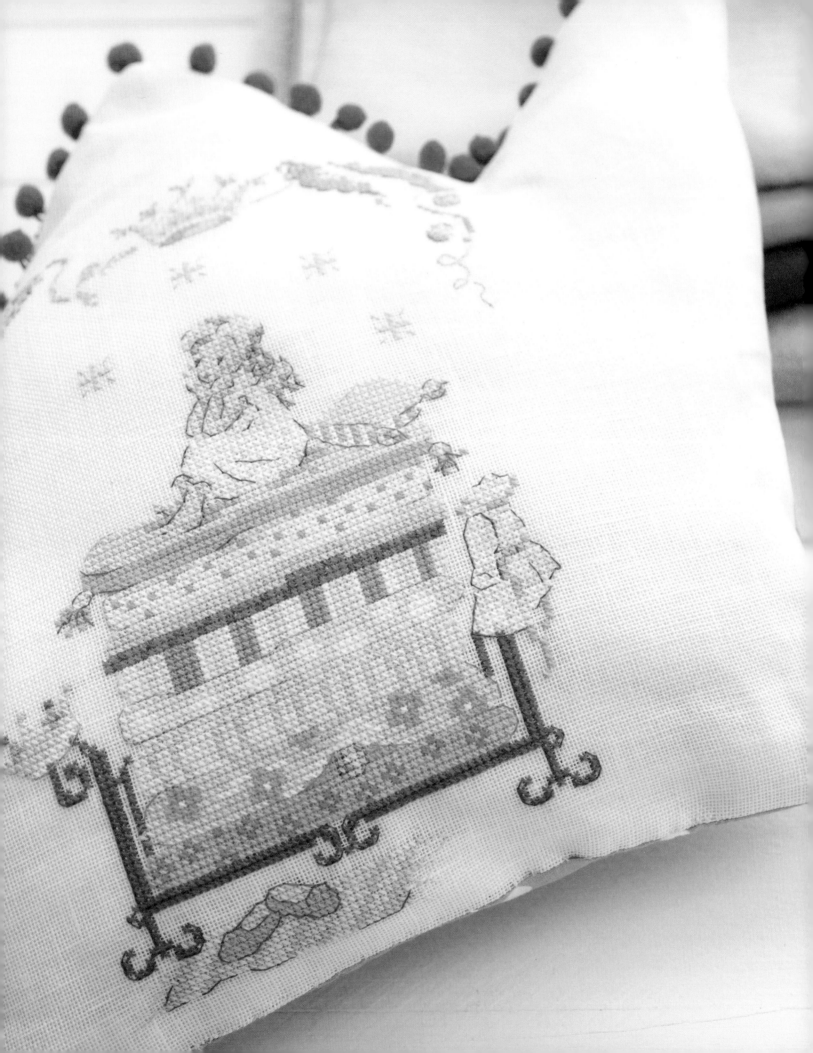

Once Upon a Time

Just as English-speaking kids love to hear the magical words "Once upon a time . . . ," French children love to hear "Il etait une fois" Protect your favorite fairy tales with this needlework book cover. You can customize it to fit any book.

Instructions on page 130.

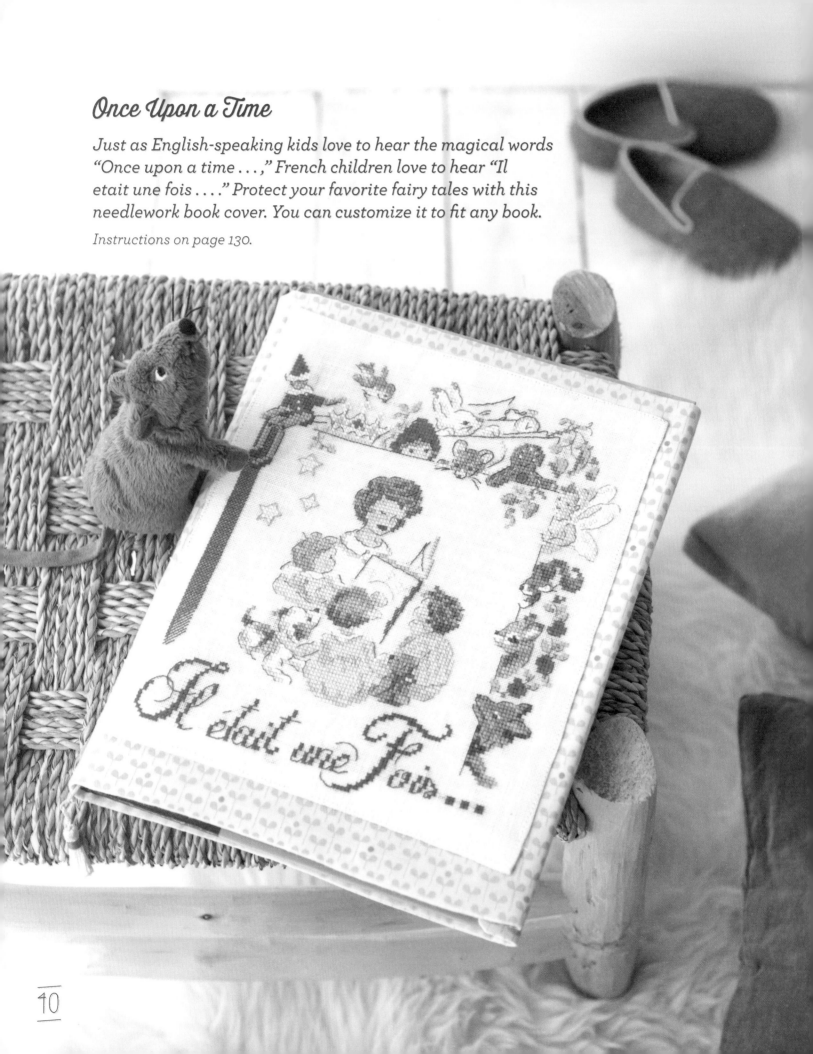

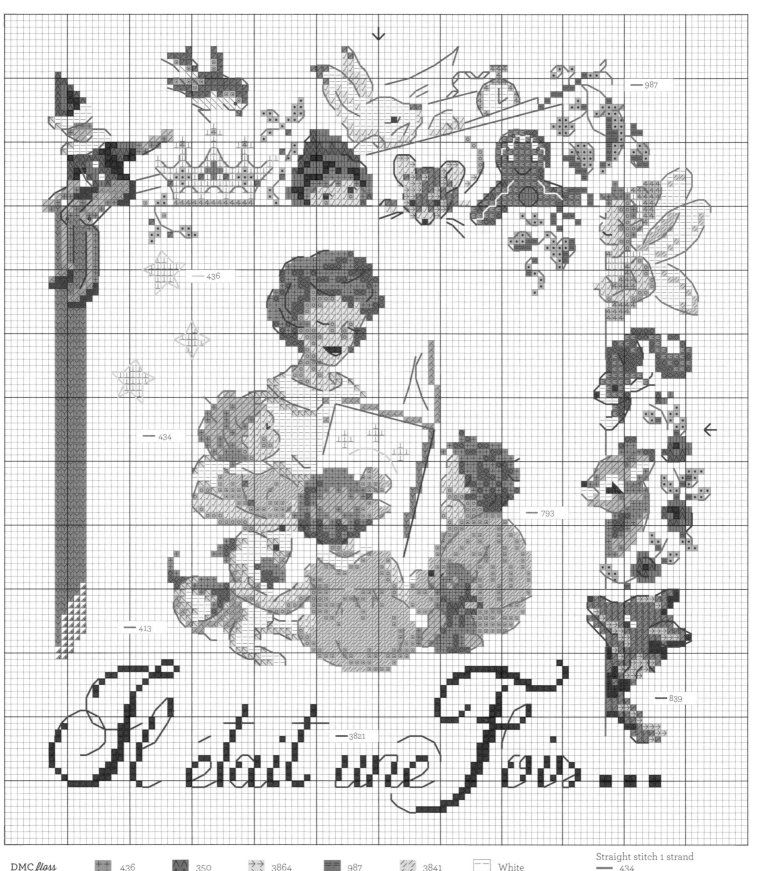

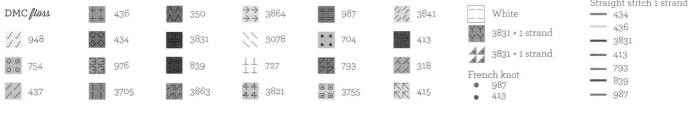

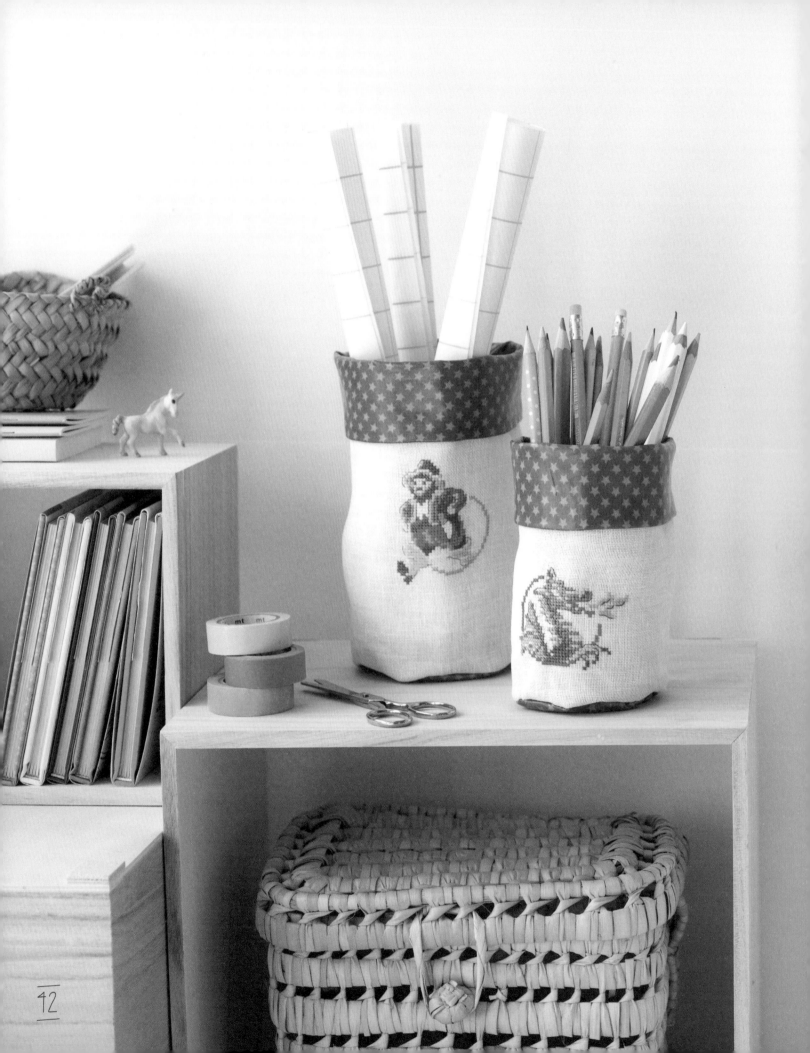

Color Your Dreams . . .

What is better than a bit of drawing and coloring to let your spirit fly? Create your own world, and keep your magic pencils or markers safe in this imaginative holder. A fairy hat can come in handy also.

Instructions on pages 130–131.

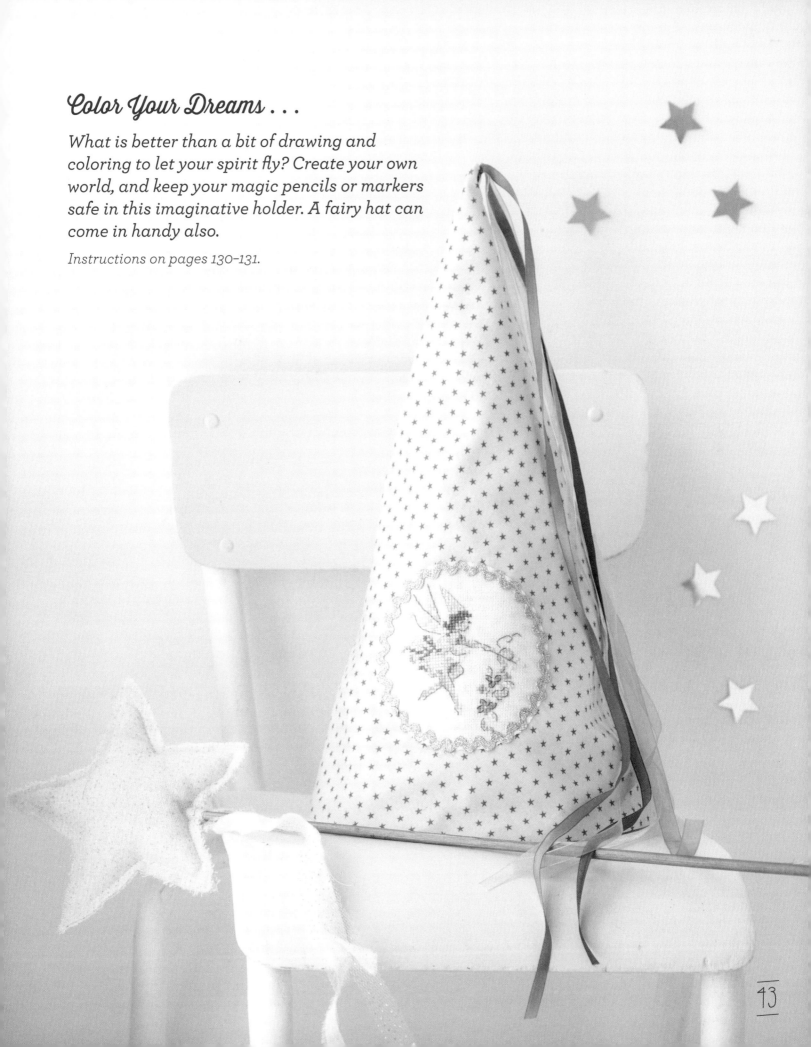

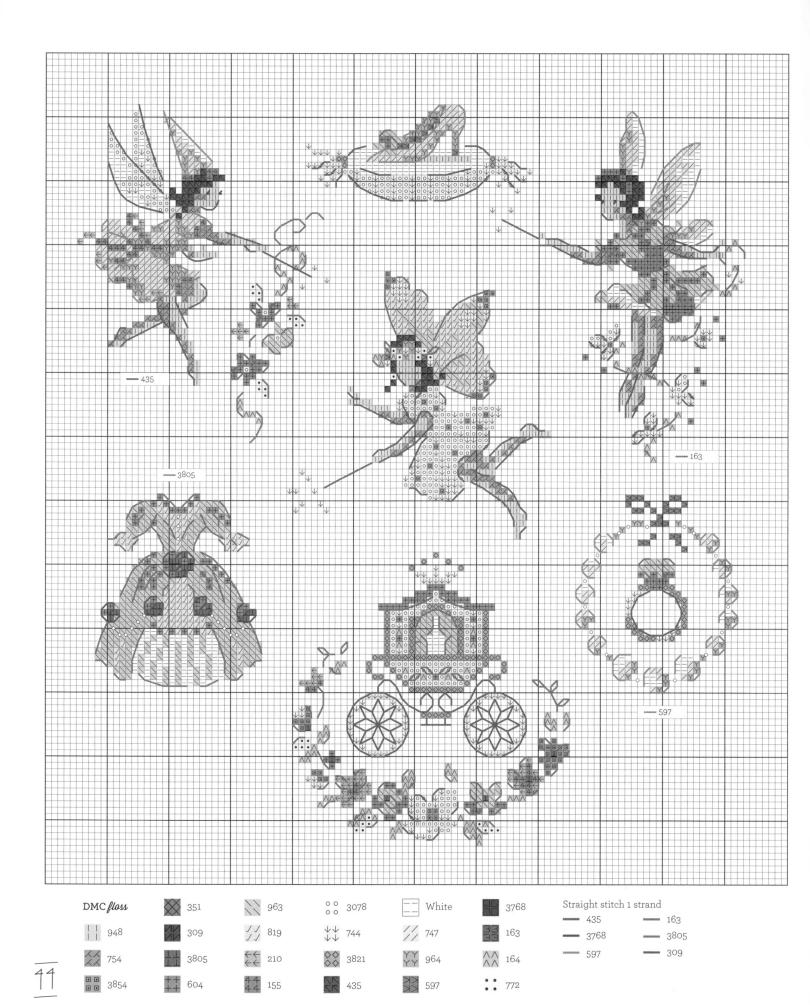

—435

—163

—3805

—597

DMC *floss*		351		963	° °	3078		White		3768	Straight stitch 1 strand	
	948		309		819	↓↓	744		747		163	—— 435 —— 163
	754		3805		210		3821		964		164	—— 3768 —— 3805
	3854		604		155		435		597		772	—— 597 —— 309

435

3768

597

309

Beauty and the Beast

Don't wait for the last petal to fall from the rose to embroider this delicate representation of the growing love between Beauty and the Beast.

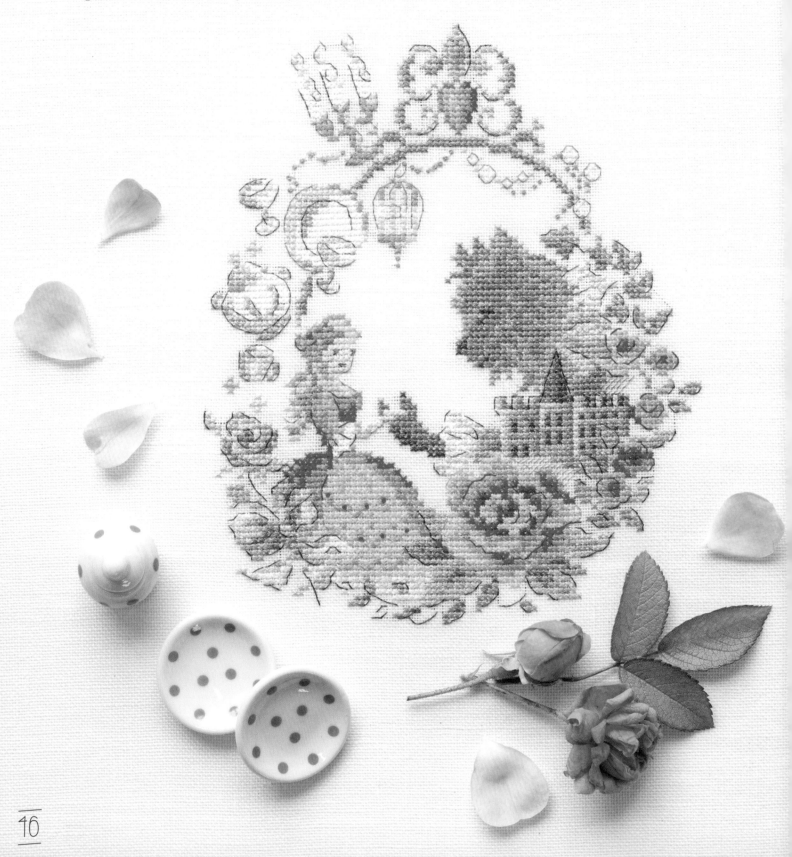

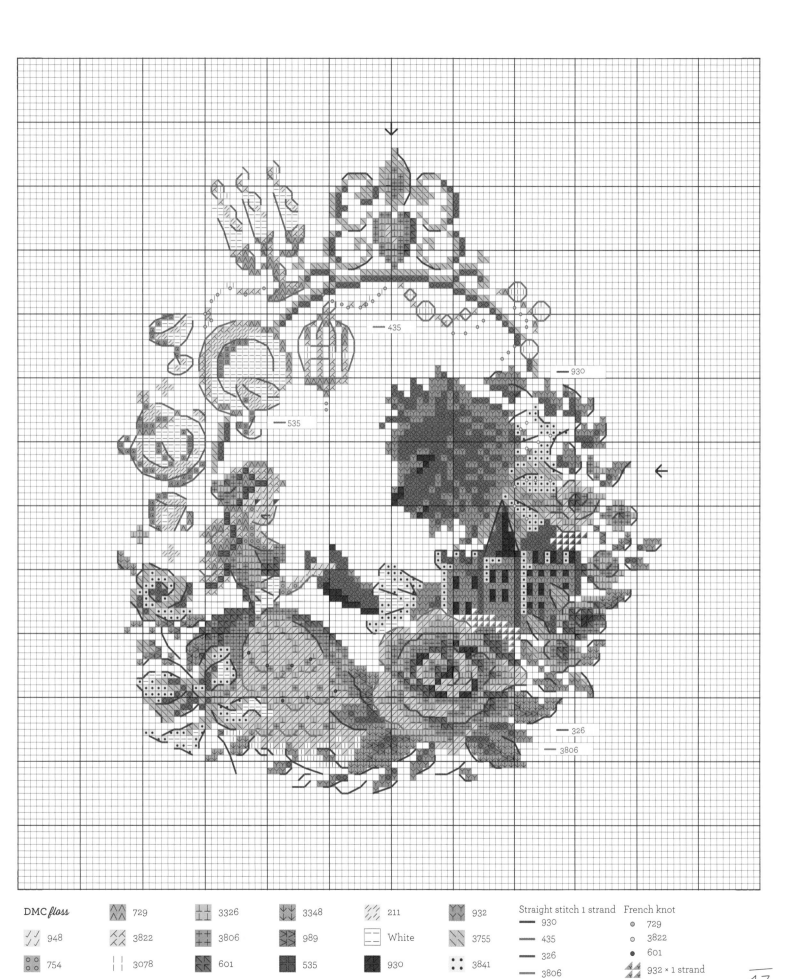

DMC *floss*

	729	3326	3348	211	932	
948	3822	3806	989	White	3755	
754	3078	601	535	930	3841	
435	967	326	3042	931		

Straight stitch 1 strand
— 930
— 435
— 326
— 3806
— 535

French knot
○ 729
○ 3822
● 601
932 × 1 strand
931 × 1 strand

47

Snow White and the Seven Dwarfs

Surrounded by her animal friends, Snow White has no idea of the fate the queen has in store for her . . . Using your best shades of red, embroider an apple that's irresistibly poisonous!

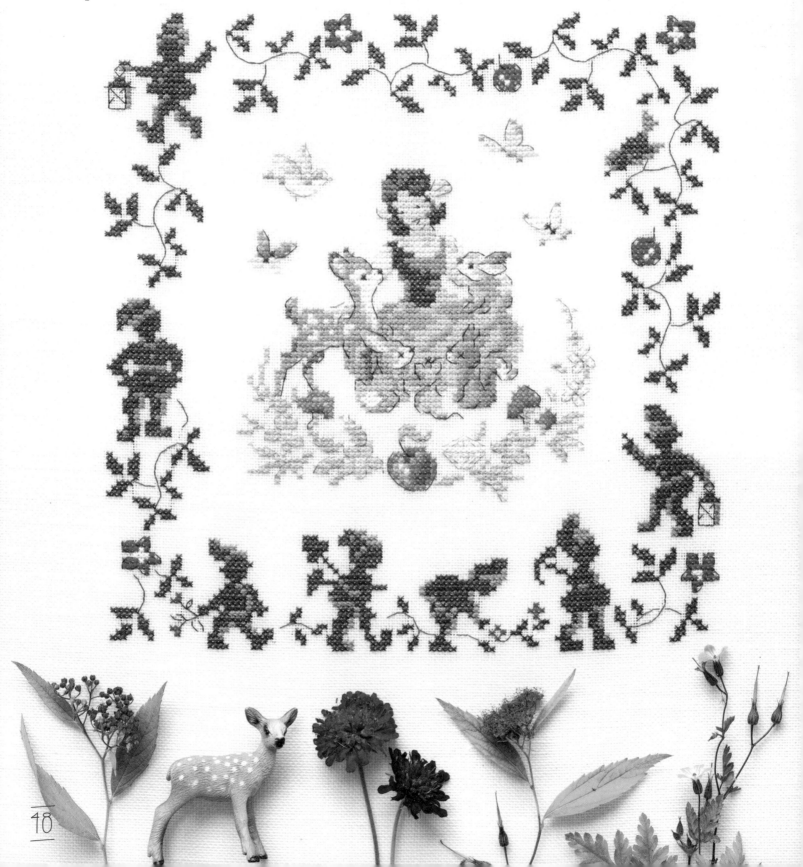

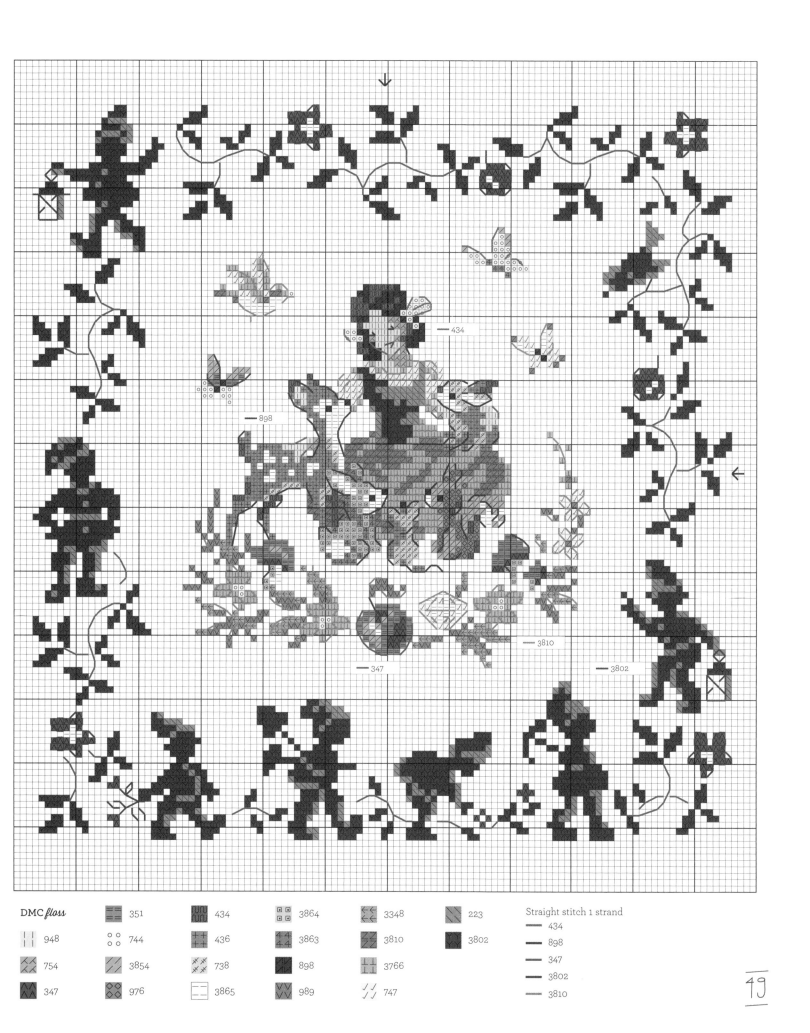

DMC *floss*

	351		434		3864		3348		223	Straight stitch 1 strand		
	948		744		436		3863		3810			— 434
	754		3854		738		898		3766			— 898
	347		976		3865		989		747			— 347
											— 3802	
											— 3810	

49

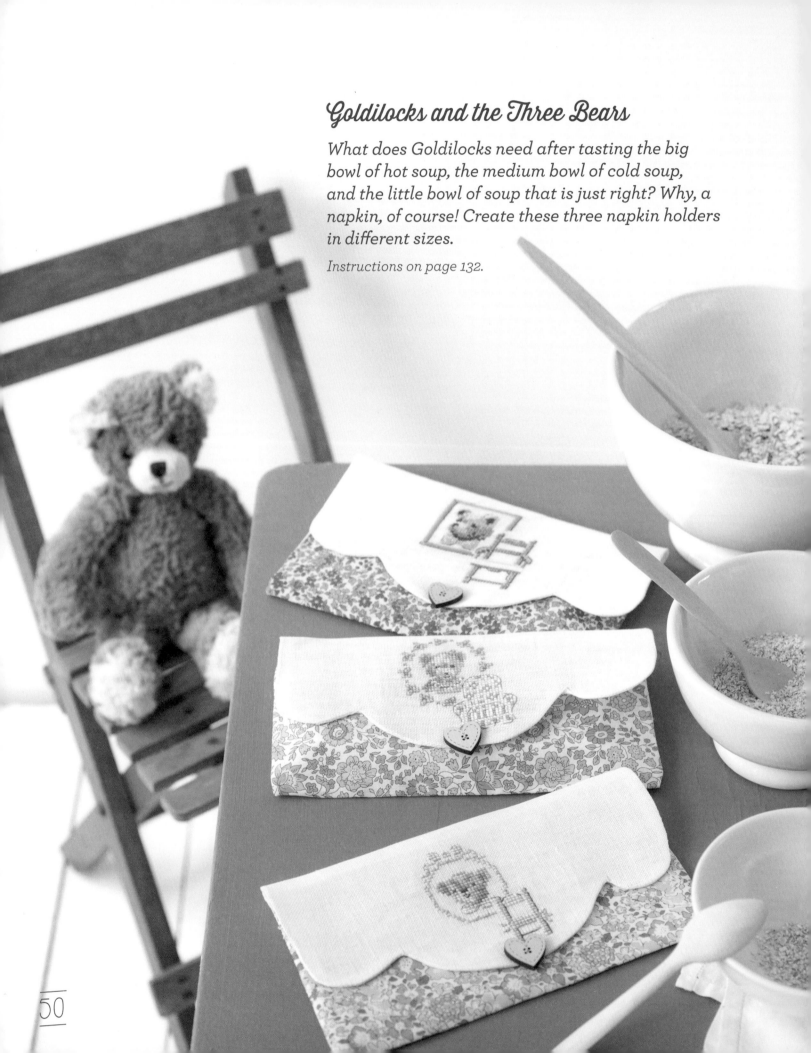

Goldilocks and the Three Bears

What does Goldilocks need after tasting the big bowl of hot soup, the medium bowl of cold soup, and the little bowl of soup that is just right? Why, a napkin, of course! Create these three napkin holders in different sizes.

Instructions on page 132.

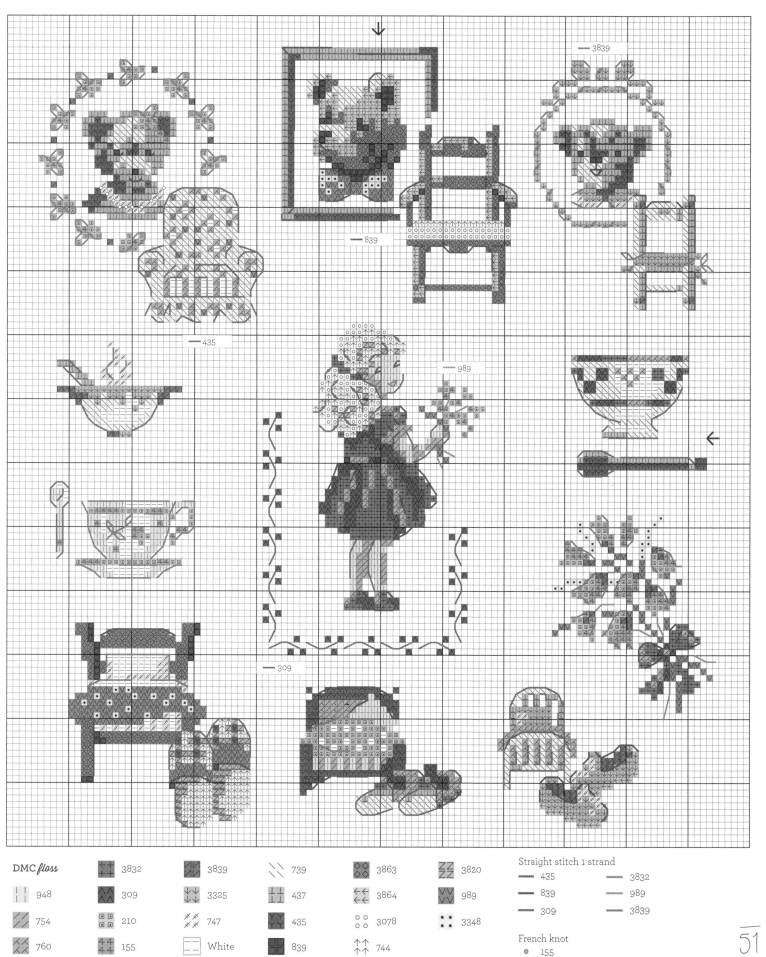

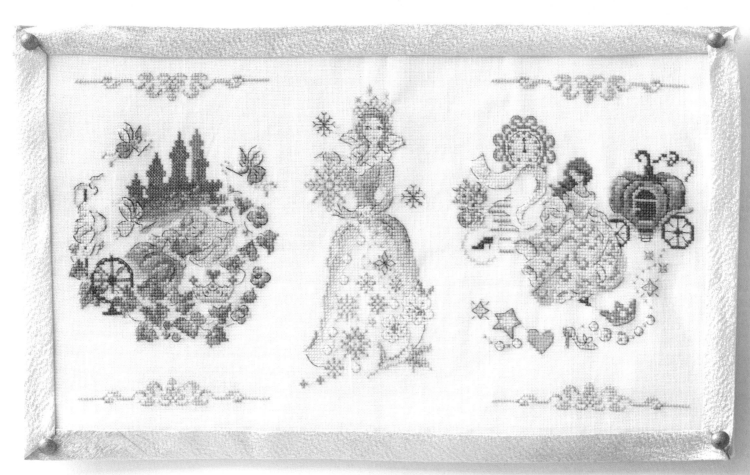

Princesses

Whether they are plunged into a deep sleep for one hundred years, imprisoned in ice palaces, or hurrying away from the ball at midnight, princesses make lovely companions for your child's bedroom (or yours!). Just be careful not to prick your finger on your spindle!

Instructions on page 133.

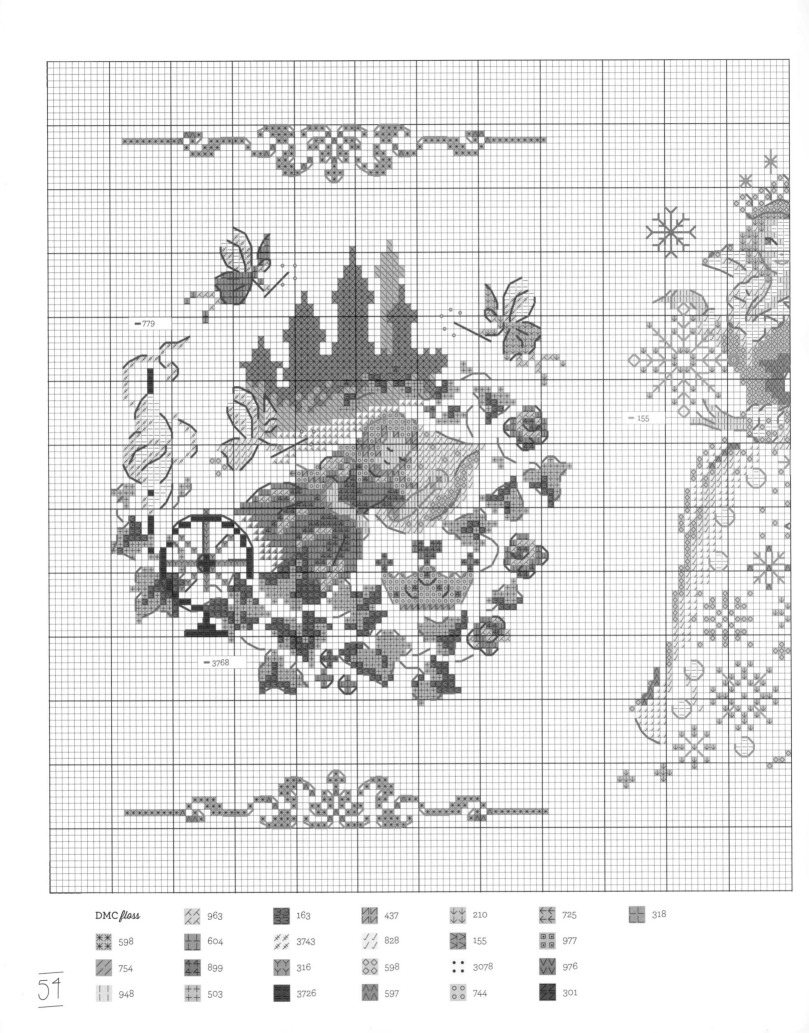

− 779

− 155

− 3768

DMC *floss*

963		163		437		210		725		318	
598		604		3743		828		155		977	
754		899		316		598		3078		976	
948		503		3726		597		744		301	

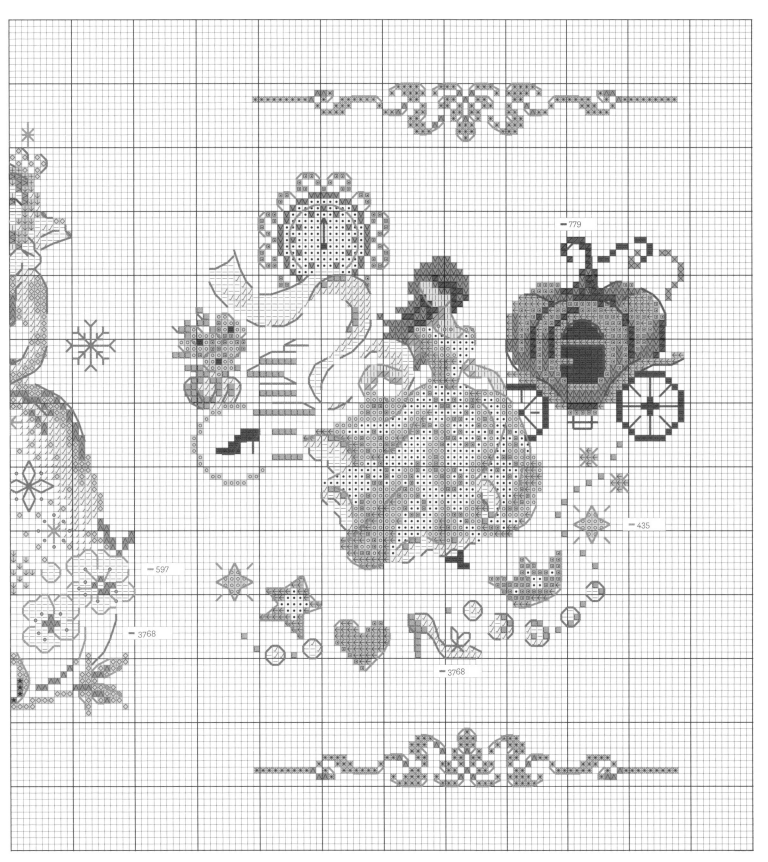

Straight stitch 1 strand

— 779

— 435

— 3768

— 597

— 155

French knot

○ 725

○ 318

○ 597

◨ 316 × 1 strand

◨ 3726 × 1 strand

◨ 316 × 1 strand

55

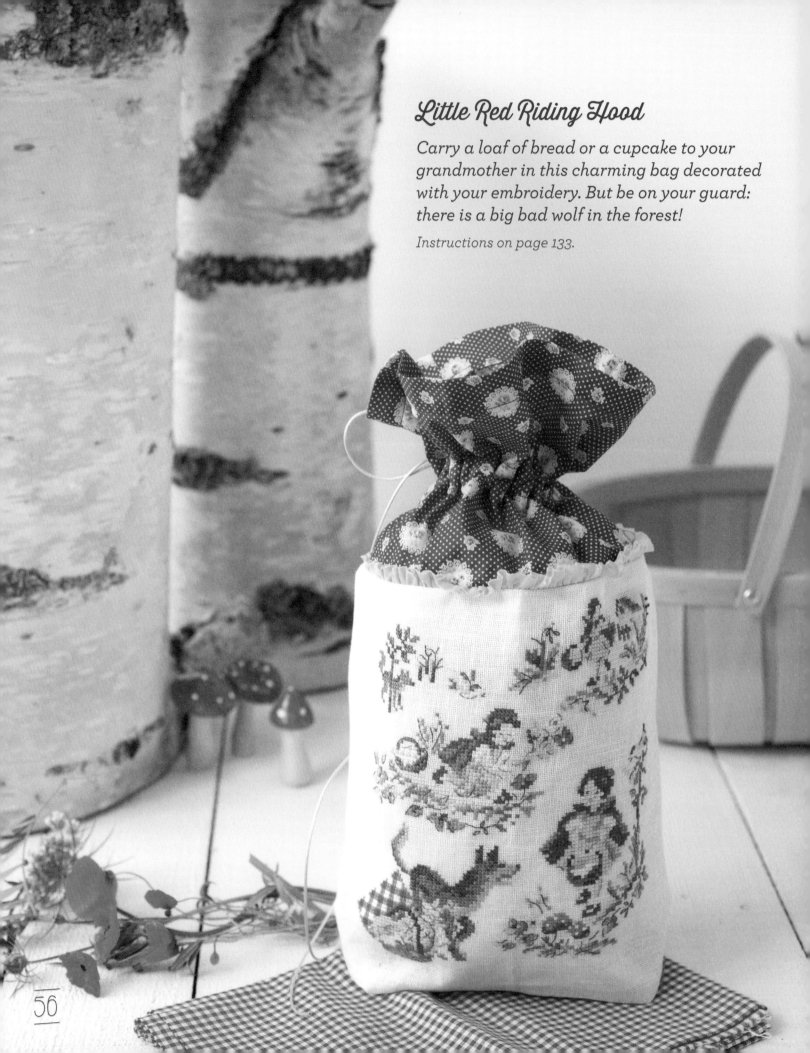

Little Red Riding Hood

Carry a loaf of bread or a cupcake to your grandmother in this charming bag decorated with your embroidery. But be on your guard: there is a big bad wolf in the forest!

Instructions on page 133.

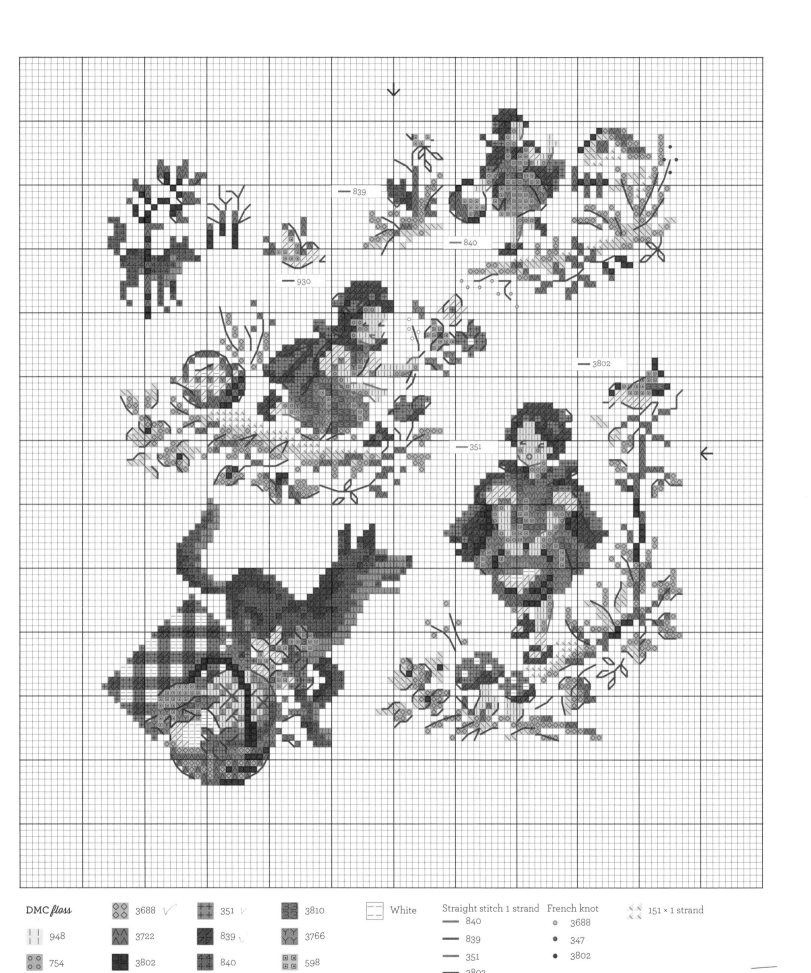

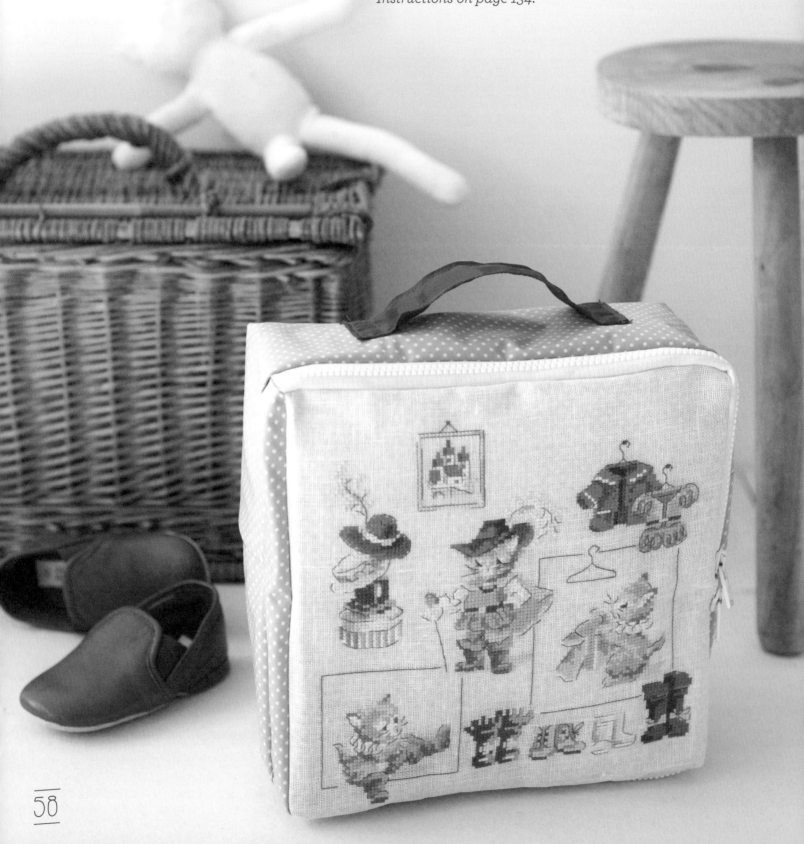

Puss-in-Boots

Store your dolls' boots, cloaks, and hats in this practical, portable suitcase!

Instructions on page 134.

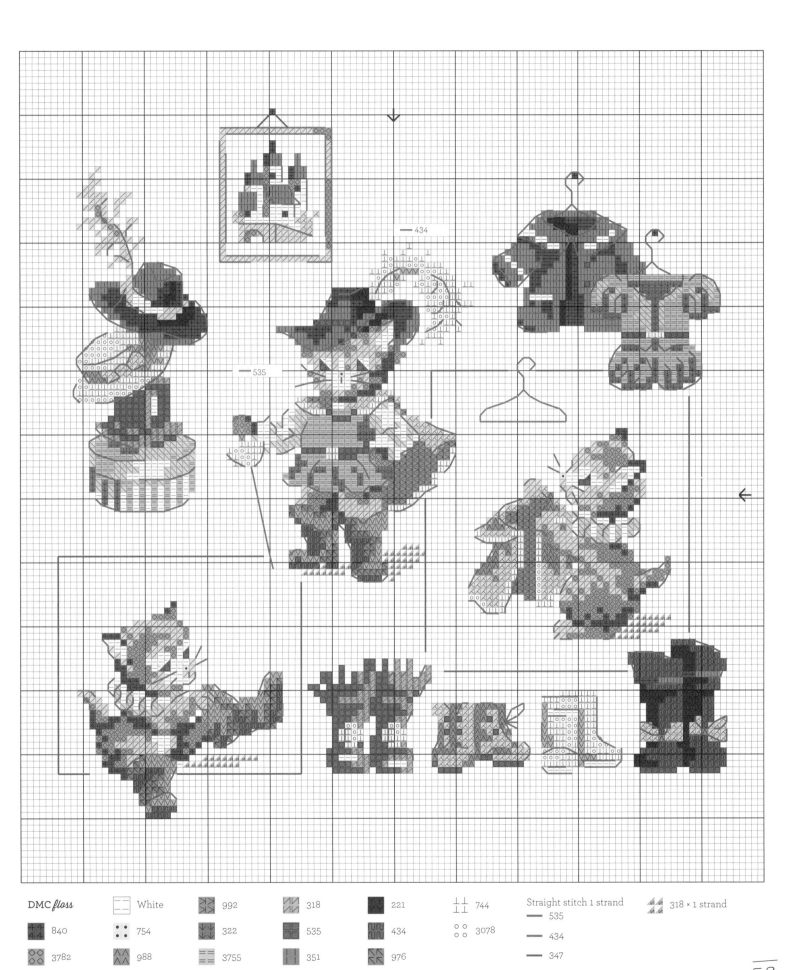

The Three Little Pigs

Straw, wood, or brick: which house will resist the huffing and puffing of the wolf? Turn into a builder and embroider a home for these three little pigs!

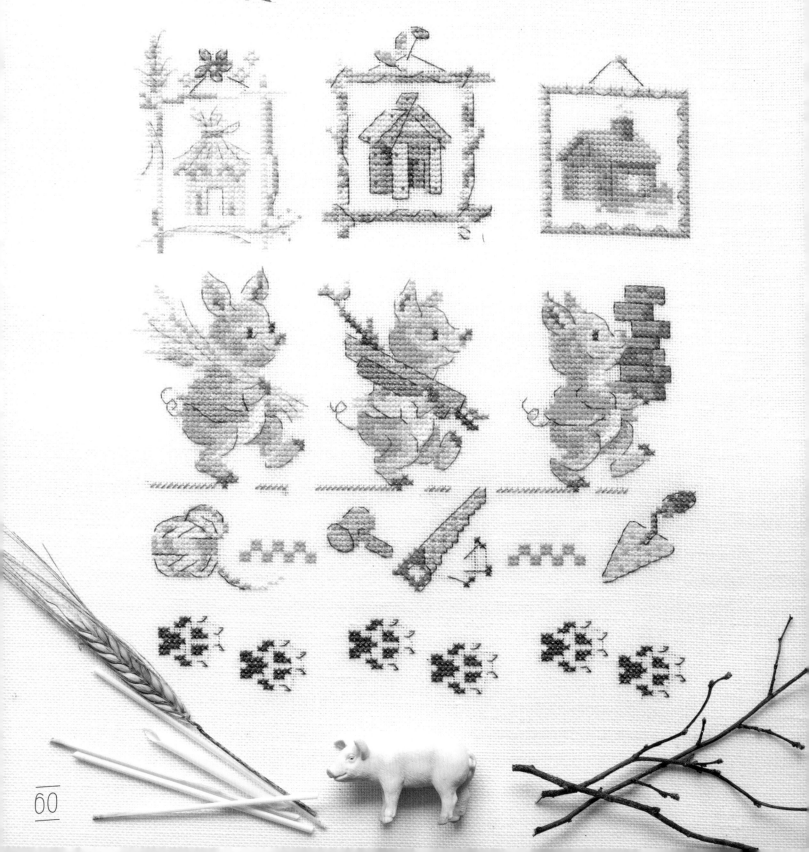

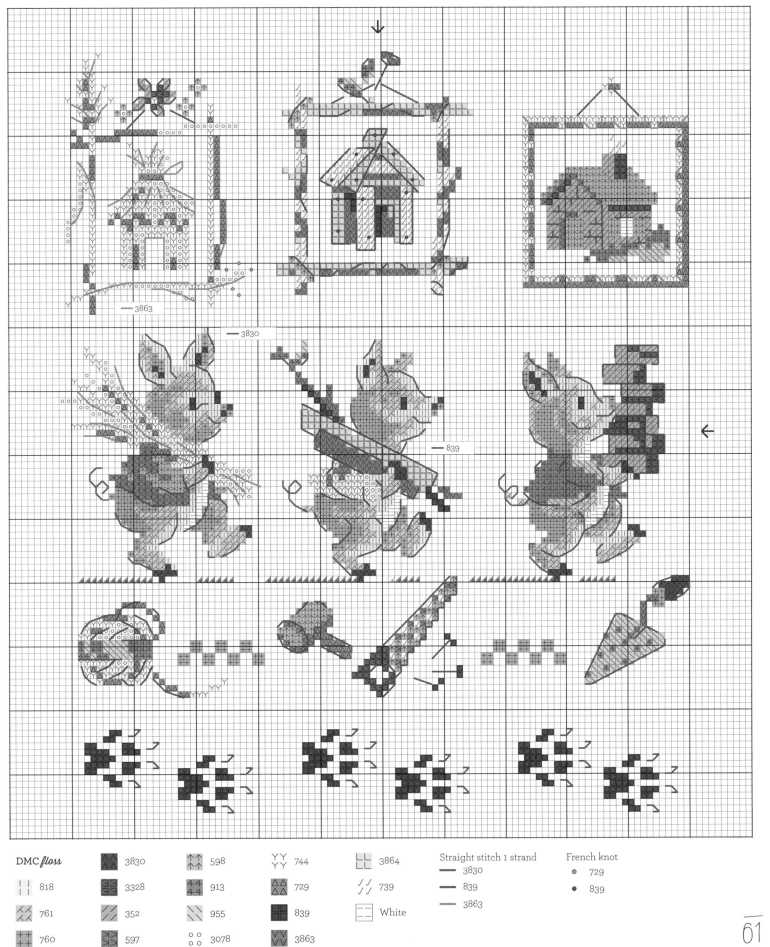

— 3863

— 3830

— 839

DMC *floss*

▮▮ 818	▦ 3830	⬆⬆ 598	Y Y 744	⊔⊔ 3864	Straight stitch 1 strand
	▦ 3328	⊞⊞ 913	△△ 729		— 3830
✕✕ 761	▨ 352	◪ 955	▦ 839	∕∕ 739	— 839
┼┼ 760	▨ 597	°° 3078	⋎⋎ 3863	☐ White	— 3863

French knot
● 729
● 839

Hansel and Gretel

Gingerbread, candy canes, and cookies—keep all your sweet things in this cookie tin decorated with the two children who are the most voracious eaters in the fairy tale world! Indulge yourself; there won't be a witch to eat you after you've tasted a few cookies.

Instructions on page 135.

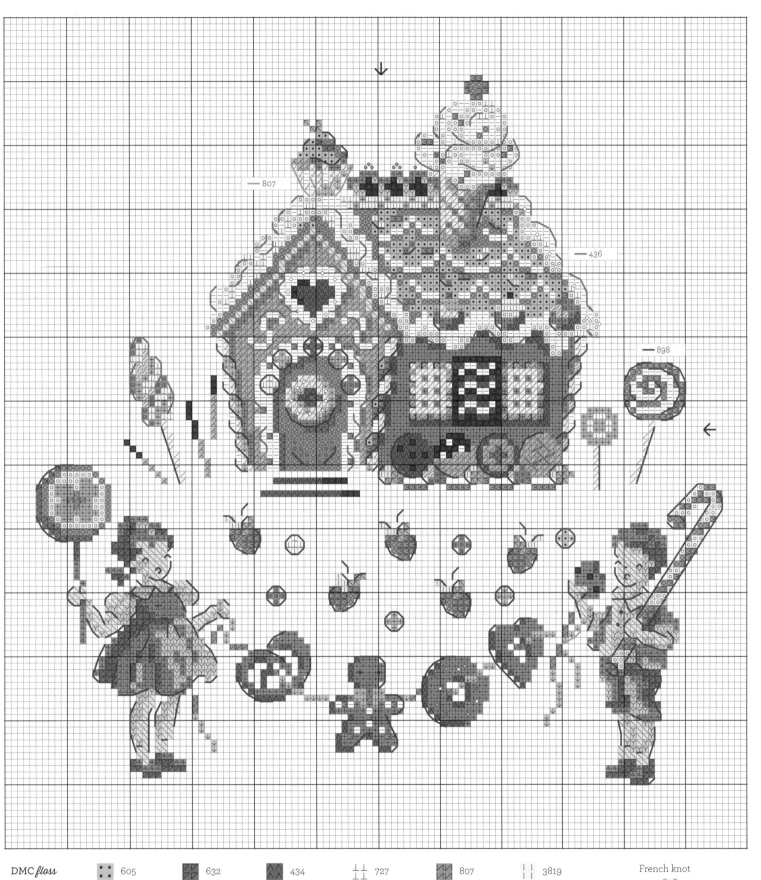

807

436

898

898

DMC *floss*

	605		632		434	⊥⊥ 727		807		3819	French knot	
3705		819		739		898		3854		913		● 898
3805	YY 950		437		White		747		955	Straight stitch 1 strand	● 907	
603	44 3064		436	°° 3823		964		907		○ White		

Straight stitch 1 strand
— 898
— 436
— 807

French knot
● 898
● 907
○ White
● 3805
● 3705

Jack and the Beanstalk

Grow this magic bean by embroidering the long trunk and its large green leaves step by step. Once it's stopped growing, who knows, you might find a hen that lays golden eggs!

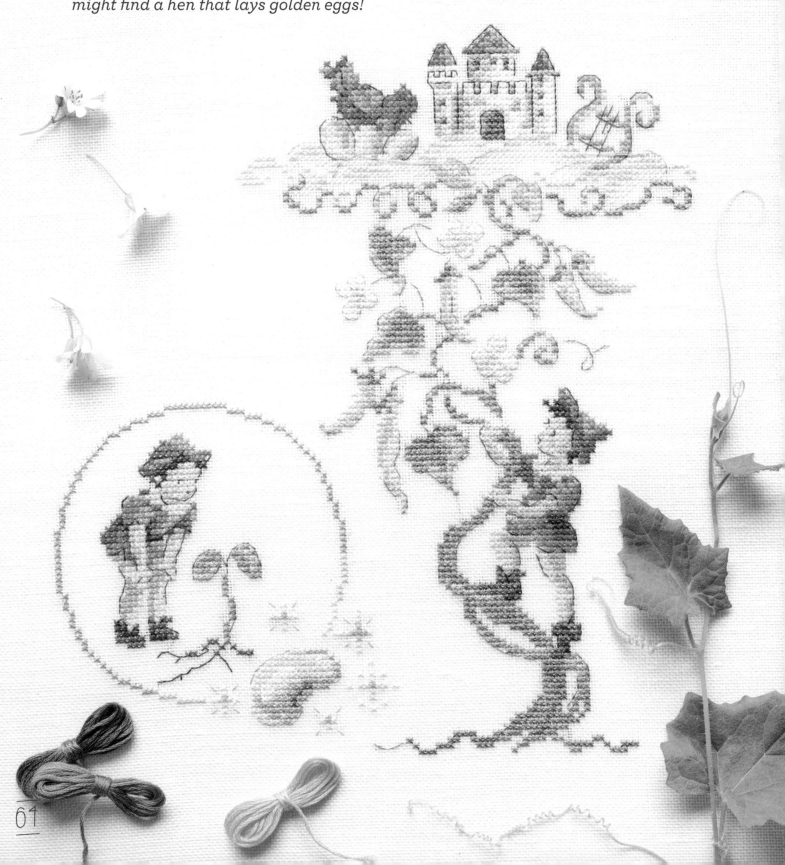

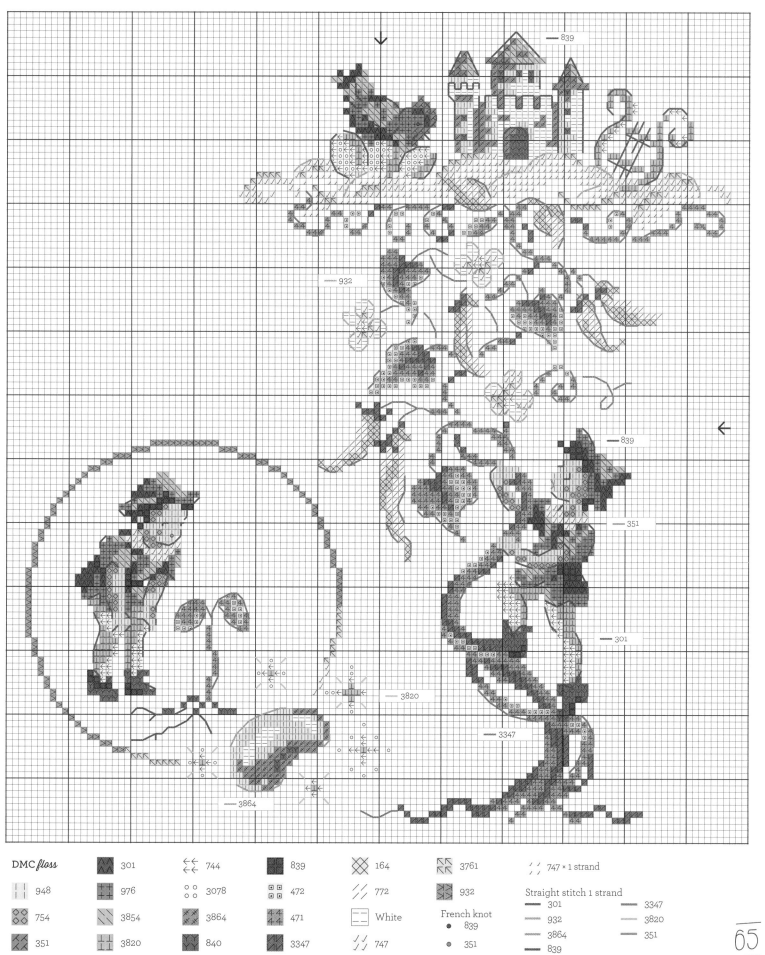

DMC *floss*

	301	←← 744	839	164	3761	`//` 747 × 1 strand
948	976	°° 3078	□□ 472	`//` 772	932	

Straight stitch 1 strand

754	3854	3864	471	White	French knot	301	3347
351	3820	840	3347	`//` 747	● 839	932	3820
					● 351	3864	351
						839	

Donkey Skin

Delicate lace, an elegant corset, and a full skirt: embroider the most sumptuous gowns in the kingdom, and don't forget the donkey skin the distressed princess asked for.

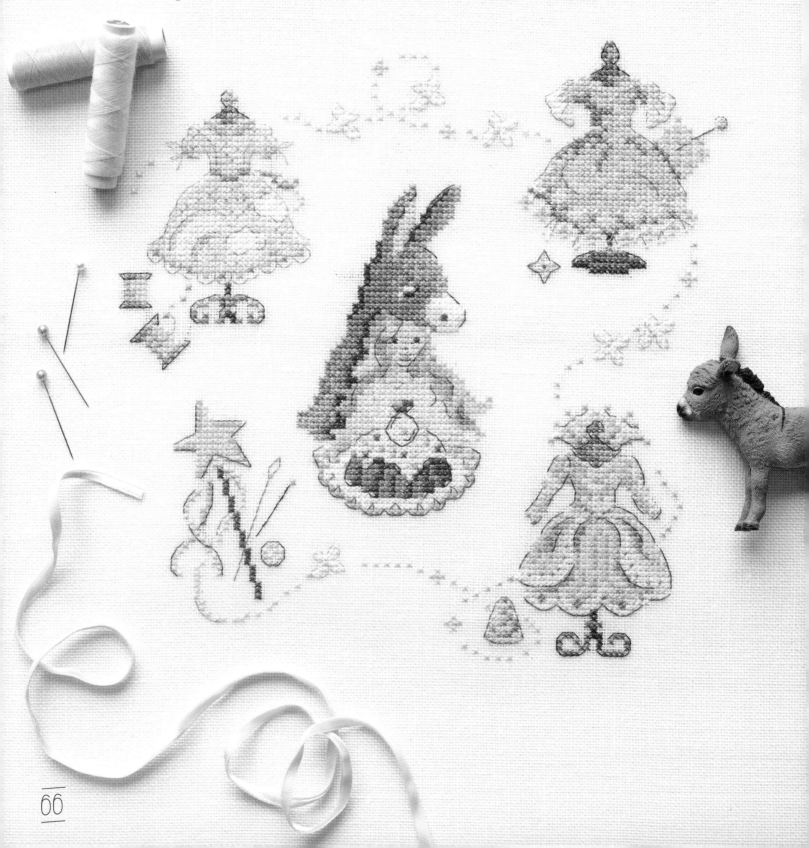

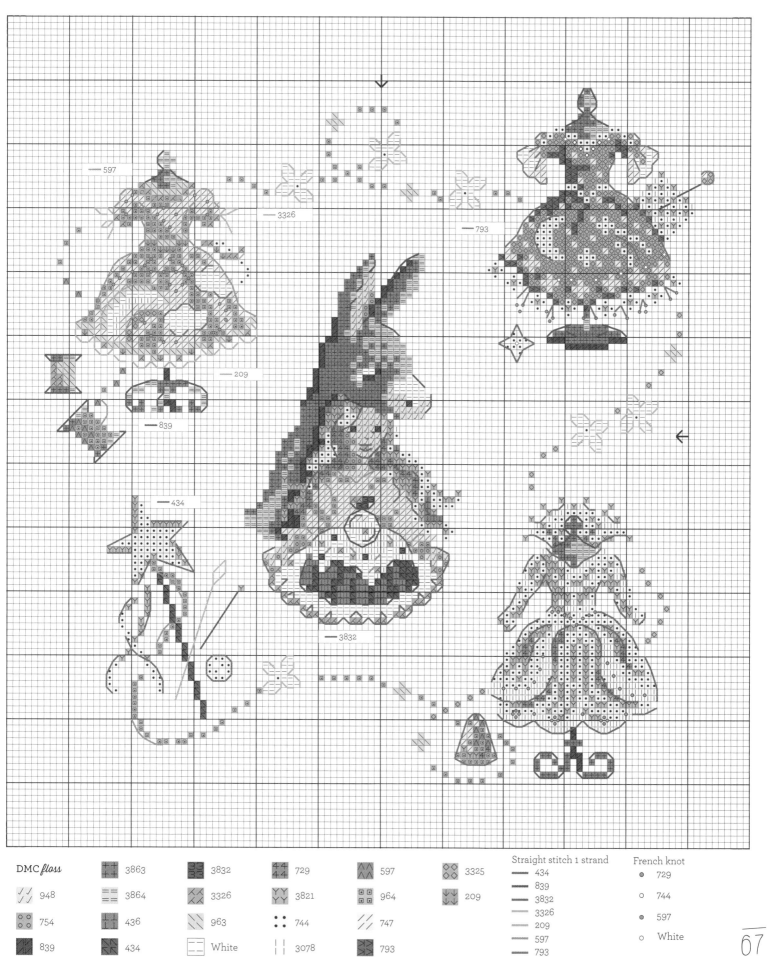

DMC *floss*

✓✓ / 948	3863	3832
○○ 754	3864	3326
839	436	963
	434	White

4 4 / 729	597	3325
Y Y 3821	964	209
:: 744	747	
White	3078	793

Straight stitch 1 strand
— 434
— 839
— 3832
— 3326
— 209
— 597
— 793

French knot
● 729
○ 744
● 597
○ White

67

Peter and the Wolf

This sweet design in shades of two colors will remind you that with a bit of cunning and courage, you can overcome all your fears!

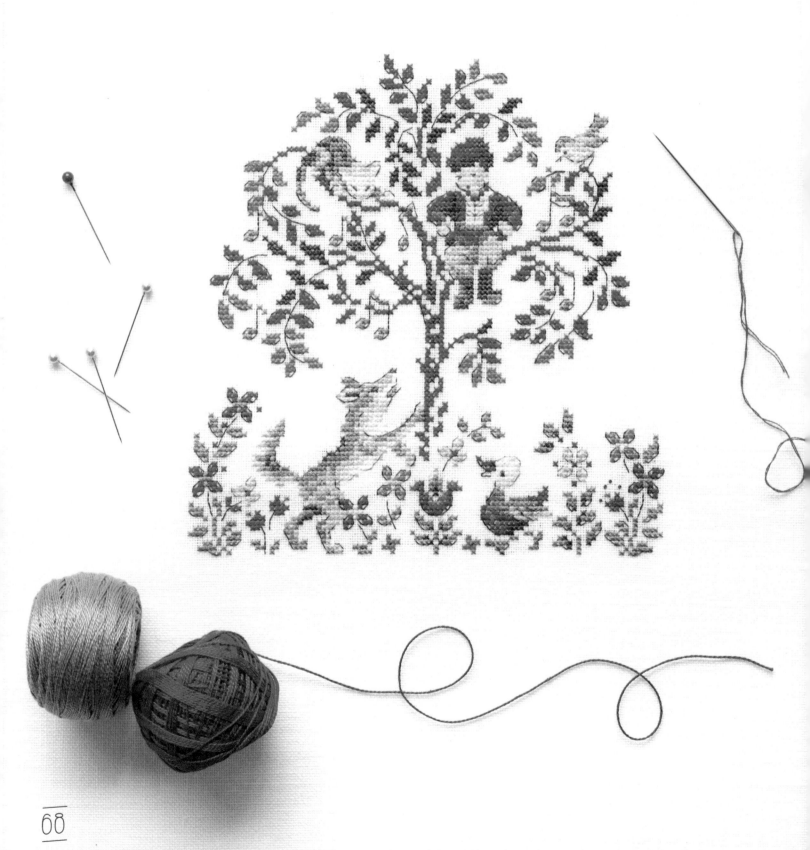

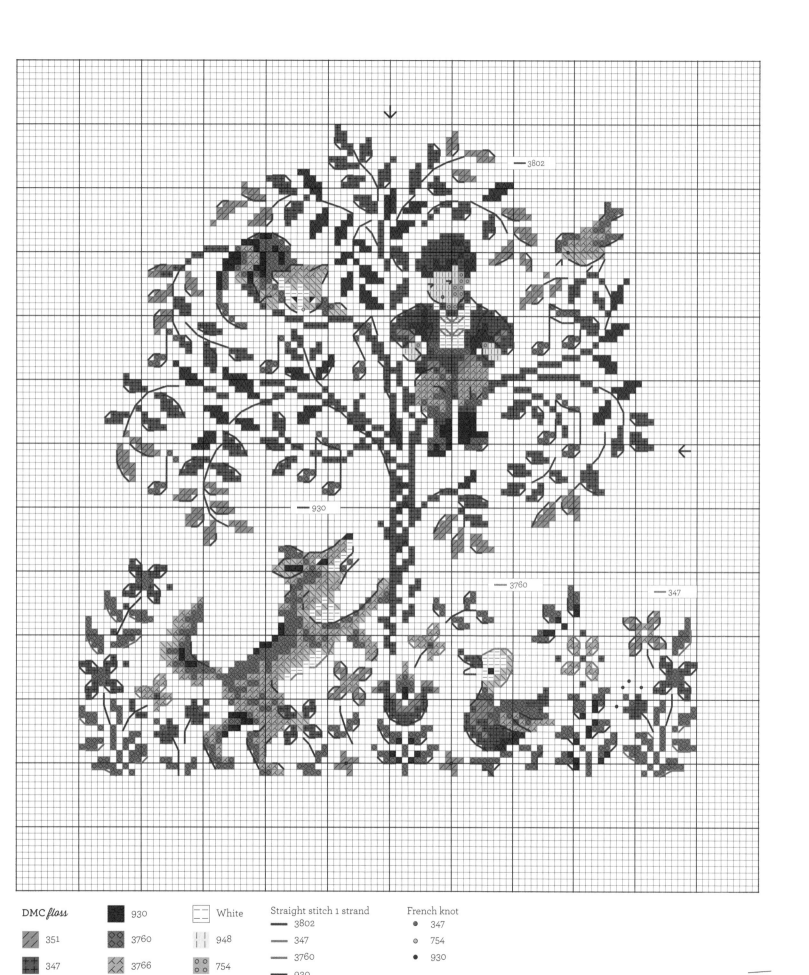

— 3802

— 930

— 3760

— 347

DMC *floss*

▨	351	■	930	⬚	White
▦	347	▦	3760	⬚	948
▧	3802	▨	3766	⬚	754
▨	162				

Straight stitch 1 strand
— 3802
— 347
— 3760
— 930

French knot
● 347
● 754
● 930

Pinocchio

Become the Blue Fairy and give life to this puppet who wants to become a real little boy!

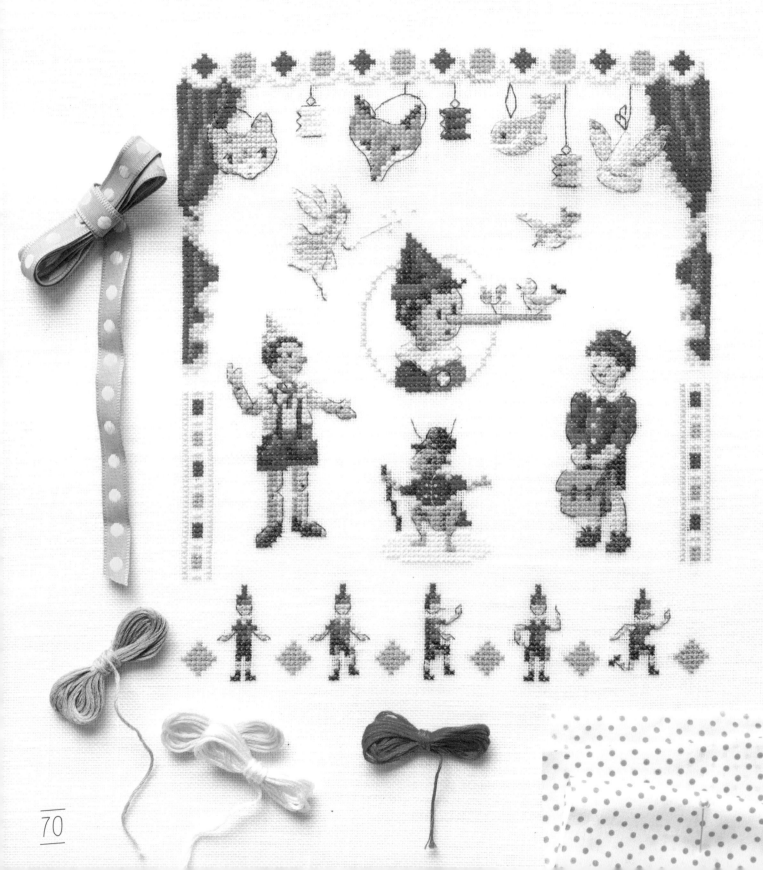

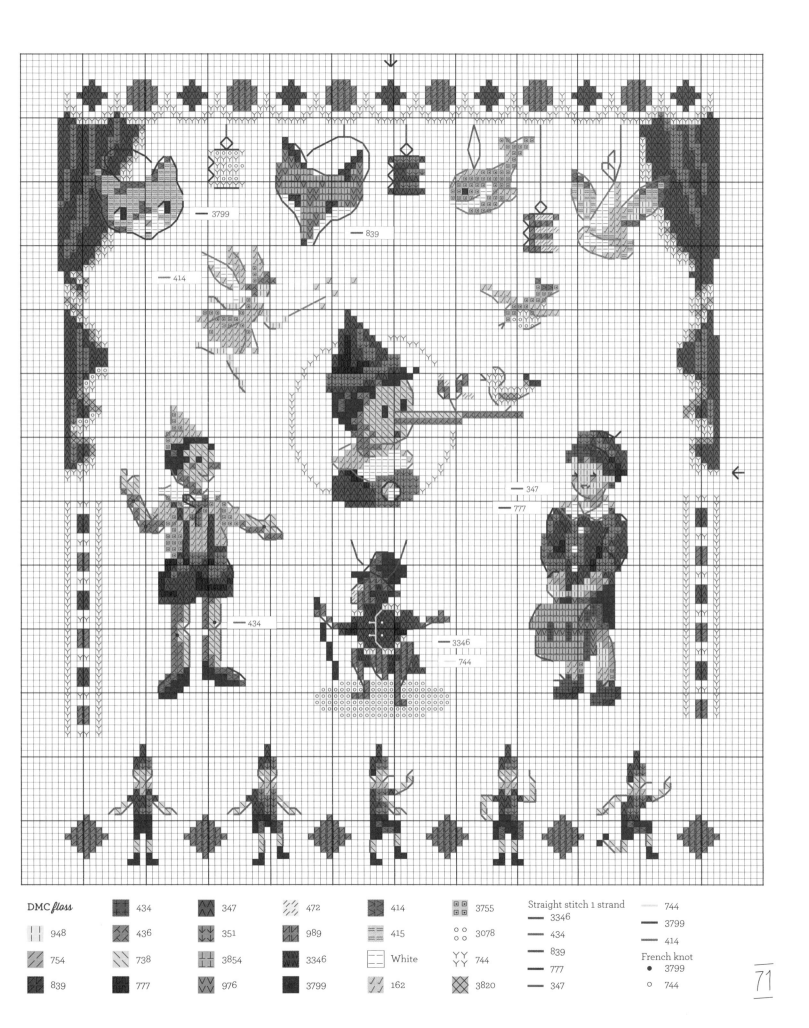

DMC *floss*

‖ 948	▨ 434	◣ 347
◿ 754	▨ 436	◿ 351
◣ 839	◺ 738	◢ 3854
	◣ 777	◿ 976

◿ 472	◣ 414	▣ 3755
◿ 989	≡ 415	○○ 3078
◣ 3346	☐ White	YY 744
◣ 3799	◿ 162	✕ 3820

Straight stitch 1 strand
— 3346
— 434
— 839
— 777
— 347

— 744
— 3799
— 414

French knot
● 3799
○ 744

Thumbelina

A fluttering butterfly, a swallow, and sweet flowers and fruit make up this design. Using soft and candylike colors, embroider the adventures of this little girl no bigger than a thumb.

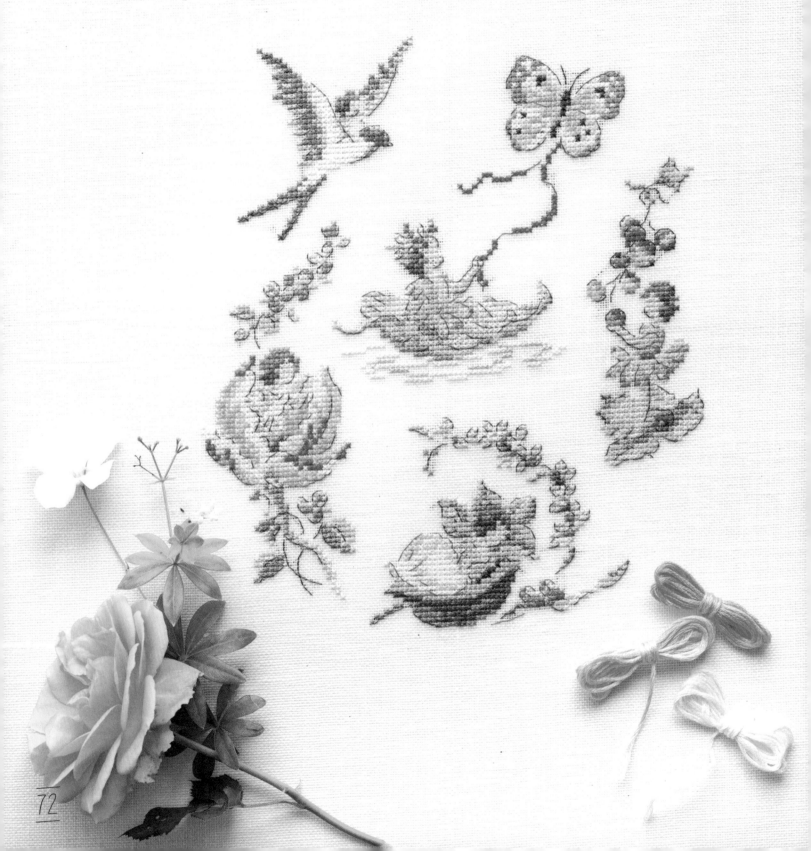

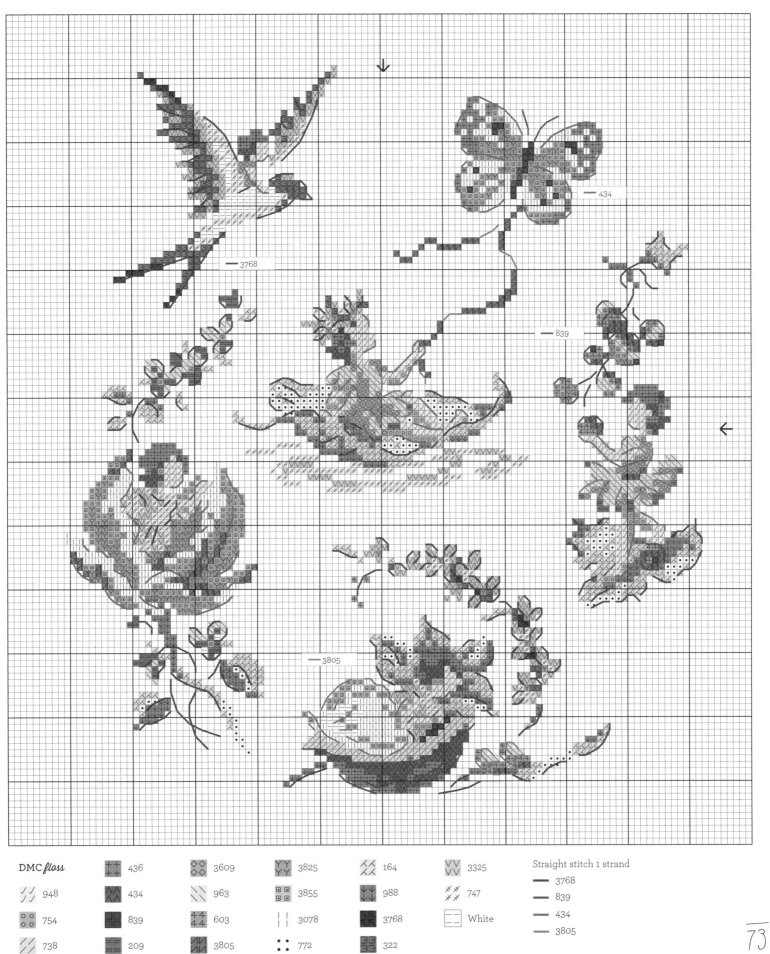

DMC *floss*

	436		3609		3825		164
	434		963		3855		988
	839		603		3078		3768
	209		3805		772		322

948
754
738

3325
747
White

Straight stitch 1 strand
3768
839
434
3805

Hop o' My Thumb

More often enjoyed by European children than American children, this is the story of Hop o' My Thumb helping his brothers find their way home. Embroidering little pebbles will help lead them!

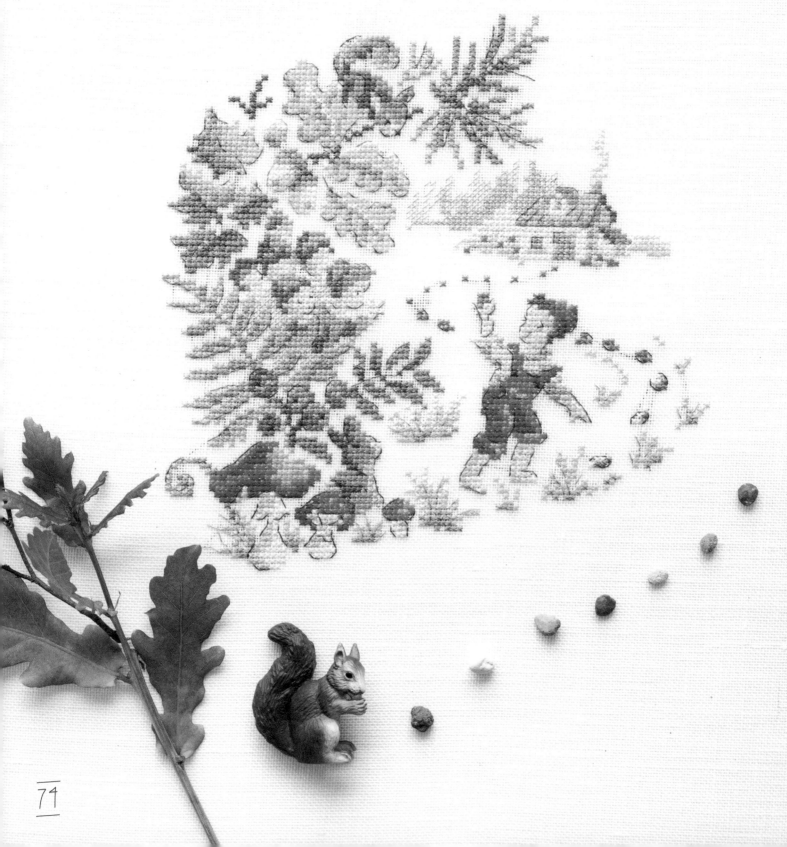

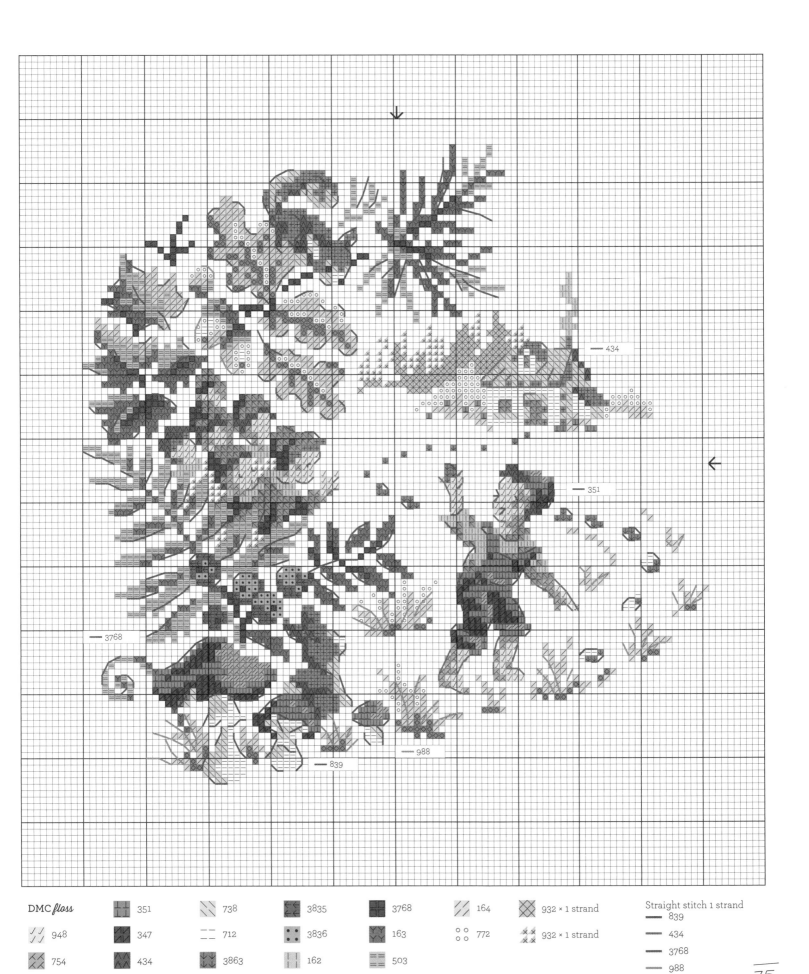

— 434

— 351

— 3768

— 839

988

DMC *floss*

✓✓ 948	351	738	3835	3768	// 164	⊠ 932 × 1 strand	**Straight stitch 1 strand**
✓✓ 754	347	−− 712	3836	163	∘∘ 772	932 × 1 strand	— 839
3854	434	3863	162	503			— 434
	436	839	932	988			— 3768
							— 988
							— 351

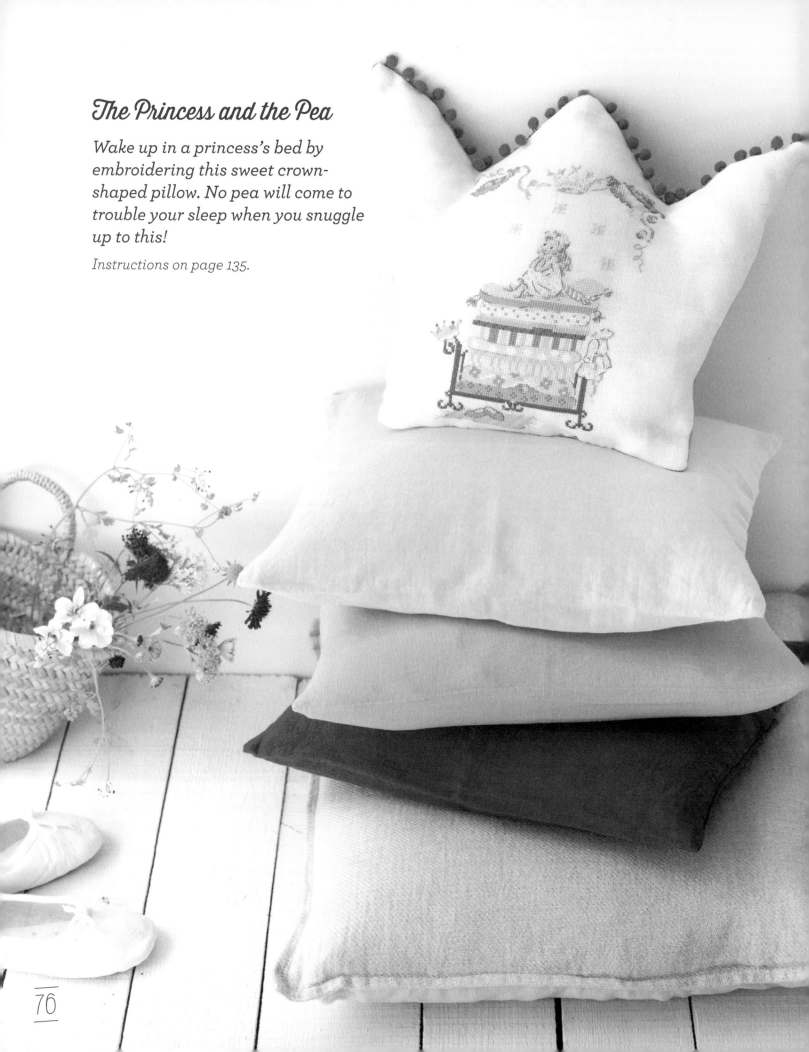

The Princess and the Pea

Wake up in a princess's bed by embroidering this sweet crown-shaped pillow. No pea will come to trouble your sleep when you snuggle up to this!

Instructions on page 135.

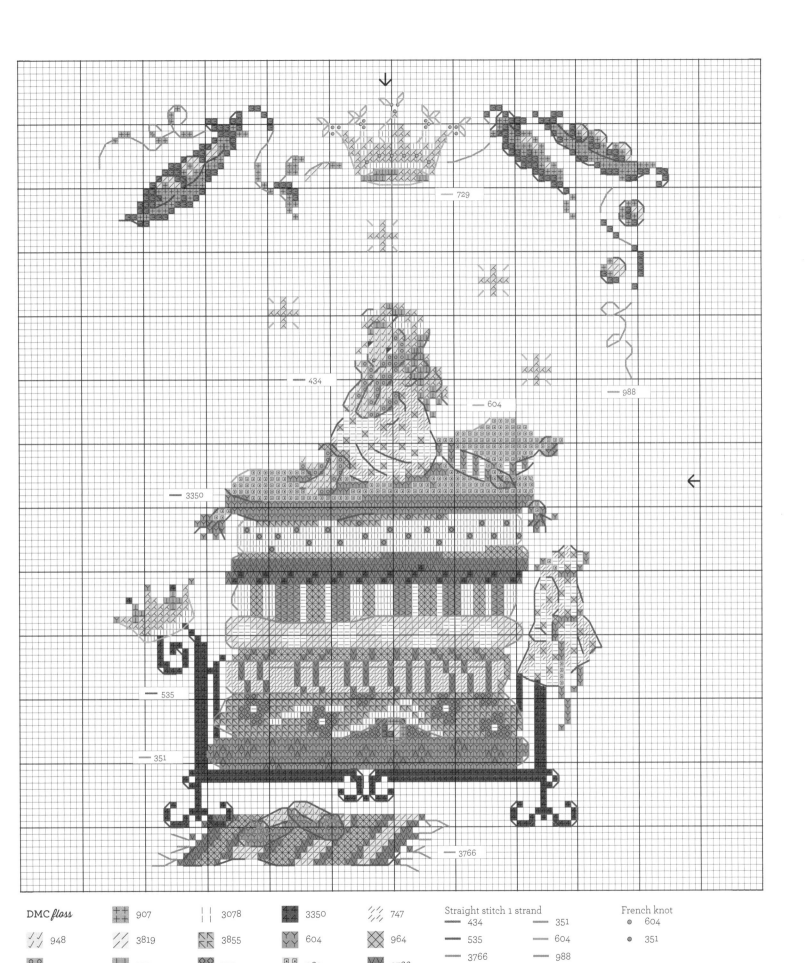

DMC *floss*

948	907	3078	3350	747	
754	3819	3855	604	964	
988	729	722	963	3766	
	3822	351	White	209	

Straight stitch 1 strand
- 434
- 535
- 3766
- 3350
- 351
- 604
- 988
- 729

French knot
- 604
- 351

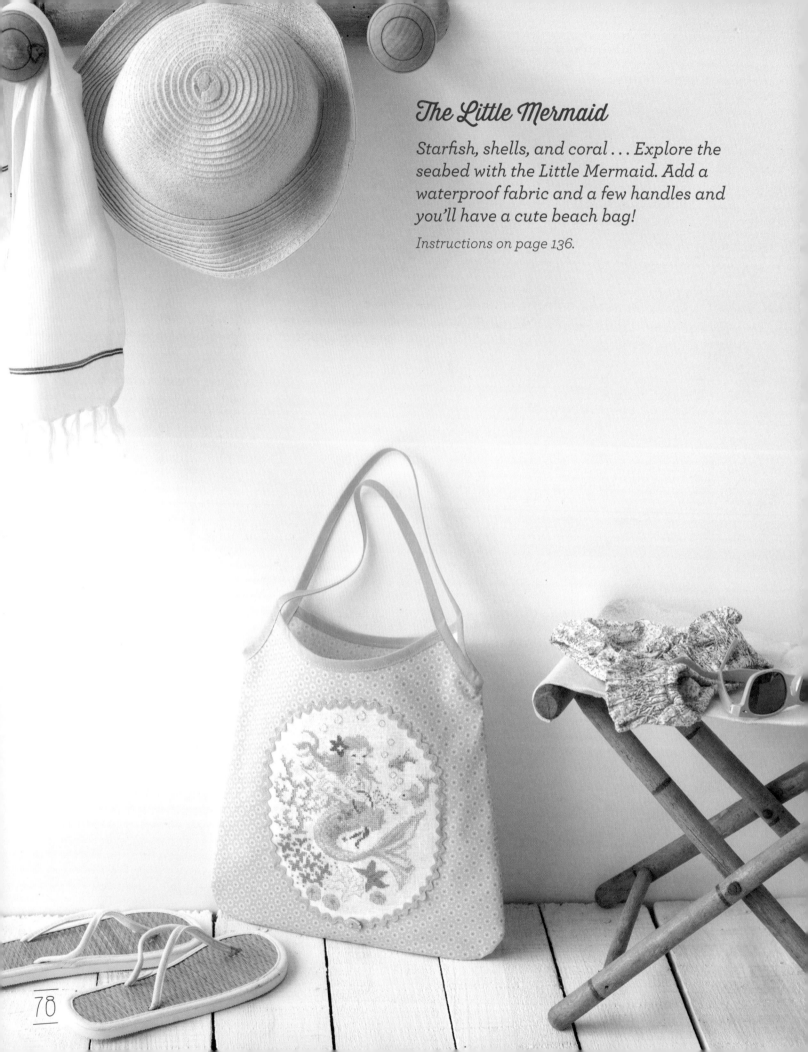

The Little Mermaid

Starfish, shells, and coral . . . Explore the seabed with the Little Mermaid. Add a waterproof fabric and a few handles and you'll have a cute beach bag!

Instructions on page 136.

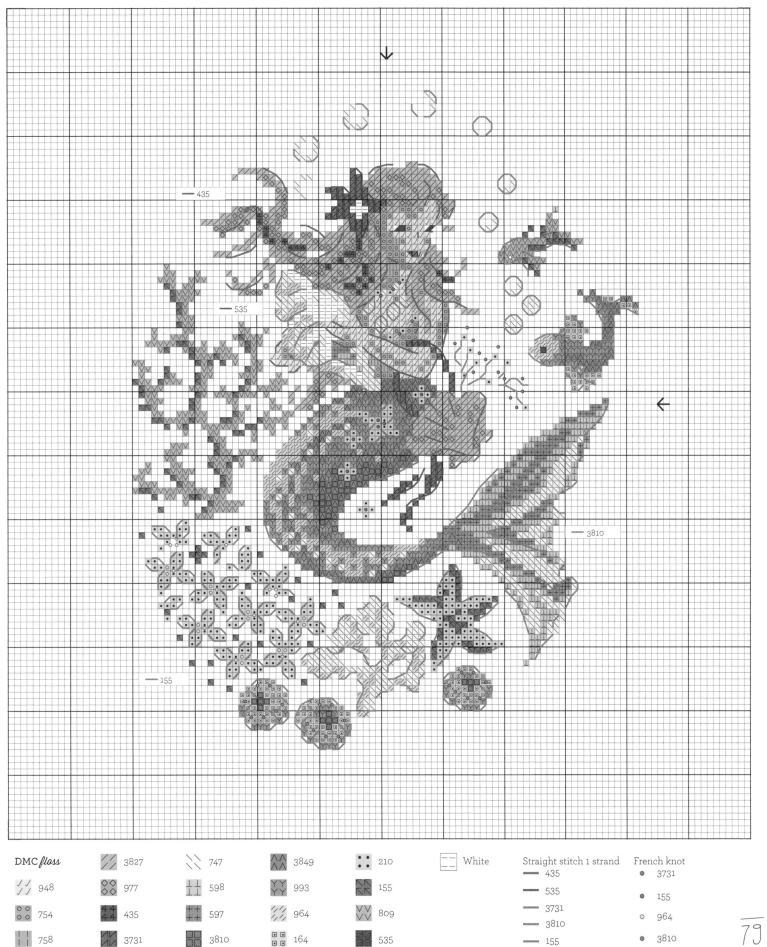

DMC *floss*

3827	747	3849	210	White				
948	977	598	993	155				
754	435	597	964	809				
758	3731	3810	164	535				

Straight stitch 1 strand
— 435
— 535
— 3731
— 3810
— 155

French knot
• 3731
• 155
○ 964
• 3810

435

535

3810

155

79

The Nutcracker

A graceful ballerina, a nutcracker with a broken leg, and the King of Mice: conjure up the famous ballet by Tchaikovsky!

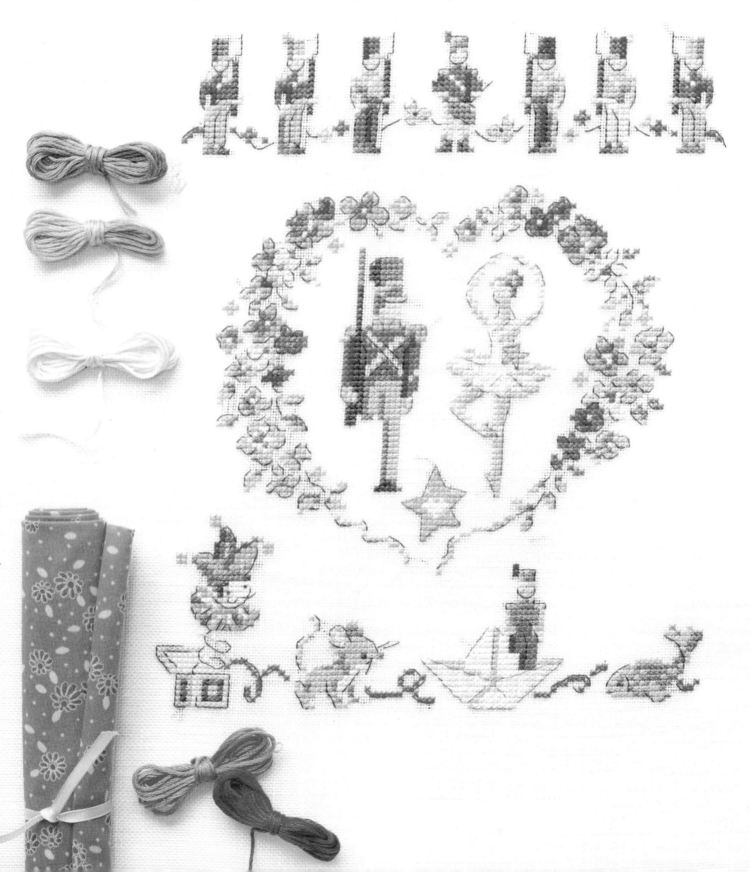

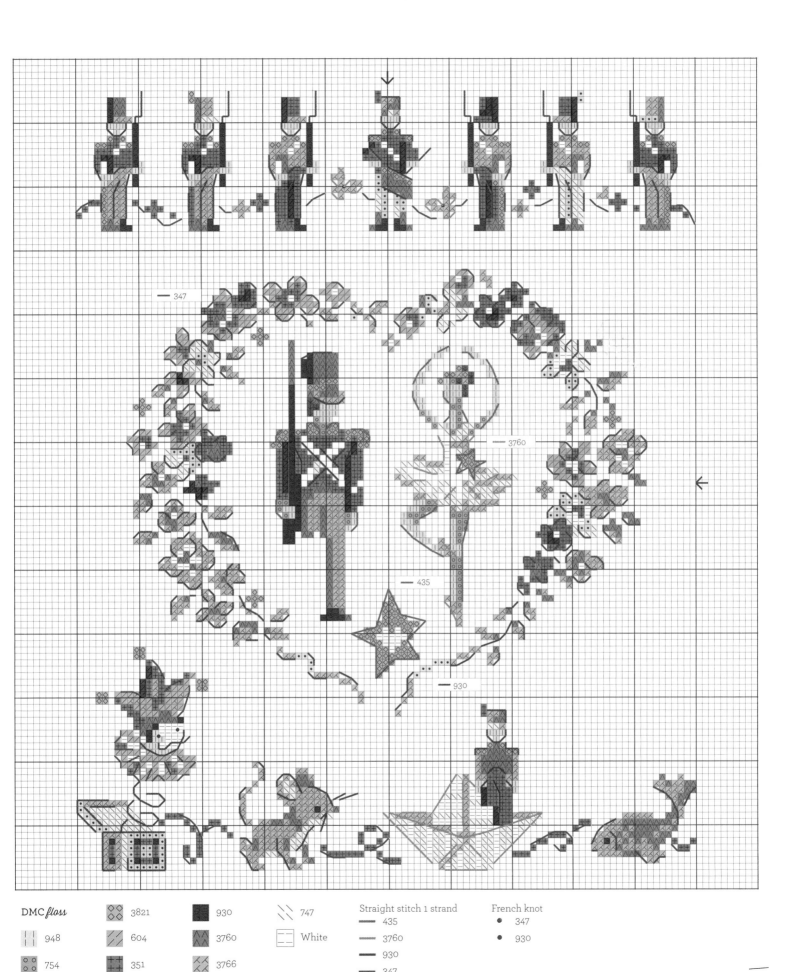

— 347

— 3760

— 435

— 930

DMC *floss*

	3821		930		747	Straight stitch 1 strand	French knot
948	604		3760		White	— 435	● 347
754	351		3766			— 3760	● 930
435	347		964			— 930	
						— 347	

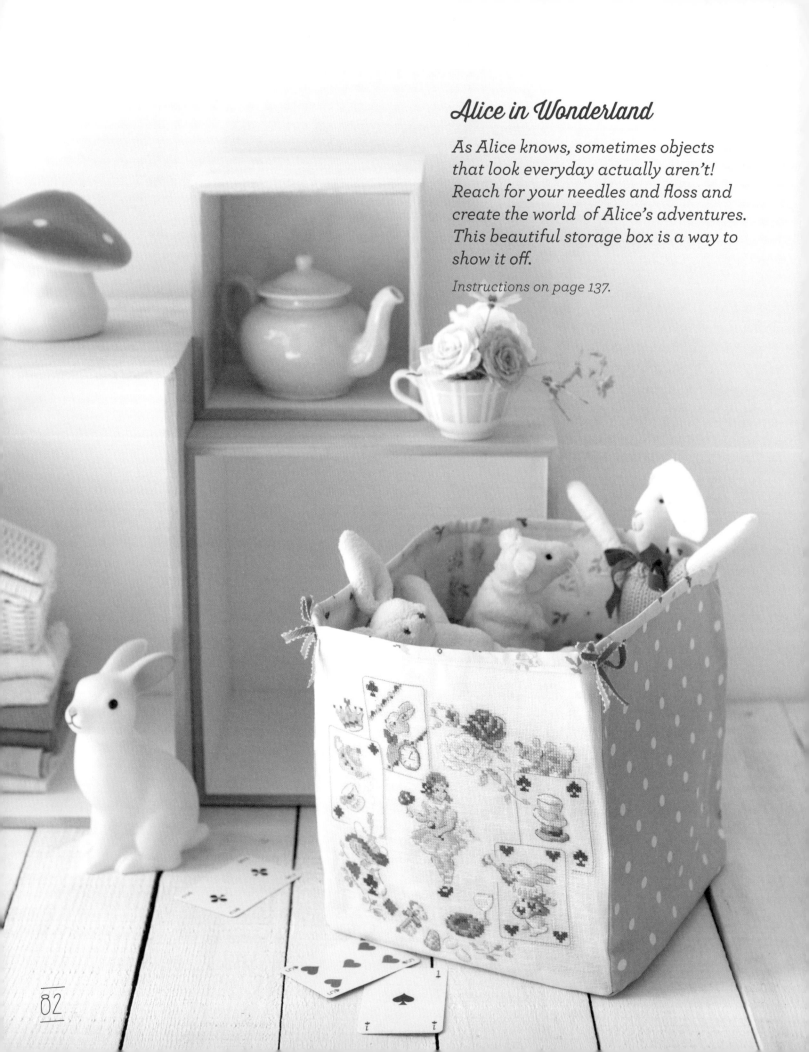

Alice in Wonderland

As Alice knows, sometimes objects
that look everyday actually aren't!
Reach for your needles and floss and
create the world of Alice's adventures.
This beautiful storage box is a way to
show it off.

Instructions on page 137.

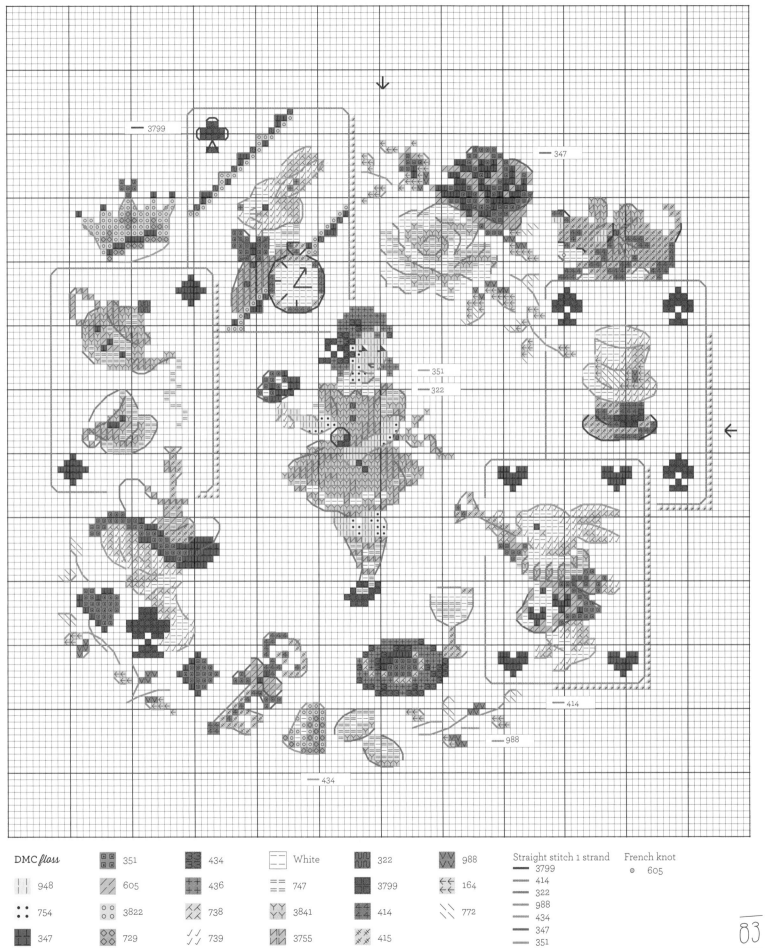

DMC *floss*

948	351	434	White	322	988
754	605	436	747	3799	164
347	3822	738	3841	414	772
	729	739	3755	415	

Straight stitch 1 strand
— 3799
— 414
— 322
— 988
— 434
— 347
— 351

French knot
● 605

FRENCH NURSERY RHYMES

With their music that trots through our minds and their easy to sing words, nursery rhymes are part of childhood in every culture. These are some that French children grow up with. Even without knowing the words, these designs are easy to enjoy and they capture the childhood experience worldwide.

(If you or little ones are curious, look them up online and learn to sing them!)

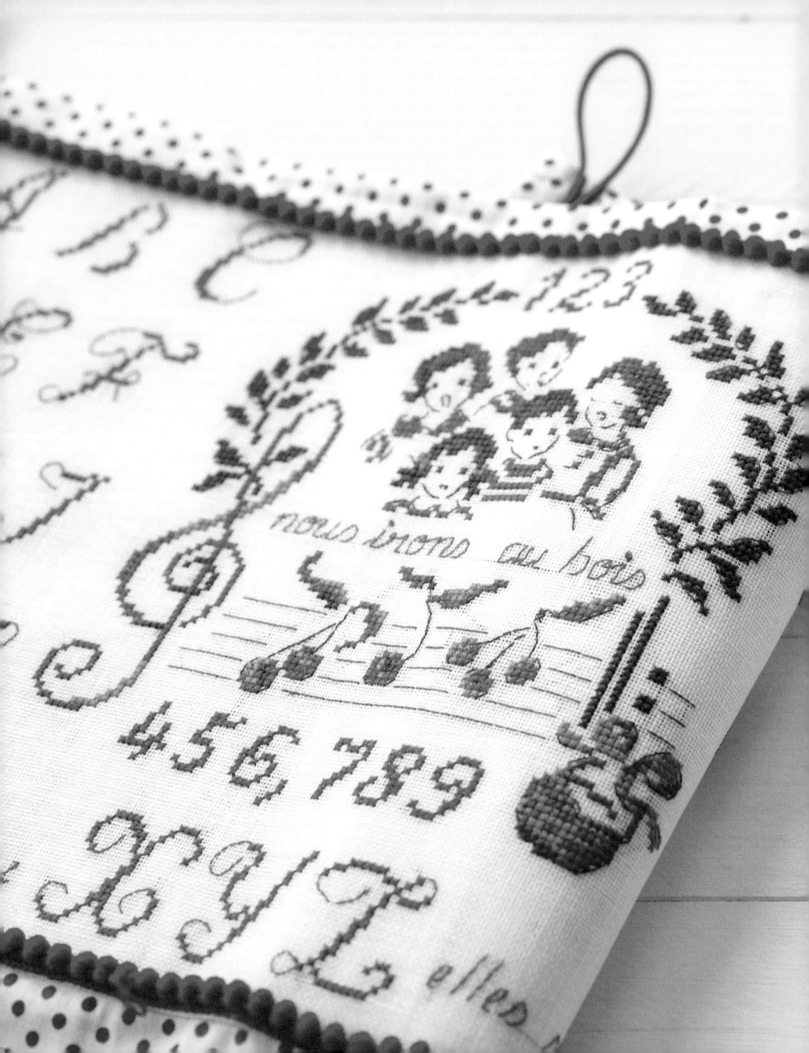

Mama, the Little Boats

The children ask their mama if the boats have legs? Wings? The questions are endless! The patient mother sings the refrain: "Going straight ahead, the boats tour the world, but since the Earth is round, they end up at home." Ahoy, sailor! Get out your blue floss and embroider these little boats floating on the sea.

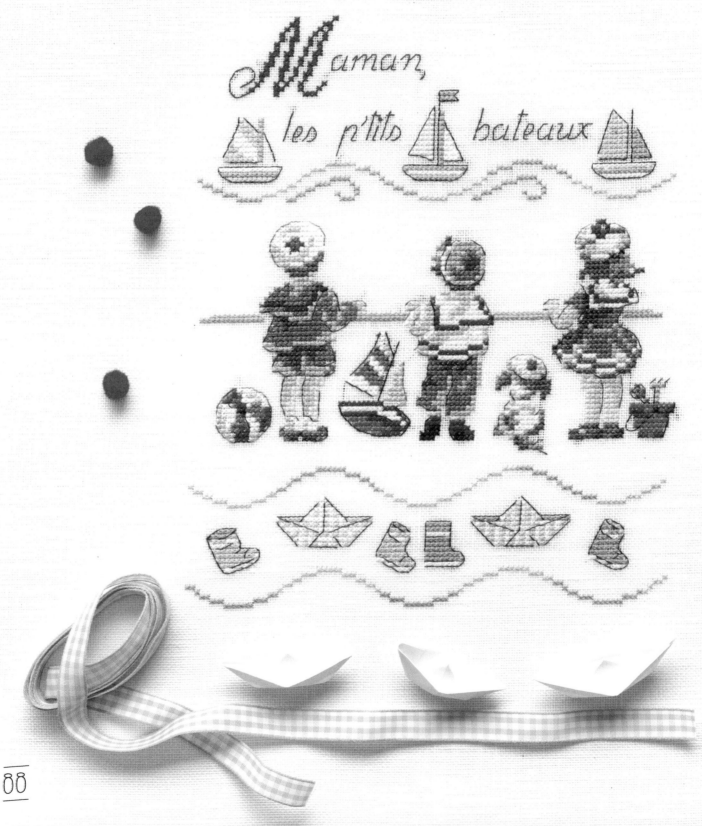

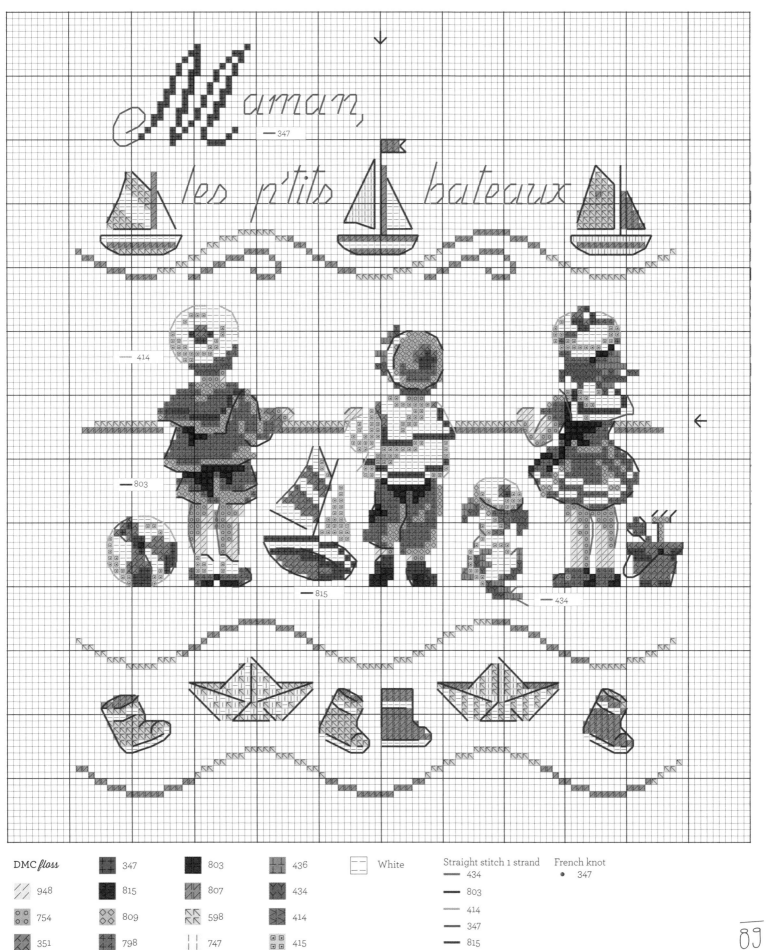

DMC *floss*								Straight stitch 1 strand	French knot
	347		803		436	White		434	● 347
948		815		807		434		803	
754		809		598		414		414	
351		798	747		415			347	
								815	

Let's Walk in the Woods

In this song, the children walk through the woods calling "Are you there, Wolf? What are you doing? Can you hear me?" The wolf, fortunately, is busy putting on his clothes, one item at a time. Get your skeins ready! The big bad wolf needs his clothes before he goes hunting.

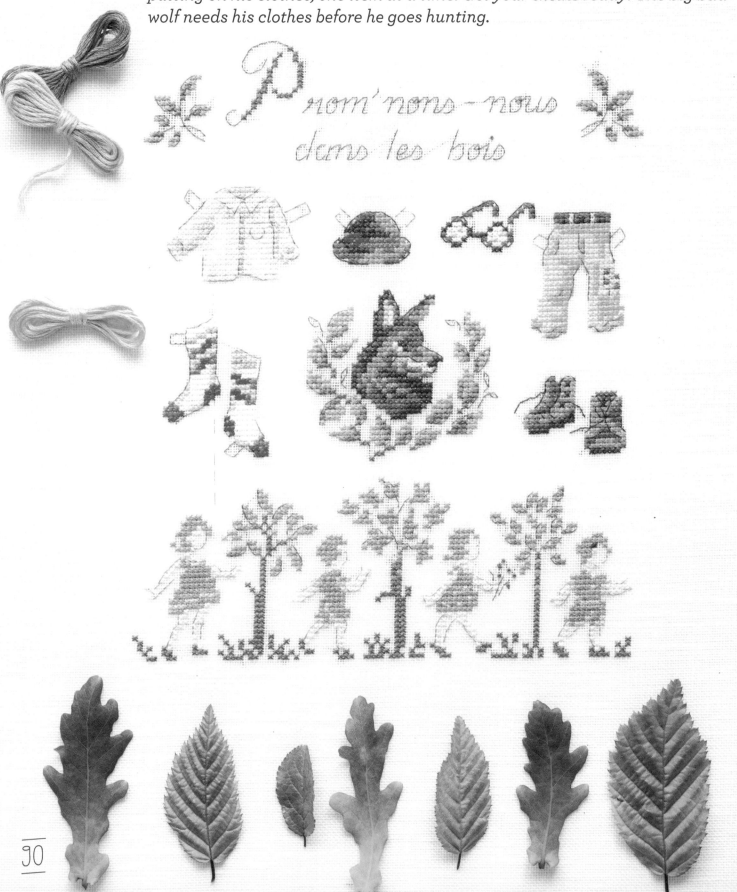

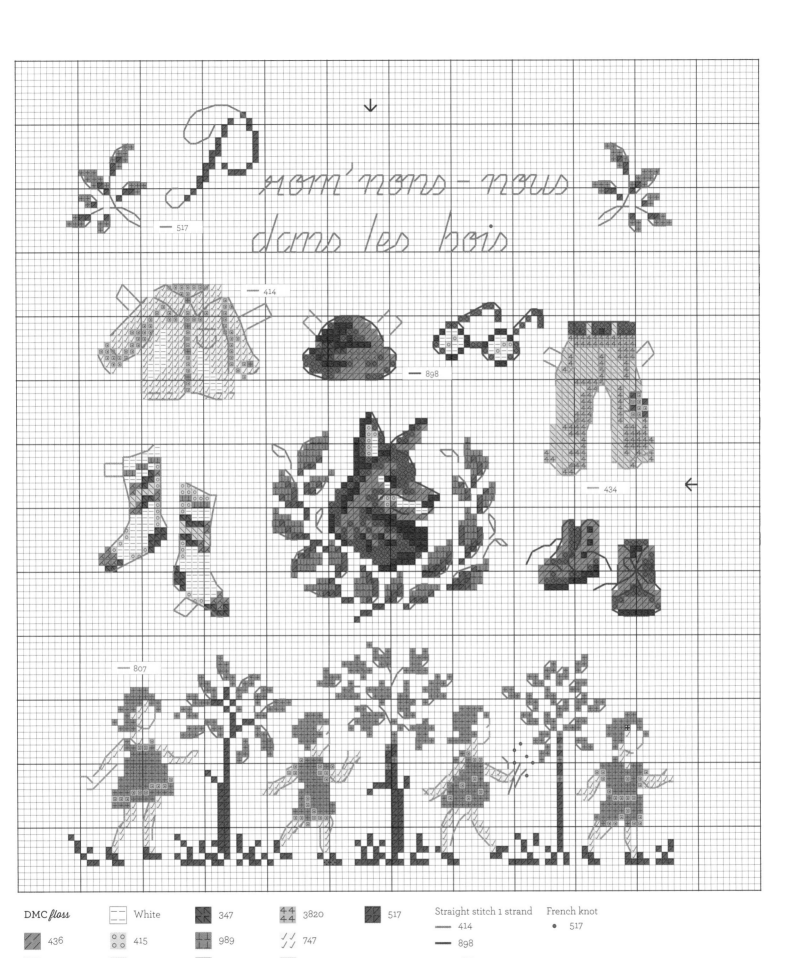

DMC *floss*

	White		347		3820		517	
	436		415		989		747	
	434		414		987		598	
	898		351		744		807	

Straight stitch 1 strand
— 414
— 898
— 434
— 807
— 517

French knot
● 517

Let's Dance the Nasturtium Dance

As we dance, we learn that there are many items missing at our house, like bread, wine, and fire. But there's plenty of fun! As is often the case, this nursery rhyme isn't the best place to look for logic. This joyfully colored design does give us dancing children with happy faces, though!

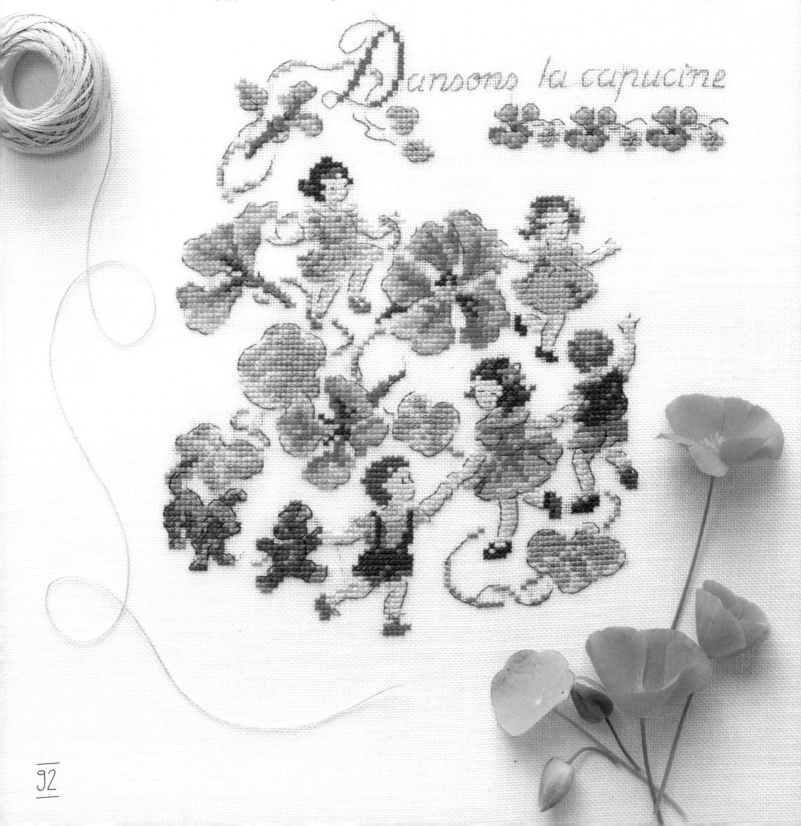

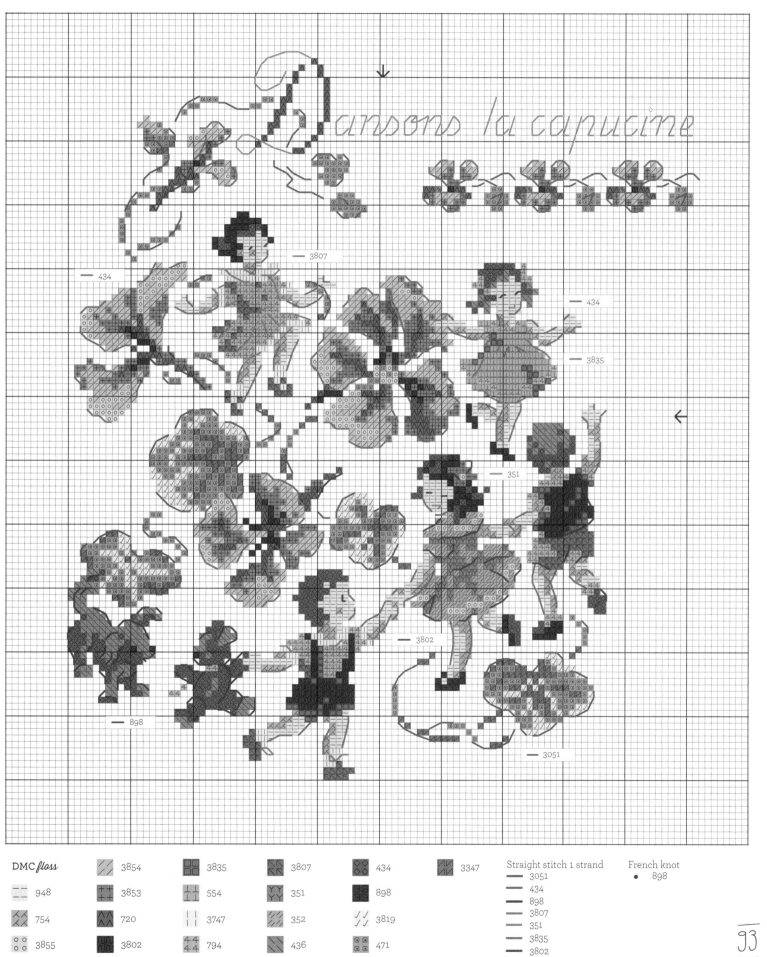

Dansons la capucine

DMC floss				
3854	3835	3807	434	3347
948	3853	554	351	898
754	720	3747	352	3819
3855	3802	794	436	471

Straight stitch 1 strand
3051
434
898
3807
351
3835
3802

French knot
● 898

Do You Know How to Plant Cabbages?

This song runs through the body parts. We plant cabbages with our thumb, with our foot, with our nose . . . An easier, but still childish, way to enjoy your vegetables is to embroider these tasty tomatoes, carrots, and cabbages.

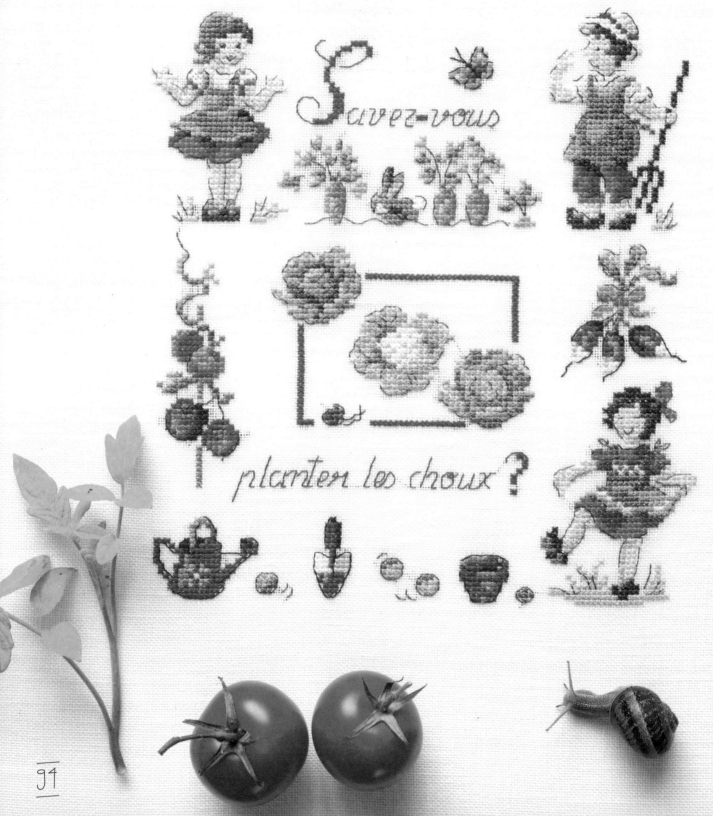

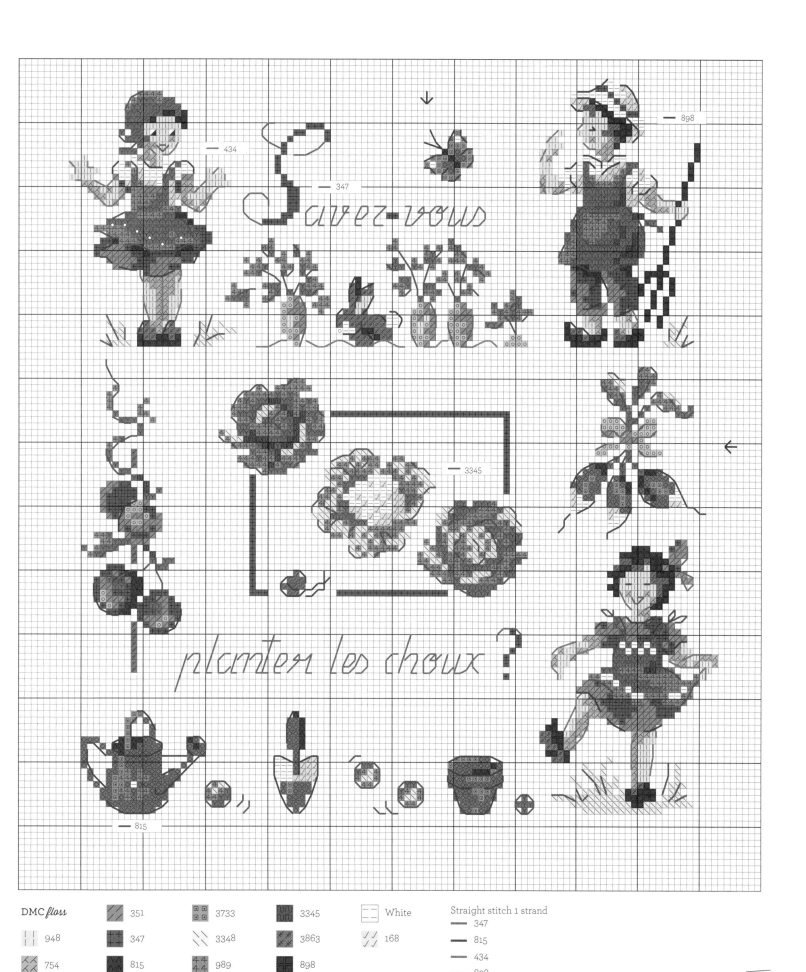

Savez-vous

planter les choux ?

DMC *floss*

▨	948	▨ 351	▨ 3733	▨ 3345	▤ White	Straight stitch 1 strand	
▨	754	▨ 347	▨ 3348	▨ 3863	▨ 168	— 347	
▨	722	▨ 815	▨ 989	▨ 898		— 815	
		▨ 3350	▨ 987	▨ 434		— 434	
						— 898	
						— 3345	

95

Go to Sleep, Colas My Little Brother

This rhyme promises baby that if he takes his nap, he'll get some milk. The sibling also sings to Colas that the other members of their family are busy making good things to eat . . . mama is making a cake, papa is making chocolate, a cousin is making bonbons, and so on! For a siesta or a longer snooze, this homemade patchwork travel quilt will warm the heart and body of your little one.

Instructions on page 138.

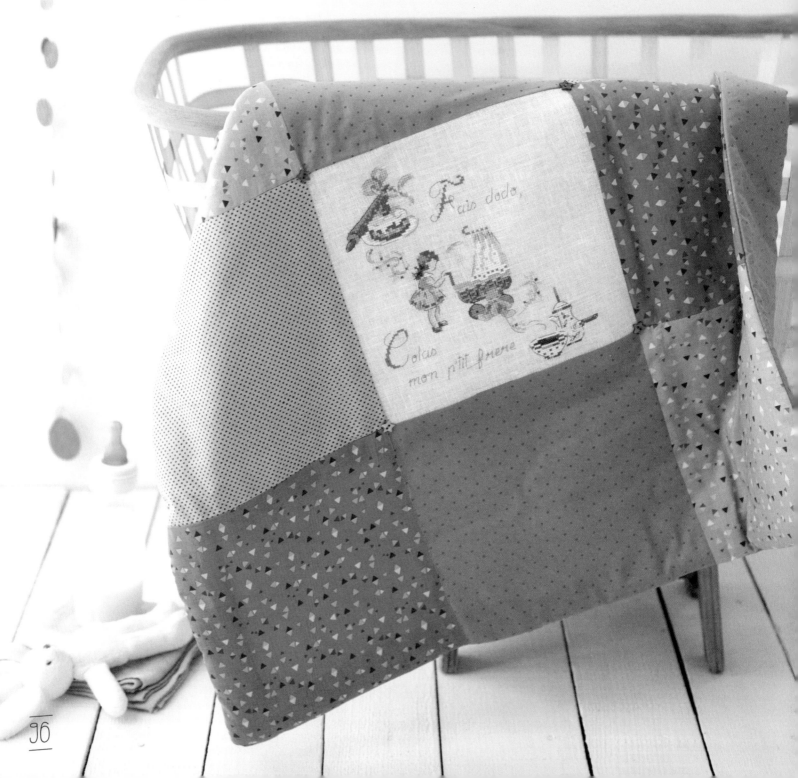

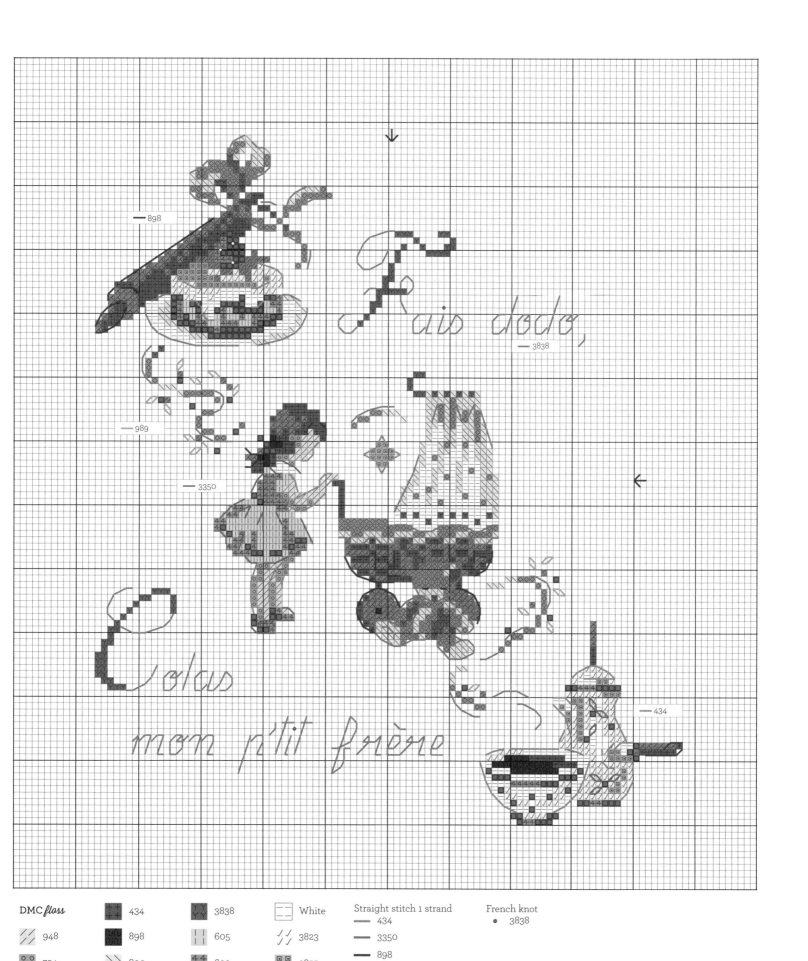

DMC *floss*

⧄ 948	■ 434	▨ 3838	▢ White	Straight stitch 1 strand
⬯ 754	■ 898	▥ 605	⧄ 3823	— 434
⬯ 436	⧄ 800	₄₄ 603	▦ 3855	— 3350
⬯ 436	◇ 809	▦ 3350	⧄ 989	— 898
				— 3838
				— 989

French knot
• 3838

Sweet Poppy, Ladies

"I went down to my garden to gather some rosemary," this nursery rhyme begins. The blazing red beauty of poppies sings out here! Embroider some, along with "the nightingale that lands on your hand."

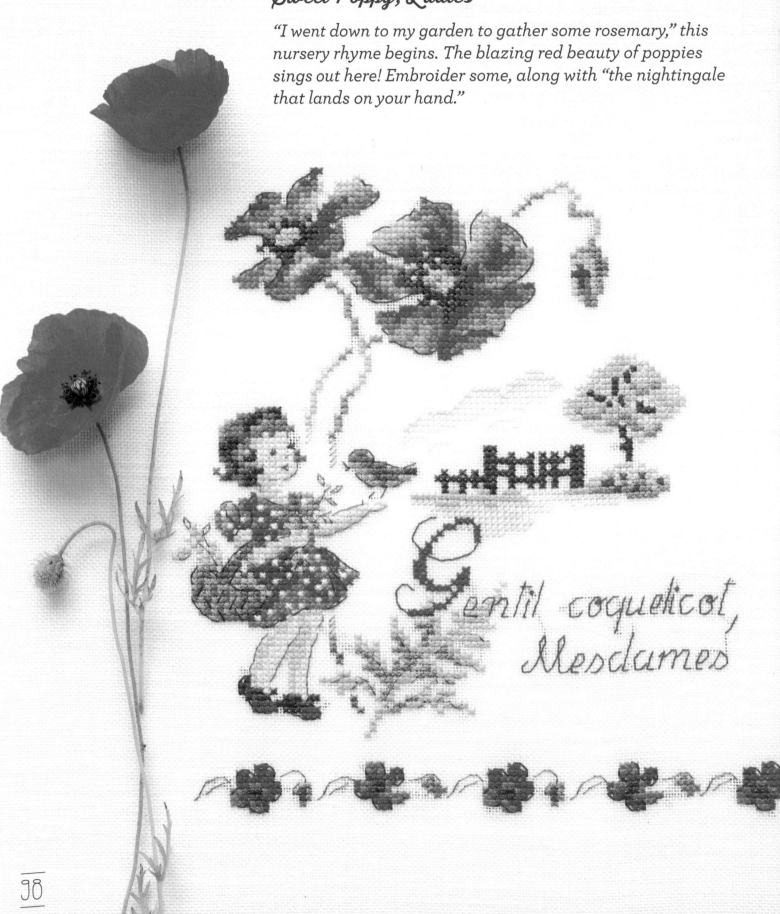

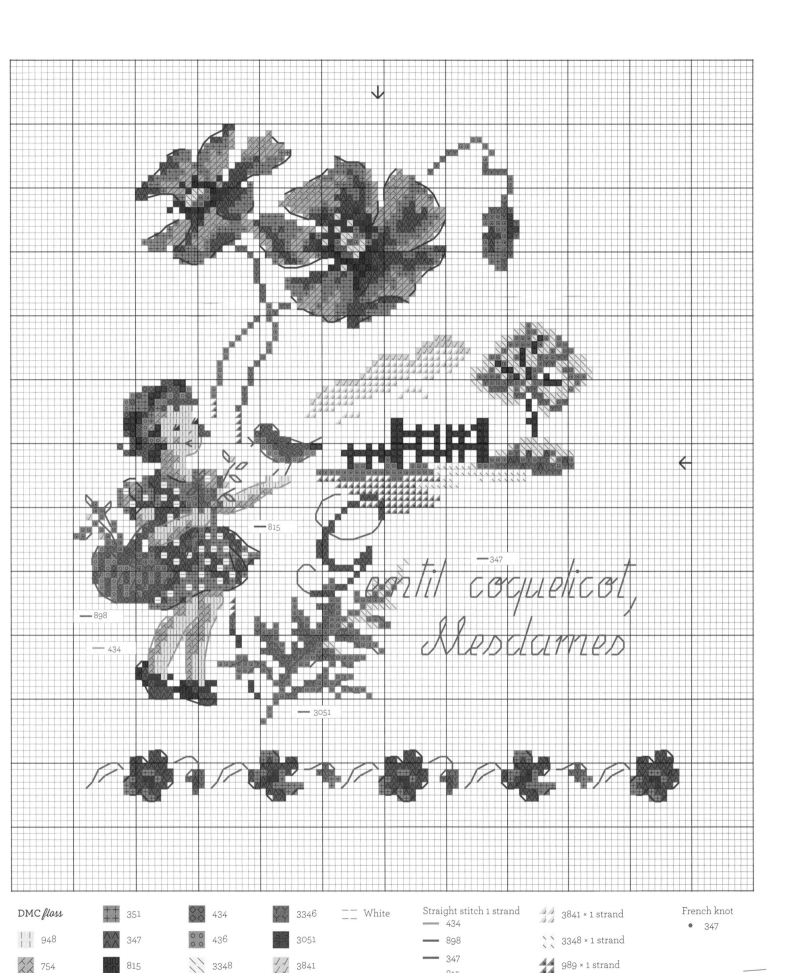

DMC *floss*

‖ 948	
⊠ 754	
⫽ 352	

┼ 351	
Λ 347	
⊔ 815	
⊠ 898	

⊠ 434	
○○ 436	
⧄ 3348	
⊡ 989	

Υ 3346	
▬ 3051	
⫽ 3841	
▪ 3799	

⚊⚊ White

Straight stitch 1 strand
— 434
— 898
— 347
— 815
— 3051

⫽ 3841 × 1 strand
⧅ 3348 × 1 strand
⫽ 989 × 1 strand
⫽ 3346 × 1 strand

French knot
● 347

99

By the Clear Spring

"At the clear spring, as I was strolling by, I found the water so lovely that I went in to bathe." Let your mind wander while you embroider the beautiful stream and the happy child paddling in it!

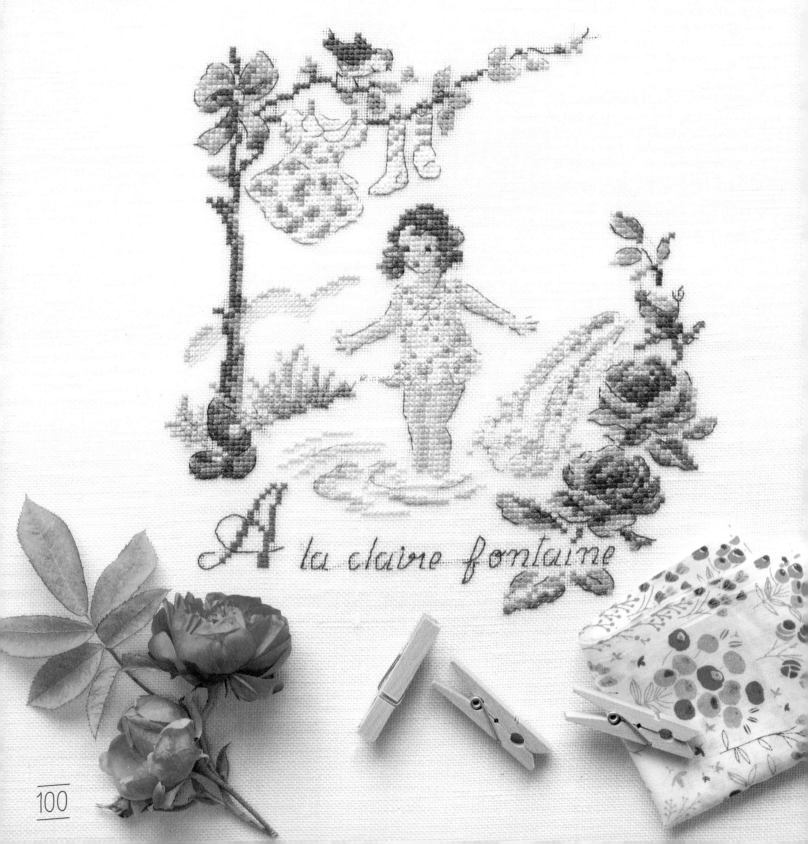

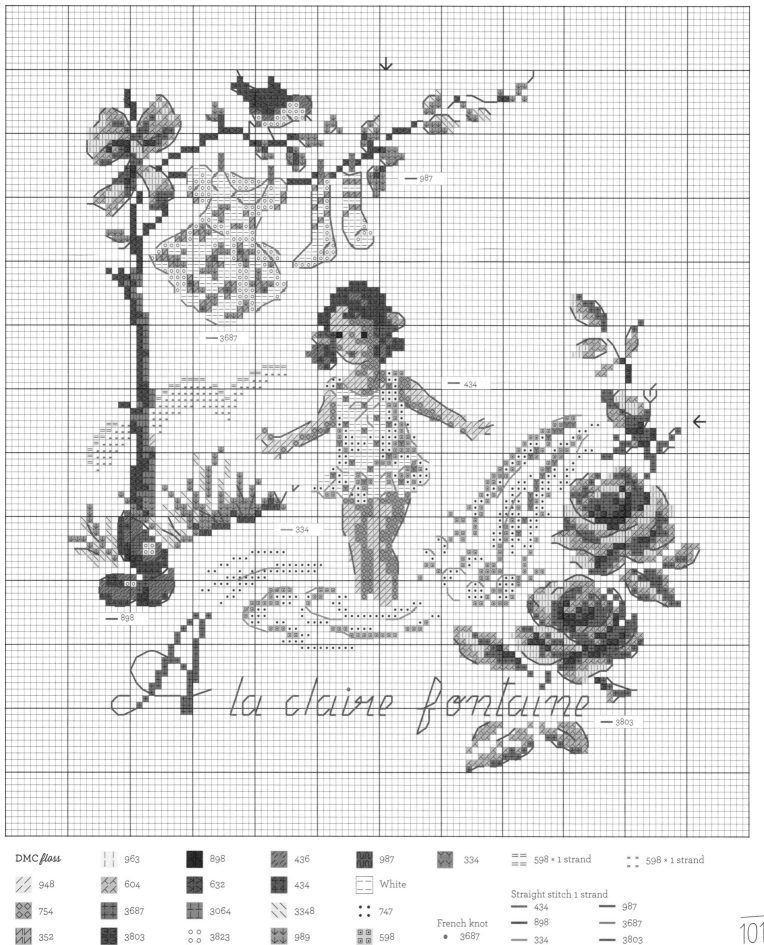

la claire fontaine

DMC floss					
963	898	436	987	334	═ 598 × 1 strand
948	604	632	White		═ 598 × 1 strand
754	3687	3064	747		Straight stitch 1 strand
352	3803	3823	989	598	434 987
					898 3687
				French knot	334 3803
				3687	

I Love Cake

A sentiment that children everywhere share! In the French nursery rhyme, the cake in question is a traditional Epiphany dessert, and there are plenty of tra-la-las to celebrate. Why not make a cake or two with the kids in your life? Create this apron to avoid getting cake batter on your clothes!

Instructions on page 139.

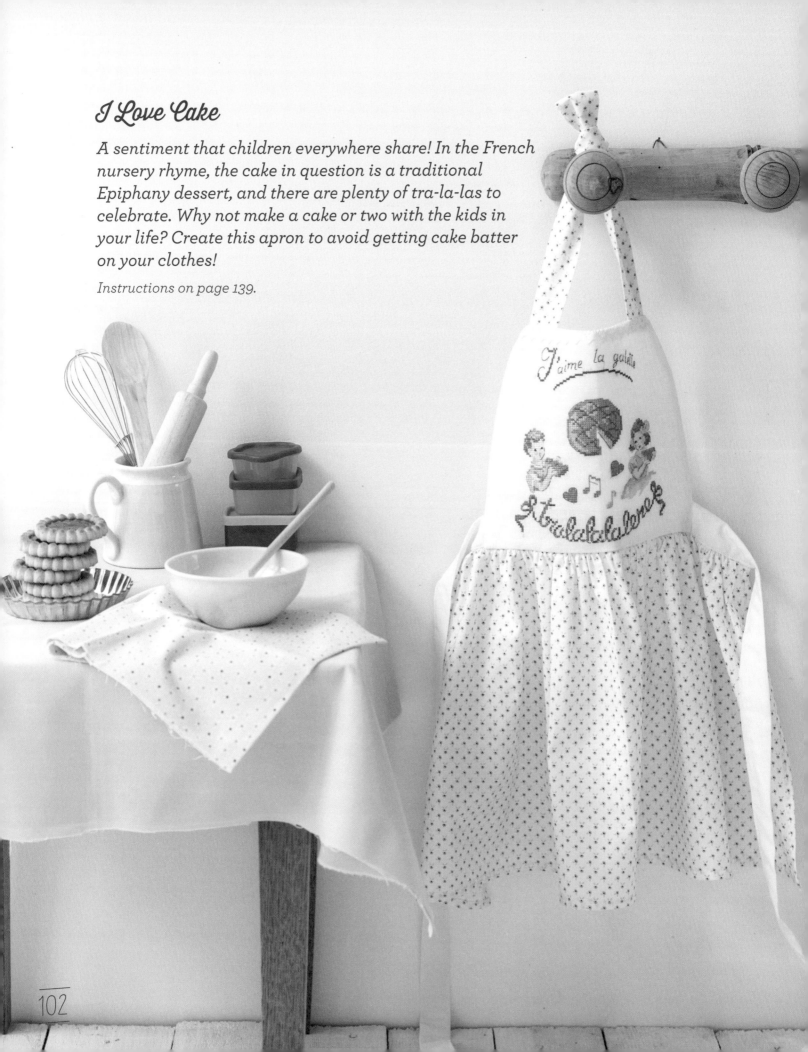

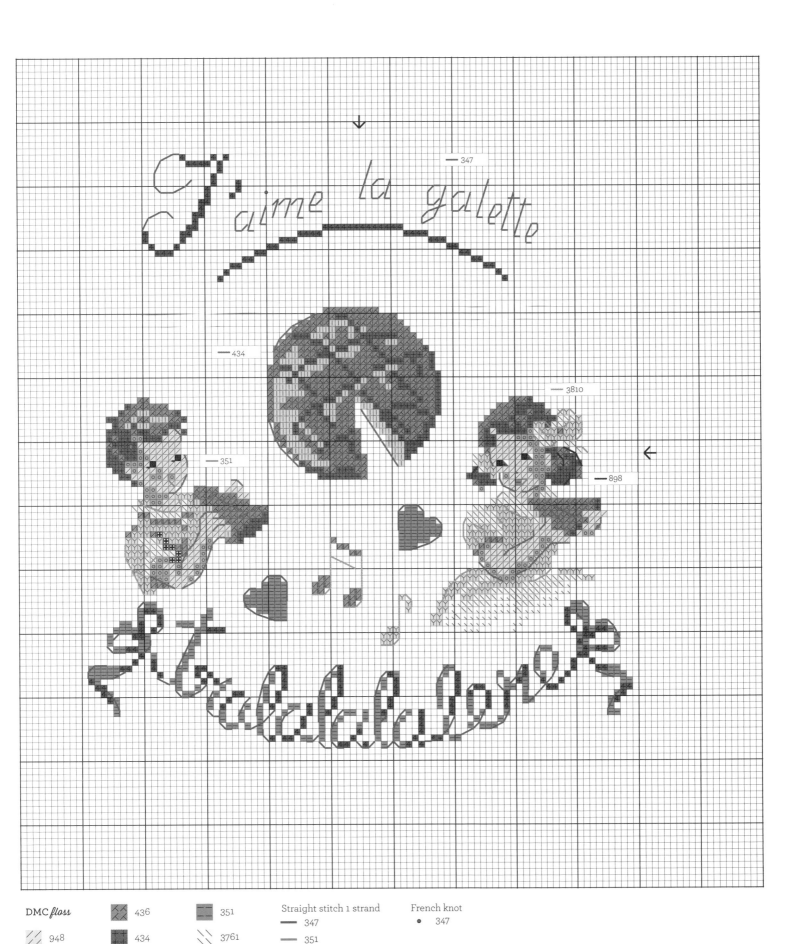

DMC *floss*

⟍⟍	436	▬	351	Straight stitch 1 strand		French knot
⟍⟍ 948		⟍⟍	3761	▬ 347		• 347
∘∘ 754	✚✚ 434			▬ 351		
∘∘	██ 898	YY	3766	▬ 434		
╫╫ 738	✚✚ 347	⟍⟍	3810	▬ 898		
				▬ 3810		

Miller, You're Sleeping

A mill is a fun thing to imitate. Children often do hand and arm movements while singing this rhyme.

Asleep in the middle of his toys, the miller is dreaming more of his childhood games than of his mill!

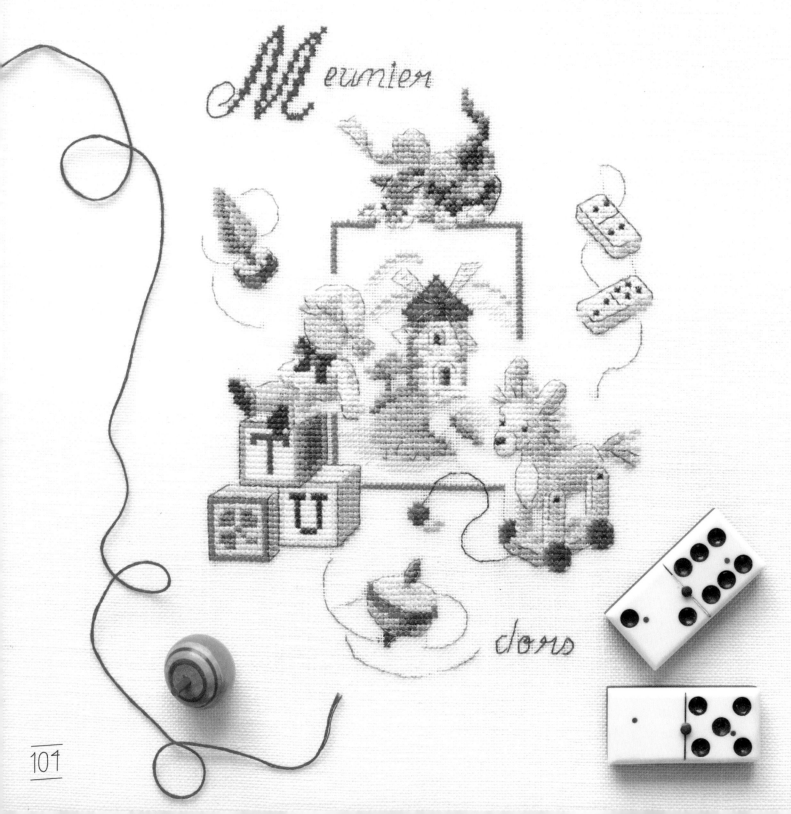

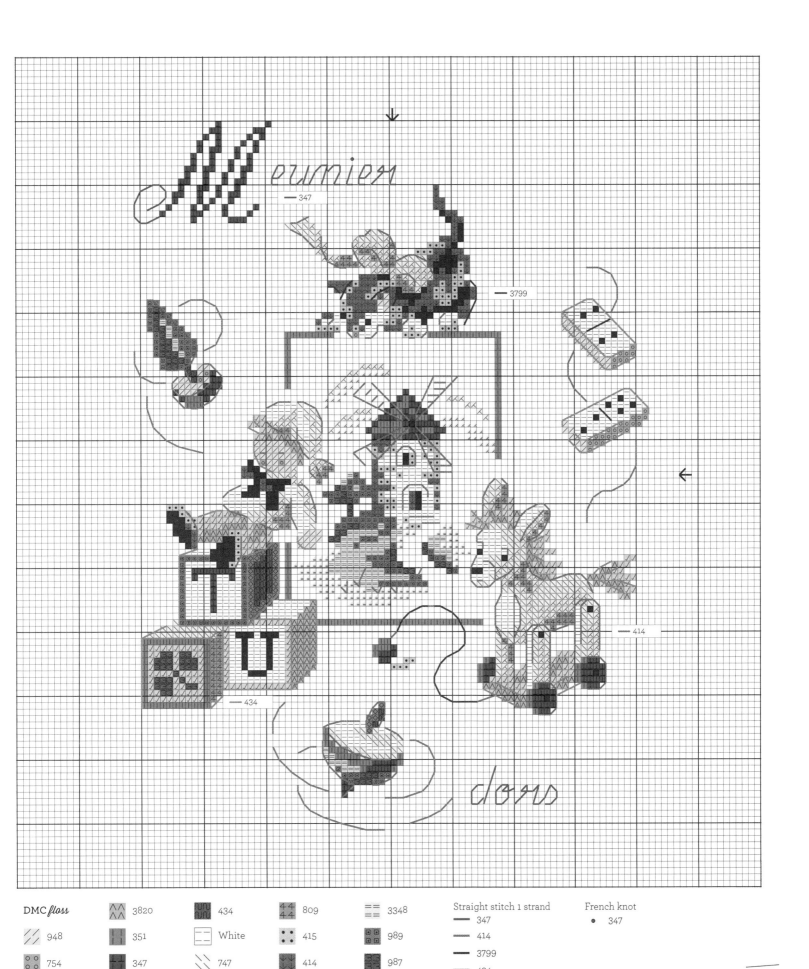

It's Raining, Shepherdess

In some children's rhymes, "the old man is snoring." Here, there's also noise and thunder. It's time to come inside! Embroider the fluffy sheep and their shepherdess, who are happy to be remembered in this darling scene.

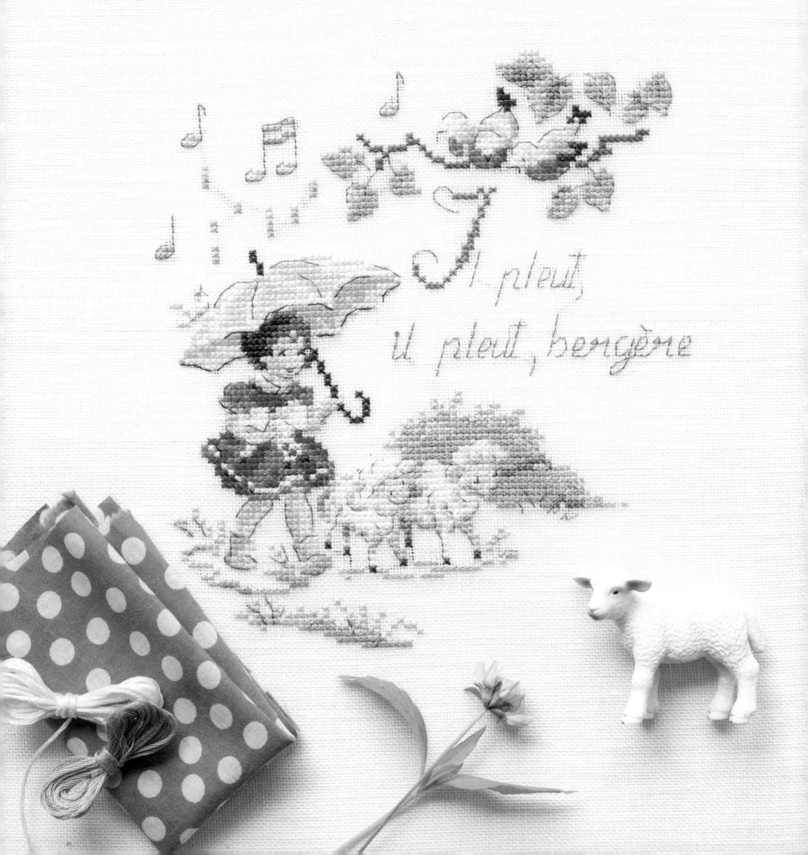

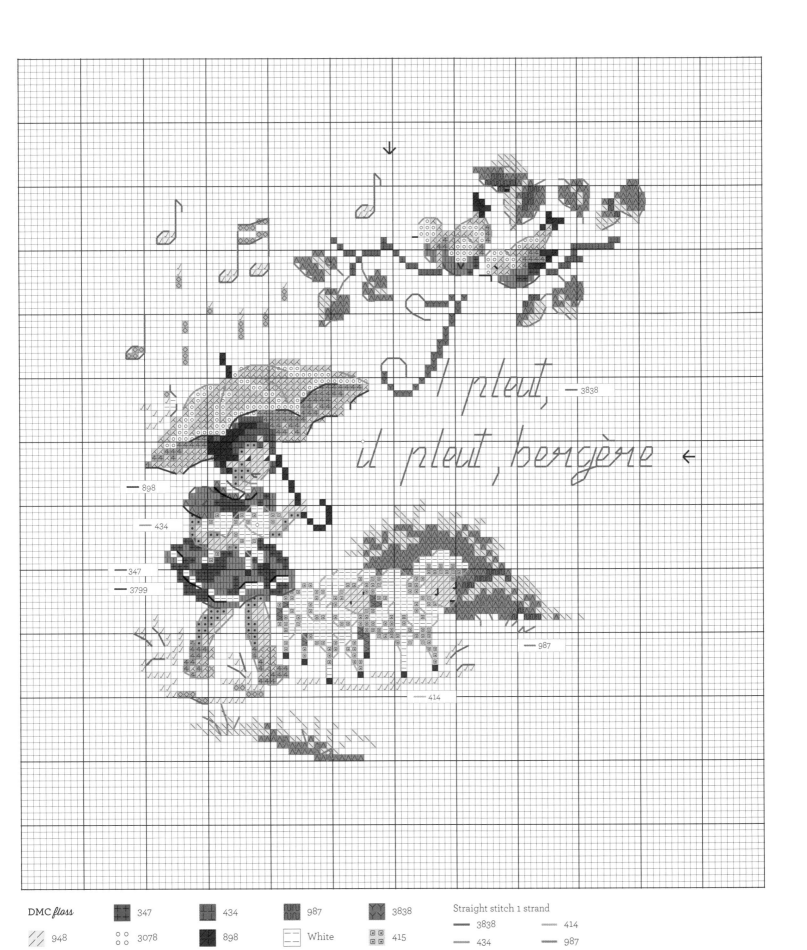

il pleut, — 3838

il pleut, bergère ←

— 898

— 434

— 347
— 3799

987

414

DMC *floss*

▨	347	▨	434	௶௶	987	▨	3838	
⁄⁄ 948	° ° 3078	▨ 898	▭ White	▨ 415				
⁙ 754	▨ 744	⁄⁄ 3348	⁄⁄ 800	▨ 414				
▥ 351	⁴⁴ 3820	▨ 989	◈ 809	▨ 3799				

Straight stitch 1 strand

— 3838 — 414
— 434 — 987
— 3799 — 347
— 898

107

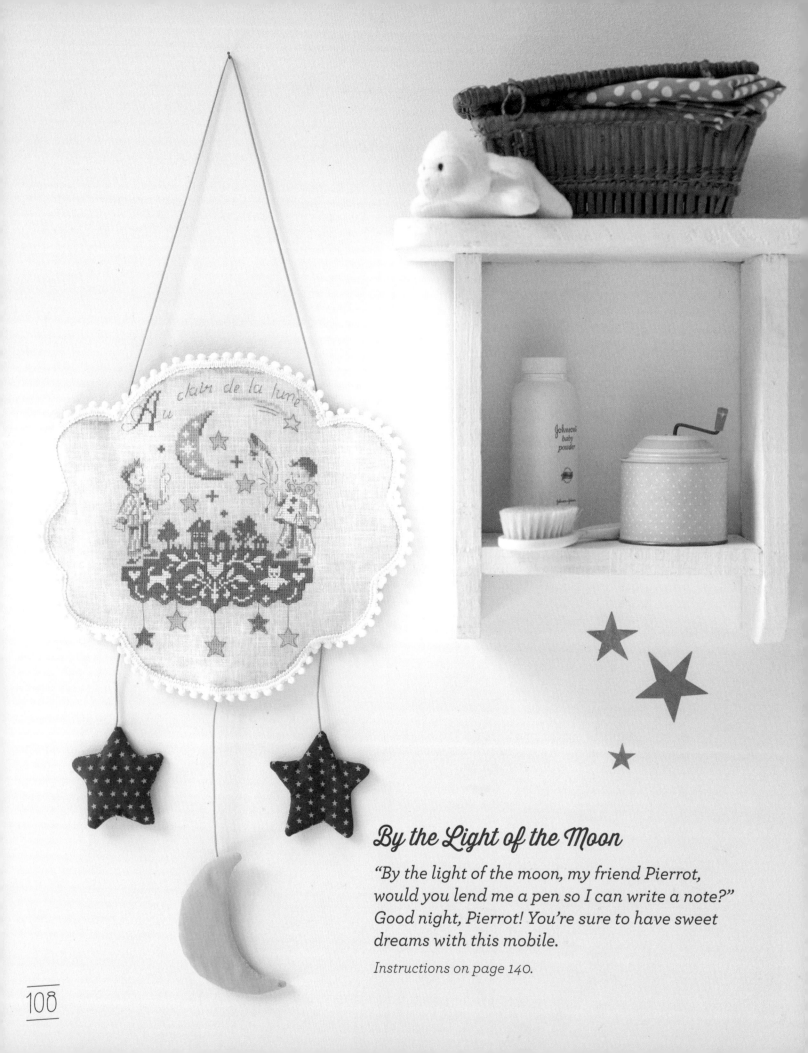

By the Light of the Moon

*"By the light of the moon, my friend Pierrot,
would you lend me a pen so I can write a note?"
Good night, Pierrot! You're sure to have sweet
dreams with this mobile.*

Instructions on page 140.

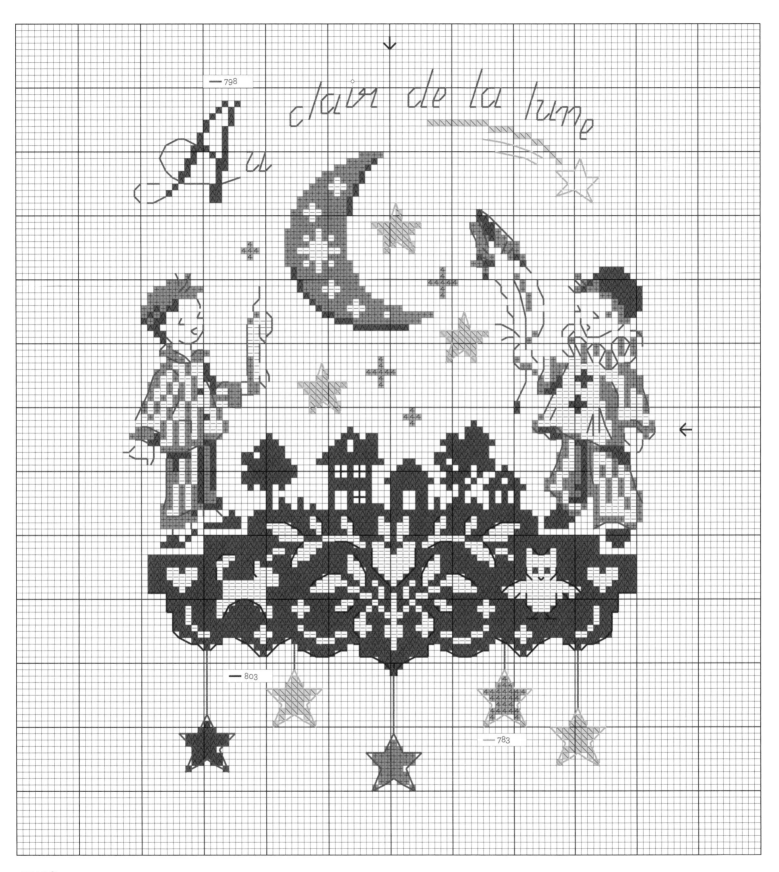

DMC *floss*

798		725		Straight stitch 1 strand
809		783		——— 798
White				——— 803
				——— 783

Pippin Apple and Lady Apple

Succumb to these lovely crisp apples! A red apple or a green one?
The song sings of two old varieties, and of a red and gray carpet.

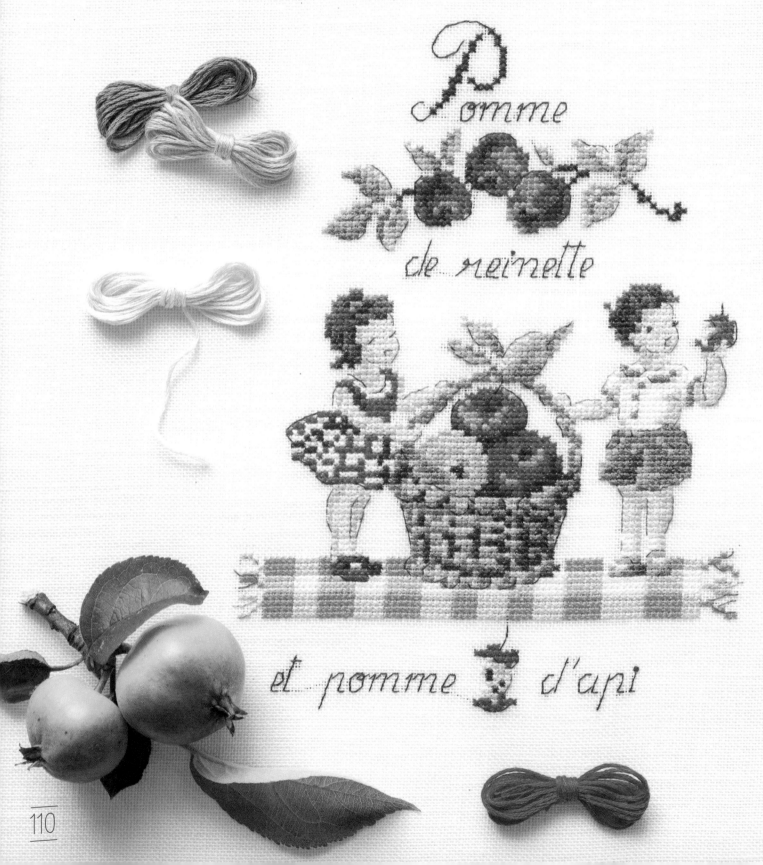

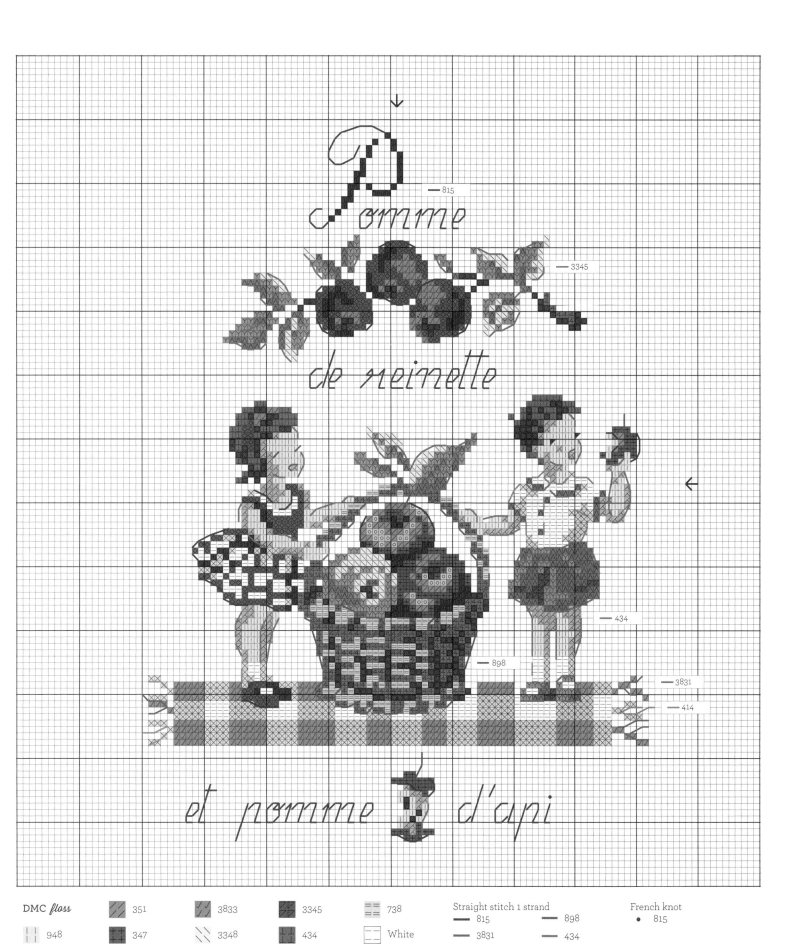

DMC *floss*

	351		3833		3345		738
948	347		3348		434		White
754	815		989		898		168
722	3831		987		3863		

Straight stitch 1 strand
— 815 — 898
— 3831 — 434
— 3345 — 414

French knot
● 815

A Hen on a Wall

The hen on the wall pecks at dry bread, making sounds of "Picoti! Picota!" Hens, chicks, and ducks: the entire farmyard gathers in this design that offers fresh country air.

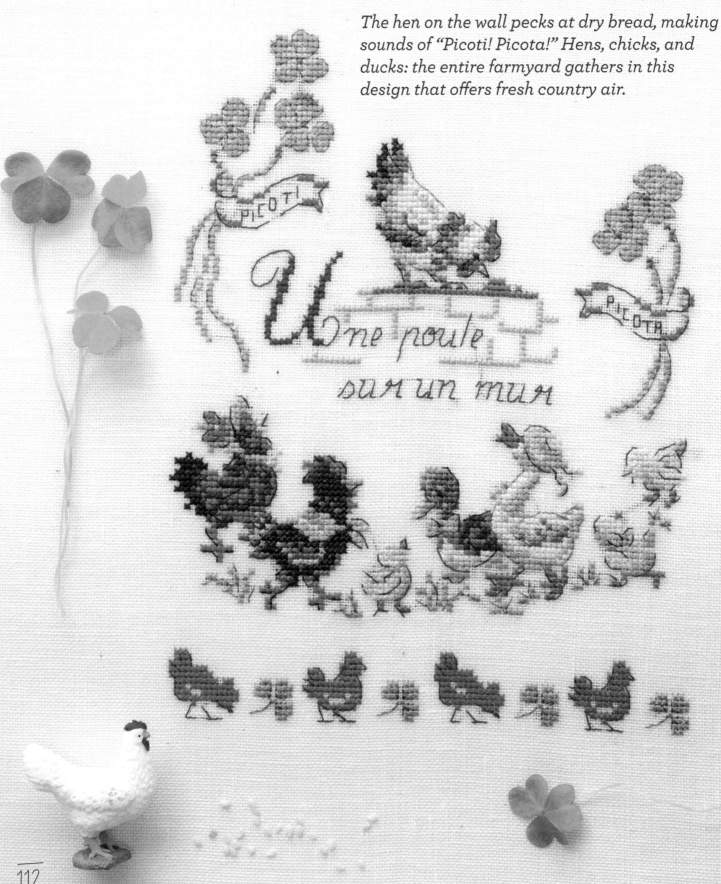

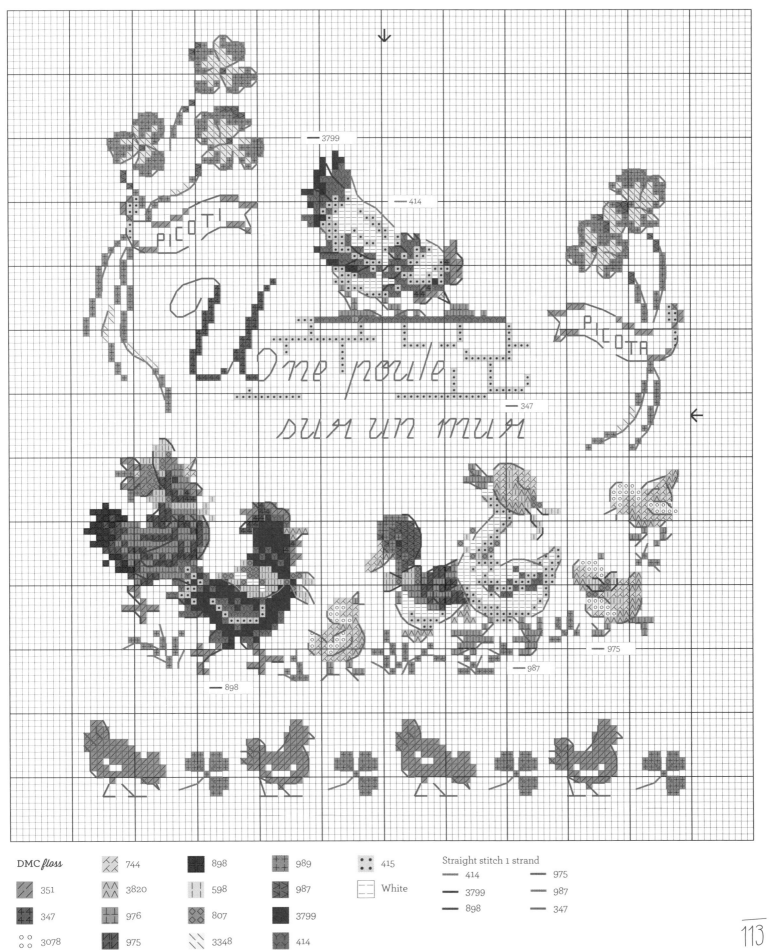

Une poule
sur un mur

PICOTI

PICOTA

DMC floss						Straight stitch 1 strand
351	744	898	989	415	414	975
347	3820	598	987	White	3799	987
3078	976	807	3799		898	347
	975	3348	414			

113

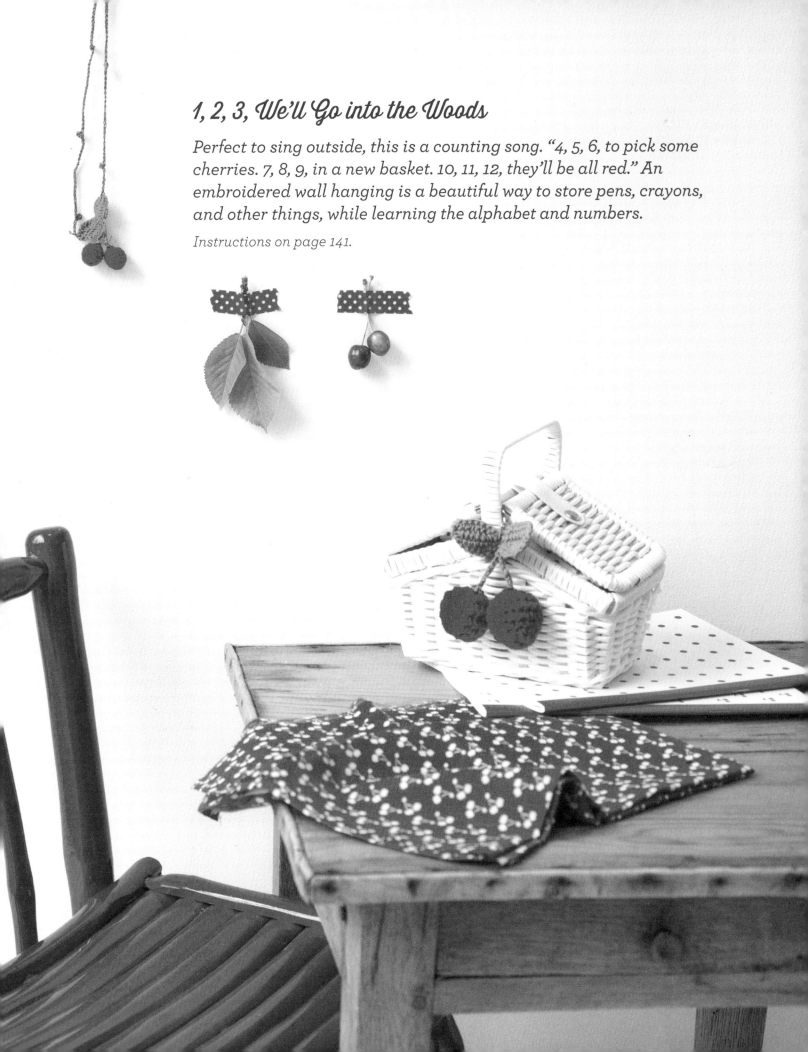

1, 2, 3, We'll Go into the Woods

Perfect to sing outside, this is a counting song. "4, 5, 6, to pick some cherries. 7, 8, 9, in a new basket. 10, 11, 12, they'll be all red." An embroidered wall hanging is a beautiful way to store pens, crayons, and other things, while learning the alphabet and numbers.

Instructions on page 141.

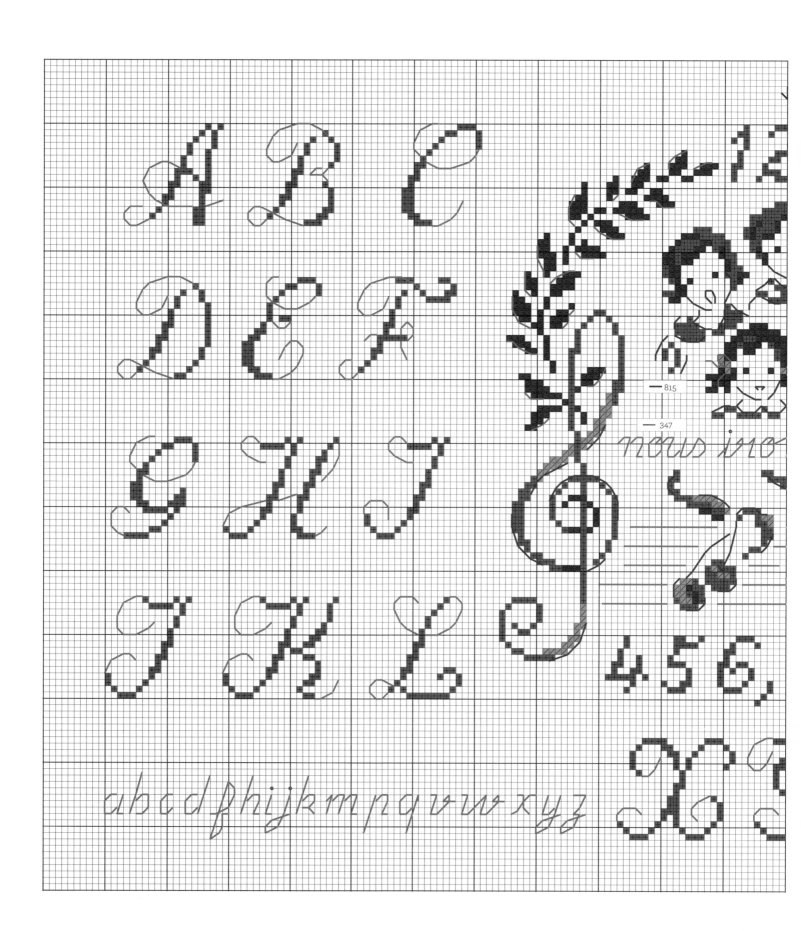

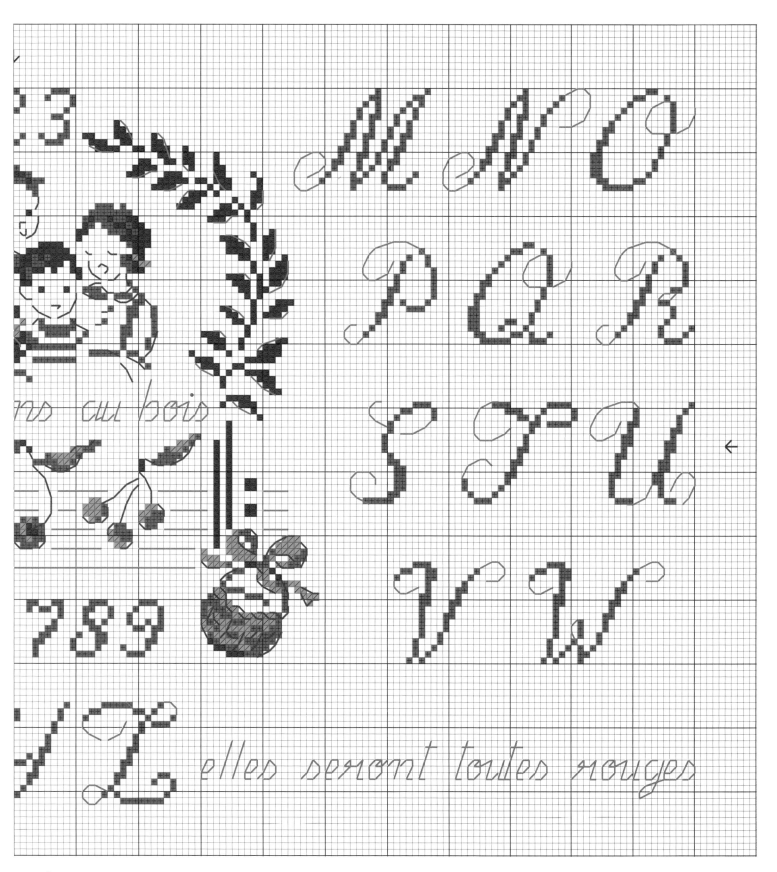

DMC *floss*

351	Straight stitch 1 strand	French knot
347	— 347	● 347
815	— 815	

A Green Mouse

*In this song, the plan is to turn a green mouse into a warm snail.
Ah, the world of nursery rhymes. There are only a few stitches
between you, the green mouse, and the warm snail!*

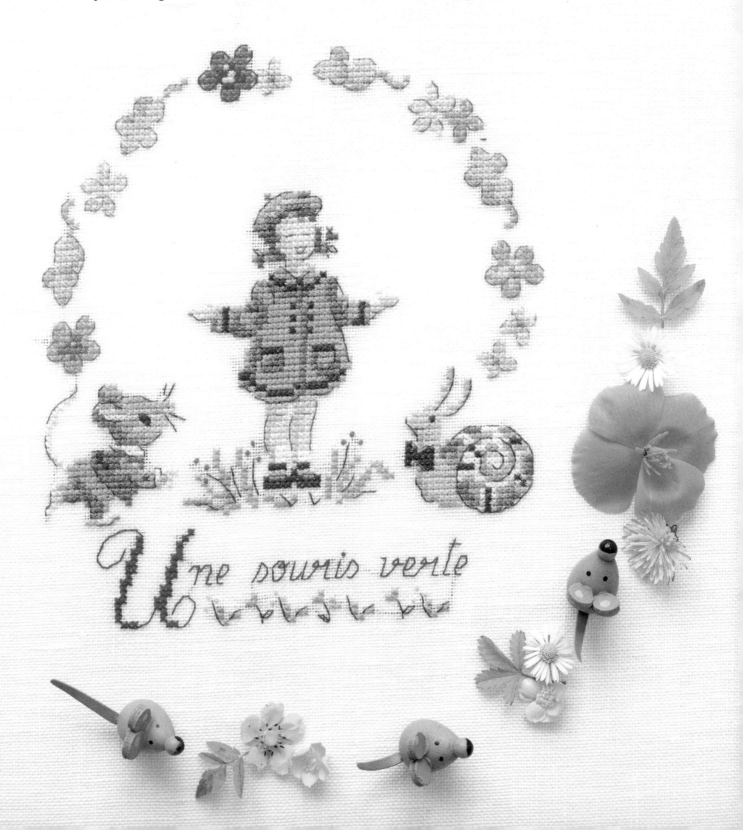

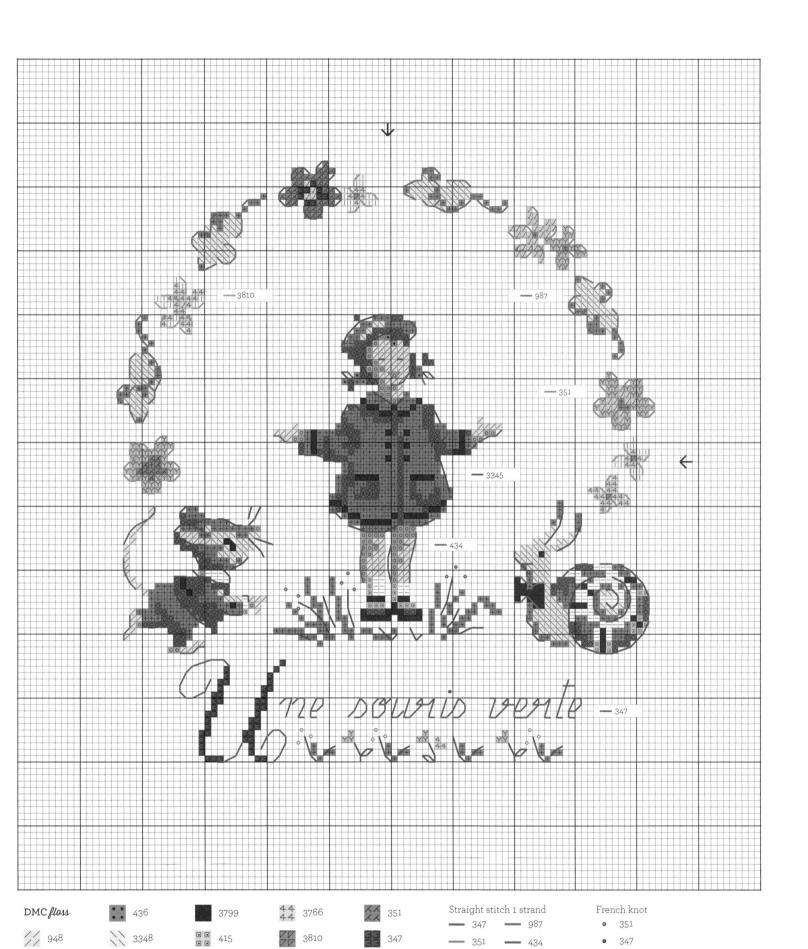

DMC *floss*

948	436	3799
754	3348	415
434	989	White
	987	3761

3766	351
3810	347
744	
3854	

Straight stitch 1 strand
— 347 — 987
— 351 — 434
— 3345 — 3810

French knot
• 351
• 347
○ 744

TECHNIQUES AND TIPS

PROJECT INSTRUCTIONS

PATTERNS

Techniques and Tips

Choosing Your Fabric

In sewing and craft stores you'll find several types of fabric, available in a large range of colors.

Aida Cloth

If you are a beginner it's best to choose Aida cloth. This is the easiest to work with. Its weaving, which mirrors the design squares, is precise and even. It allows you to cross stitch quickly and evenly without having to count the individual threads. Aida cloth comes in various sizes, such as 14 count, 16 count, and 18 count. The size indicates the number of holes, or stitches, per inch. It's available in a wide range of colors.

Linen and Evenweave Fabrics

The most common linen fabrics for cross stitch are 28 count or 32 count. Yes, that means linen has about double the number of holes as Aida cloth, but usually when stitching on linen you do not make a cross stitch on every "square" of the fabric. You skip some holes. On 28-count linen, you might skip one hole per stitch. That would equate to working on 14-count Aida cloth.

Evenweave is the term used to describe other fabrics that have an even warp and weft. Typically, evenweave fabrics are smoother than Aida or linen because they contain some man-made fibers.

Waste Canvas

Waste canvas is useful if you want to embroider material with such tight weave that counting threads would be very hard. It's called waste canvas because it's temporary, and you pull out its threads after your stitchwork is completed.

If you want to embroider a small design on bed linen or on a clothing item, for example, waste canvas has squares that guide your stitches. Tack the canvas in place on the item you want to embroider and work over both layers of material, counting the threads of the waste canvas. Once you have finished, simply pull the waste canvas's threads out and the stitched design remains on the support fabric. Don't make your stitches too tight, or it will be difficult to pull out the canvas threads.

The size of the finished work will obviously vary according to the weave of the chosen fabric. The higher the number of threads per inch, the smaller the embroidered design will be. To determine the size your finished design will be based on the weave of your fabric, use these calculations: divide the fabric's number of threads per inch by the number of threads used to make each cross. Let's say you are working over 2 fabric threads per cross stitch. If you are working on a fabric with 14 threads per inch, you will make 7 stitches per inch (14 divided by 2). So to determine the size of your finished embroidery in inches, count the number of squares that make up the length and width of the design, and divide these numbers by 7.

Preparation

Once you have chosen your fabric, cut a piece the size you have determined following the above instructions. Remember the fabric should be large enough to allow

you to embroider easily. It should also have a wide enough margin on each side to allow for framing or for assembling it into its final format.

Oversew the edges to keep them from fraying.

Determine the center of the fabric by folding it in four. When working on complex designs, such as large scenes, tack in a line of thread horizontally and then another line vertically passing through the center of the fabric to guide you. Make sure you don't tack too tightly because you need to be able to remove the tacking easily once you have finished your embroidery.

Designs

Whether scenes or smaller motifs, all the designs in this book are accompanied by a pattern to make them. The grids are made up of small blocks showing the color of the floss used. As each design uses a large range of color shades that can be very similar (like in the examples on page 27 or 63, which use over 20 different colors), a symbol is associated with the color of the square to make things clear. A palette of the colors used in the designs is given with the DMC floss color numbers. On each design, arrows help you find the center of the design to be embroidered. For better legibility, don't hesitate to enlarge the chosen design using a photocopier: you'll save time in deciphering the design and doing the embroidery.

Accessories

Needles

Embroidery needles have a rounded tip to avoid damaging the fabric's threads. The needle eye is large to be able to thread one, two, or three strands.

Cross stitch is usually done with two strands, so a number 24 size needle is perfect.

A number 26 size needle is better adapted for working with one strand, when doing straight stitches for example.

Embroidery Hoops

These stretch your fabric taut. You can find them in different diameters. Choose one large enough to encircle the design, at the same time leaving you room to work comfortably. When setting up the hoop, make sure that the fabric's meshes are straight before tightening the hoop's screw.

Floss

All the examples in this book were made using DMC floss; DMC has a range of around 500 colors so you will find the necessary shades for your work.

Floss is made up of 6 strands that are easy to separate.

To stay organized you may want to use plastic embroidery classifying cards. These help keep floss neat and clearly indicate color codes.

Embroidery Stitches

Cross Stitch

Cross stitch is easy. It's composed of two crossing slanted stitches. They can be done individually or continuously (see the diagrams below).

- For a more perfect result it's best to always make each cross's two stitches in the same order.

- It's better to start from the inside of a design and work outward (from the center toward the bottom, for example).

- This stitch can be done using one, two, or three strands depending on the fabric's weave and the desired effect.

Advice and Tricks of the Trade

- Generally you should never make a knot on the end of the yarn when embroidering; that causes unsightly bulges.

- When starting on a piece of work, bring the needle up from the reverse side of the fabric, leaving a tail of about an inch.

- Hold this tail in place and make your first five or six stitches over the tail, tacking it down.

- To finish off, carefully run the floss back through the last several stitches on the reverse side.

- Avoid working with floss that's too long: the strands can get damaged and break. A good length is between 11 and 15 inches.

- If the floss starts to get twisted, suspend your needle on the end of the yarn so that it dangles, and wait for it to unwind.

Continuous cross stitch

Individual cross stitch

Three-quarter Stitch

The three-quarter cross stitch is made up of a half stitch and a quarter stitch. It helps with adding detail, including curves, to designs.

On the charts, the three-quarter stitch is symbolized by a half-filled square.

French Knot

This stitch helps you make small dots in relief and creates a nice textural effect. It is particularly useful as a complement to cross stitches or straight stitches when you are embroidering words.

With one hand bring the needle up from the wrong side to the right side. With the other hand pull the floss and wrap it around the needle once or twice depending on the desired thickness of the knot. Keep hold of the yarn at the base of the needle and insert the needle as close as possible to the starting point in the fabric. Pull the needle and the yarn behind the fabric to form a knot.

Straight Stitch

The straight stitch, also called the back stitch, is ideal for bordering a motif within a larger design, emphasizing a certain part, or showing a detail, just the way a line drawn with a pencil would. It is done after the cross stitch design is completely finished.

Usually the straight stitch is done with fewer strands than the cross stitch, and most of the time in a color that's a shade darker. Depending on what result you want, you can follow the contours of the crosses, lengthen the stitches, or work diagonally. On the charts, the straight stitches are represented by continuous lines.

Finishing Off and Care

Once you've finished stitching your design, remove the fabric from the hoop, cut off any strands of floss that are sticking out, and remove the tacking used to mark the center. Carefully handwash the piece in cold water and leave it to dry flat on a towel. Just before it's completely dry, iron the reverse side with a thick towel under it. Your work is now ready to be framed or sewn onto another creation!

French knot

Straight stitch

Project Instructions

Totebag

(photo page 14)

MATERIALS

- Linen fabric, 27.5 threads/in.: 10.25" × 11"
- Quilted cotton fabric: 15" × 20.5"
- Fusible interfacing: 23.5" × 27.5"
- Bias tape: 31.5"
- Strap: 11.25"

1. Embroider the design (page 15) on the linen being careful to center it first. For the flap, cut a piece of lining fabric to the same size as the embroidery. Place the embroidery on the lining, wrong sides together.

2. Pin the bias tape along three sides and sew it on.

Flap

3. Measuring in 1.75" from each corner, pin and sew the ends of the handle strap to the flap.

4. Cut the bag's lining fabric to the same size as the quilted cotton fabric. Adhere interfacing to the lining. Place the flap embroidery side down on the main bag, centering it on one of the short sides. Cover it with the lining. Sew along the two short sides of the bag.

Sides

5. Reposition the long sides of the bag, fabric against fabric and lining against lining. Sew the two sides leaving an opening of 4" on one side. Shape the corners and sew across them 2" from each point. Turn the bag right side out and sew up the opening with small stitches.

Cuddly Fox

(photo page 18)
Pattern on pages 142–143

MATERIALS

- Orange velvet: 11.25" × 19.75"
- White felt: 4" × 8"
- Brown felt: 4" × 8"
- Stuffing
- 1 button and 2 beads

Face :

1. Cut 2 bottom fronts of head from the white felt. Align them right sides together. Make a dart on the top of this piece, on the wrong side.

2. Sew the two bottom front parts of head together, right side against right side.

3. Cut 2 ears from the white felt and 2 ears from the brown felt, following the pattern. Sew each ear's pieces (1 brown piece and 1 white piece) together, right side against right side; don't sew the short side.

4. From the orange felt, cut the top front of head along the fold, following the pattern. Sew it to the bottom front of the head, right sides together. Place the ears on the marks on the top of the head.

5. Cut the back of head from the orange velvet. Place the back of the head on the front of the head, right side against right side. Sew along the outside edge, leaving the neck open. Turn it right side out and fill it with stuffing.

Arms :

6. Cut 4 tops of arm from the orange velvet, following the pattern. Cut 4 bottoms of arm from the brown felt. Sew together the top and bottom of each arm, right sides together. Sew the front and back of the arms, right sides together, leaving an opening of 1.25" along one side. Turn the arms right side out and stuff them. Blind-stitch the openings closed.

Tail :

7. Cut 2 bottoms of tail from the orange velvet, following the pattern. Cut 2 tips of tail from the white felt. Sew the bottom of the tail to the tip. Sew the front and back of the tail together. Turn it right side out.

Back of the Body :

8. Cut 2 body pieces along the fold from orange velvet, following the pattern. Cut 4 bottoms of leg from the brown felt, following the pattern. Sew the legs, right sides together. Make a slit following the dotted line in the pattern. Fold the body in half and insert the fox's tail. Sew it on.

Front of the Body :

9. Tack-stitch the white felt ruff onto the neck. Sew the legs, right sides together.

10. Place the front of the fox on the back, right sides together. Sew around the outer edge, except for the neck. Turn right side out and stuff it.

11. Sew the arms onto the back using small stitches.

12. Insert the head into the body. Fold the fabric of the neck inward 0.25" and sew it using small stitches. Sew on two beads for the eyes and a button for the nose. Embroider the mouth using straight stitch.

Fox's Sleeping Bag

(photo page 18)

MATERIALS
- Linen fabric, 27.5 threads/in.: 9" × 9"
- White lining fabric: 9" × 9"
- Quilted cotton fabric: 16.5" × 18.125"
- Ribbon: 9"

1. Embroider the design (page 19) on the linen being careful to center it first. Assemble the white lining and the fabric, right side against right side. Sew the top, then press the seam open with an iron and turn right side out. Sew the ribbon around the edge.

2. Cut two pieces of quilted cotton 18.125" × 8.25". Place the embroidery between the two pieces. Sew around the edges, leaving an opening of 2.25" along the top. Turn it right side out and close the opening with a running stitch.

Key Ring

(photo page 30)

MATERIALS
- Linen fabric, 27.5 threads/in.: 4" × 4"
- Fabric: 4" × 4"
- Ribbon
- Key ring

1. Embroider one of the medallions in the fable designs on the linen being careful to center it first. Cut around the embroidery, leaving a margin of 0.25". Fold the margin in to the wrong side.

2. Cut a circle of fabric the same size as the embroidery.

3. Place a ribbon between the two circles. Sew the two circles together. Attach a key ring to the end of the ribbon.

Pin

(photo page 30)

MATERIALS
- Linen fabric, 27.5 threads/in.: 4" × 4"
- Fabric: 5.875" × 5.875"
- Ribbon
- Button
- Brooch-clasp style pin backing

1. Embroider one of the medallions in the fable designs on the linen being careful to center it first. Cut around the embroidery, leaving a margin of 0.375". Fold the margin in to the wrong side.

2. Cut a circle 5.875" in diameter and ruffle the edges.

3. Sew the embroidery in the center, placing the ribbon between the two pieces of material, sewing around the edge of the embroidery. Sew a ribbon bow and a button on the top. Attach the clasp to the back.

Bookmark

(photo page 30)

MATERIALS

- Linen fabric, 27.5 threads/in.: 8" × 8"
- Fabric: 8" × 8"
- Ribbon

1. Embroider one of the medallions in the fable designs on the linen being careful to center it first. Cut the fabric and embroidery adding a rectangle of 4" extending from the bottom of the circle.

2. Sew the two pieces of fabric right side against right side, placing a piece of ribbon folded in half at the top of the circle. Leave an opening. Turn the bookmark right side out and close the opening.

Storage Pouch Pennant

(photo page 32)
Pattern on page 144

MATERIALS

- Linen fabric, 27.5 threads/in.:
 6 pieces, each 8" × 10"
- Yellow fabric: 23.75" × 27.5"
- Print fabric: 26" × 29.5"
- Yellow lace: 8"
- Orange lace: 16"
- Green lace: 24"
- Bias tape: 8"

1. Embroider the designs (pages 34–35) on the 6 linen pieces being careful to center them first. Cut out the embroideries using the pattern, then cut 6 linings. Place each embroidery on its lining, right side against right side.

2. Pin them together. Sew around the edges, leaving a 2.5" opening at the top. Turn them right side out and close the opening with a running stitch.

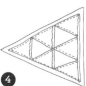

3. Sew the lace along the top edge of the bottom pennant. Join the next two pennants using lace sewn along their tops. Do the same for the three top pennants.

4. Cut a triangle 22.5" × 26.75" × 26.75" from the yellow fabric. Place the pennant on it being careful to align the left and right sides of the pennant in a parallel direction. Sew the pennant in place (except for the lace tops which are the pouch openings).

5. Cut a triangle 26" × 29.5" × 29.5" from the print fabric. Fold the edges of the larger triangle over the edges of the pennant and the top of the yellow triangle and sew it in place 0.125" from the edge.

6. Cut two 4" lengths of bias tape, and fold them in half. Place them on the back of the print triangle, pin them in place, and sew them on.

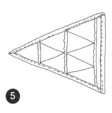

Book Cover

(photo page 40)

MATERIALS

- Linen fabric, 27.5 threads/in.:
 9.5" × 10.25"
- Fabric and lining: sized to the
 dimensions of the book you are
 going to cover
- Cord
- Tassel

1. The size of the book cover adjusts to your notebook or book. Embroider the design (page 41) being careful to center it first. Cut the embroidered design out 0.375" from the design. Cut the fabric and lining, adding a margin of 0.75" to the long side and 2.375" to the short side.

2. Pin the top of the cord to the center of the top of the fabric. Sew the fabric and the lining together right side against right side, leaving an opening of 2" on one of the short sides.

3. Turn it right side out and close the opening with a running stitch. Fold the short sides in 2" and sew them with a running stitch.

4. Sew the embroidery onto the cover using a blind stitch. Attach the tassel to the cord.

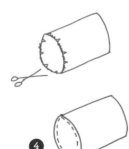

Pencil Holder

(photo page 42)

MATERIALS

For the small version:
- Linen fabric, 27.5 threads/in.:
 8" × 16"
- Oilcloth: 8" × 16"

For the large version:
- Linen fabric, 27.5 threads/in.:
 9.5" × 18.5"
- Oilcloth: 9.5" × 18.5"

1. From both linen and oilcloth, cut a rectangle 8" × 11.5" and a circle 3.75" in diameter (small version) or 9.5" × 13.75" and a circle 4.5" in diameter (large version). Embroider one of the designs on page 45 being careful to center it first.

2. Pin together the rectangles of oilcloth and linen, right side against right side. Sew one of the long sides. Unfold, turn right side out, and fold it short end to short end, embroidery against embroidery and fabric against fabric. Sew. Turn it inside out with the oilcloth on the outside. Sew the edge and clip it 0.25".

3. Place the round piece of linen on the round piece of oilcloth, wrong side against wrong side. Sew them together.

4. Assemble the tube and the circle right side against right side. Sew them together. Turn it right side out.

Fairy Hat

(photo page 43)

MATERIALS

- Linen fabric, 27.5 threads/in.: 6" × 6"
- Fabric: 15" × 23"
- Fusible interfacing: 15" × 23"
- Lining fabric: 15" × 23"
- Silver rickrack: 12"
- Ribbons: 6, each 24" long

1. Embroider one of the designs (page 44) being careful to center it first. Cut identical triangles from the fabric, the lining, and the fusible interfacing. A triangle measuring 16.125" × 16.125" × 23" = a head measurement of 22". If necessary, increase or reduce the size by increasing the length of the short sides then adjusting the long side.

2. Iron the fusible interfacing to the fabric. Tack the embroidery to the center of the front of the fabric, pin the rickrack to the edge of the embroidery, and sew on.

3. Assemble the lining and the fabric following the rounded edge. Sew along it 0.25" from the edge. Open the seam with an iron.

4. Assemble the two hat shapes end to end, lining against lining, fabric against fabric. Sew a 0.25" seam leaving an opening of 4" in the lining seam. Turn it right side out and close the opening with a running stitch.

5. Sew the ribbons to the tip of the hat.

Napkin Holder

(photo page 50)

MATERIALS

- Linen fabric, 27.5 threads/in.: 8.75" × 10"
- Print fabric: 4.75" × 8.75"
- White fabric (lining): 8.75" × 15"
- Cord
- Button

1. Embroider one of the designs (page 51) being careful to center it first. Cut the bottom edge into a scalloped shape. Assemble the print fabric and the linen, right side against right side. Sew one of the long sides. Open the seam with an iron.

2. Sew the two short sides, stopping 0.25" from the top.

3. Cut the lining fabric to match the above joined two pieces in size and shape. Fold, then sew the two short sides as done above. Leave an opening of 0.25" on one side.

4. Assemble the lining and the embroidery, right side against right side. Pin the rectangular edges of the embroidery to the edges of the print fabric. Sew together. Assemble the embroidery and the print fabric wrong sides together, and sew. Clip the seams.

5. Turn right side out, and close the opening with a running stitch. Sew on a decorative button.

Princess Wall Art

(photo page 52)

MATERIALS

- Linen fabric, 27.5 threads/in.: 18.5" × 25.75"
- Foam board: 10.5" × 17.75"
- Silver bias tape: 5 ft.
- 4 buttons

1. Embroider the design (pages 54–55) being careful to center it first.

2. Glue the embroidery to the foam board, folding 4" of margin to the back. Glue the bias tape around the edge to form the border. Sew the buttons onto the corners.

Little Red Riding Hood's Bag

(photo page 56)

MATERIALS

- Linen fabric, 27.5 threads/in.: 11" × 17.75"
- Fabric: 19.75" × 11"
- Cord: 19.75"
- Lace: 17.75"
- Bias tape: 17.75"

1. Embroider the design (page 57) being careful to center it first. Cut the fabric for the lining to the same dimensions as the embroidery. Assemble the short sides of the embroidery, right side against right side, and sew them together. Assemble the short sides of the lining, right side against right side, and sew them together.

2. On the embroidered piece, with the seam in the center, sew across the bottom. Form the corners and sew across them at 1.5" from the tip. Turn right side out. Repeat on the lining piece.

3. Place the lace around the edge of the embroidery. Insert the lining into the bag.

4. Prepare the drawstring top: cut a band of fabric 7" × 17.75". Pin the bias tape to the wrong side of the fabric at 2.75" from the bottom of the band. Sew along the two edges of the bias tape very close to the edges. Assemble the two short sides and sew them together, but not the bias tape. Hem the top.

5. Place the drawstring band on the bag, right side against right side. Sew them together. Run the cord through the bias tape casing using a safety pin.

Puss-in-Boots Suitcase

(photo page 58)

MATERIALS
- Linen fabric, 27.5 threads/in.:
 10" × 10"
- Oilcloth: 20" × 40"
- 2 separating zippers: 15.75"
- Strap: 8"

1. Embroider the design (page 59) being careful to center it first. From the oilcloth, cut three 10" squares, two bands measuring 3.75" × 37", and two bands measuring 1.5" × 10".

2. Assemble one of the squares with the embroidery, wrong side against wrong side. Oversew the edges. Assemble the other two squares wrong sides together. Oversew the edges. Assemble the two long bands wrong sides together. Oversew the edges. Do the same with the two shorter bands.

3. Separate the two zippers. Pin the two zipper halves together on the edge of the large band, centering them on the length. Sew them on. Assemble the two short sides of the band, with the zipper inside.

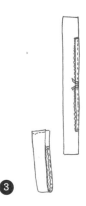

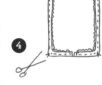

4. Sew the two other zipper halves onto the edge of the embroidery as shown. Clip the corners so that the zipper lies properly. Sew the small band along the free side.

5. Assemble the zipped band and the unembroidered square. Sew the edges. Clip the corners so that the band lies properly.

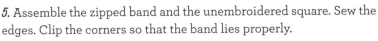

6. Form a handle by sewing the ends of the strap onto the center of the top.

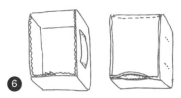

7. Partially close the zippers and sew the last edge. Open the zippers and turn right side out.

Hansel and Gretel Cookie Tin

(photo page 62)

MATERIALS

- Linen fabric, 27.5 threads/in.:
 10.5" × 10.5"
- Metal tin, 10" × 10" square
- Ribbon: slightly more than 1 yd.
- Fabric glue

Embroider the design (page 63) being careful to center it first. Fold the four edges of the linen 0.25" toward the wrong side. Glue it to the top of the tin. Glue the ribbon around the border using fabric glue.

Princess and the Pea Pillow

(photo page 76)

Pattern on pages 142–143

MATERIALS

- Linen fabric, 27.5 threads/in.:
 12" × 12"
- Polka dot fabric: 12" × 12"
- Stuffing
- Pompom trim: 20"

1. Embroider the design (page 77) being careful to center it first. Using the pattern, cut the linen into the crown shape. Cut a second crown shape from the polka dot fabric. Sew the two pieces together, right side against right side, leaving a 4" opening on the straight edge.

2. Turn the pillow right side out. Sew on the pompom trim using small stitches. Fill the pillow with the stuffing and close the opening with small stitches.

Little Mermaid Beach Bag

(photo page 78)

Pattern on pages 142-143

MATERIALS

- Linen fabric, 27.5 threads/in.: 9.5" × 7.5"
- Oilcloth: 11.75" × 23.5"
- Bias tape: 1.25 yd.
- Rickrack: 20"

1. Embroider the design (page 79) being careful to center it first. Using the pattern, cut two pieces from the oilcloth. Cut out the embroidered design in an oval shape and pin it to the center of one of the pieces. Stitch it on using a zigzag stitch 0.75" from the edges. Sew on the rickrack over the zigzag stitches.

2. Assemble the two pieces of the bag, right side against right side, and sew the sides. Turn it right side out.

3. Pin and sew the bias tape along the edge of both sides of the bag's opening.

4. Sew on the rest of the bias tape as shown to serve as handles.

Alice Storage Box

(photo page 82)

MATERIALS

- Linen fabric, 27.5 threads/in.:
 9.5" × 9.5"
- Fabric: 9.5" × 39.25"
- Lining fabric: 9.5" × 47.25"
- Heavy weight fusible interfacing:
 9.5" × 47.25"
- Ribbon: 8"

1. Embroider the design (page 83) being careful to center it first. Cut four 9.5" squares from the fabric and five 9.5" squares from the lining. Iron the interfacing to all the exterior squares and to the embroidery. Assemble the embroidery with a square of lining, wrong side against wrong side, and sew them together.

2. Assemble the other squares, right side against right side, as shown. Do the same with the lining. Folding it into a box shape, sew the other sides to the bottom edges. Repeat to make the lining cube.

3. Fold the edges of the lining cube 0.25" to the wrong side. Iron. Fold edges again 0.5" and iron. Fold the top edge outside the embroidered cube. Sew the border along the top 0.0625" from the edge. Add two pretty bows made with the ribbon and stitch them to the corners.

Patchwork Travel Quilt

(photo page 96)

MATERIALS
- Linen fabric, 27.5 threads/in.: 9.5" × 9.5"
- Fabric A: 9.5" × 18"
- Fabric B: 9.5" × 18"
- Fabric C: 9.5" × 18"
- Fabric D: 9.5" × 18"
- Backing fabric: 27.5" × 27.5"
- Batting: 27.5" × 27.5"
- 4 buttons

1. Embroider the design (page 97) being careful to center it first. Cut the embroidery into a 9.25" square; cut two 9" squares from each of the four pieces of fabric.

2. Assemble the squares into rows of 3, right side against right side, placing the embroidery square in the middle. Sew them together into a 9-block square and press open the seams with an iron.

3. Place the backing fabric on the batting. Place the patchwork on top, right side against right side. Sew the borders leaving a 4" opening on one of the sides. Turn right side out and close the opening using a running stitch.

4. Sew four buttons onto the corners of the embroidery block.

Cake-Baking Apron

(photo page 102)

MATERIALS

- Linen fabric, 27.5 threads/in.:
 10.25" × 10.25"
- White cotton fabric: 11.75" × 27.5"
- Print fabric: 17.75" × 35.5"
- Lace: 8"

1. Embroider the design (page 103) being careful to center it first. Cut around the design leaving a margin of 1.5" on the sides and 0.75" on the top and bottom. Cut the same dimensions from the white fabric. Round off the top corners.

2. Prepare the band that goes around the neck: cut a band 9.75" × 3.25" from the print fabric. Fold it in half lengthwise, right side against right side, and sew the long side. Turn right side out.

3. Pin the lace on the top border of the embroidery. Place the two ends of the band over it on the right side of the design. Cover it with the white fabric. Sew the edges, except for the straight one. Turn right side out and sew the bottom.

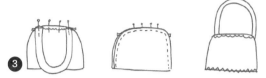

4. Hem three sides of the print fabric to form the skirt. Run two gathering threads along the edge that isn't hemmed. Reduce its length to 14.5" by pulling on the threads. Pin the bib to the center of the skirt and sew it on.

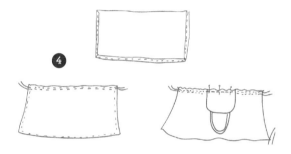

5. For the ties: cut two 2.75" × 27.5" bands from the white fabric. Place the bands on the border of the skirt, overlapping the ends 1.25" onto the bib. Fold these ends under, pin them, and sew them on.

6. Fold the edges of the bands 0.25" to the wrong side and press. Do the same with the two ends. Sew them 0.125" from the edge.

Pierrot Mobile

(photo page 108)
Pattern on page 144

MATERIALS

- Linen fabric, 27.5 threads/in.:
 10.25" × 10.25"
- Fabric printed with stars:
 9.75" × 12.75"
- Batting: 9.75" × 19.75"
- Yellow fabric: 4" × 4"
- Gold cord: 40"
- White pompom trim: 10"

1. Embroider the design (page 109) being careful to center it first. Cut out around the embroidery using the cloud pattern. Cut 1 cloud from the batting and 1 cloud from the star fabric. Place the wrong side of the star fabric on the batting. Place the embroidery right side against right side onto the star fabric. Pin and sew the edges leaving a 2.25" opening on the bottom.

2. Turn it right side out and close the opening with small stitches. Sew the pompom trim around the edge of the cloud.

3. Cut four stars from the star fabric and two stars from the batting, following the patterns. Cut two 4" lengths of cord. Place wrong side of a star on the batting. Pin the end of the cord to the top tip of the star and cover it with the second star, right side against right side. Sew the edges leaving a 1.25" opening on one side. Turn it right side out and close the opening with small stitches. Sew the cord to the back of the cloud. Do the same for the second star and the moon.

4. Sew the remaining cord to the back of the cloud at the top.

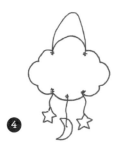

Alphabet Wall Hanging

(photo page 114)

MATERIALS

- Linen fabric, 27.5 threads/in.:
 9.25" × 17.75"
- White fabric with red polka dots:
 19.75" × 21.25"
- Red pompom trim: 56"
- Red fabric with white polka dots:
 10.25" × 17.75"
- 2 buttons

1. Embroider the design (pages 116–117) being careful to center it first. Turn the edges of the white fabric under 1.25" to the wrong side and sew them at 0.0625" from the cut edges. Fold the edges of the embroidery to the wrong side; tack it to the white fabric, attaching the pompom trim around the edges.

2. Fold the edges of the red fabric (pouches) to the wrong side and fold it in half lengthwise. Mark the center of the red fabric.

3. Pin the short sides to the sides of the white fabric. Sew them together at 0.0625" from the edges. Space out the red strip to be even on each side of the center. Sew the center, then space out each side 3.25" from the center and sew these.

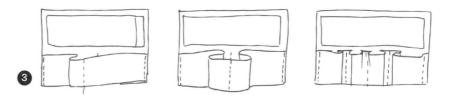

4. Sew the sides at 1" from the edge. Sew two loops of cord to the back of the hanging. Sew two buttons onto the corners.

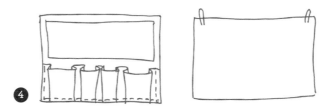

Patterns

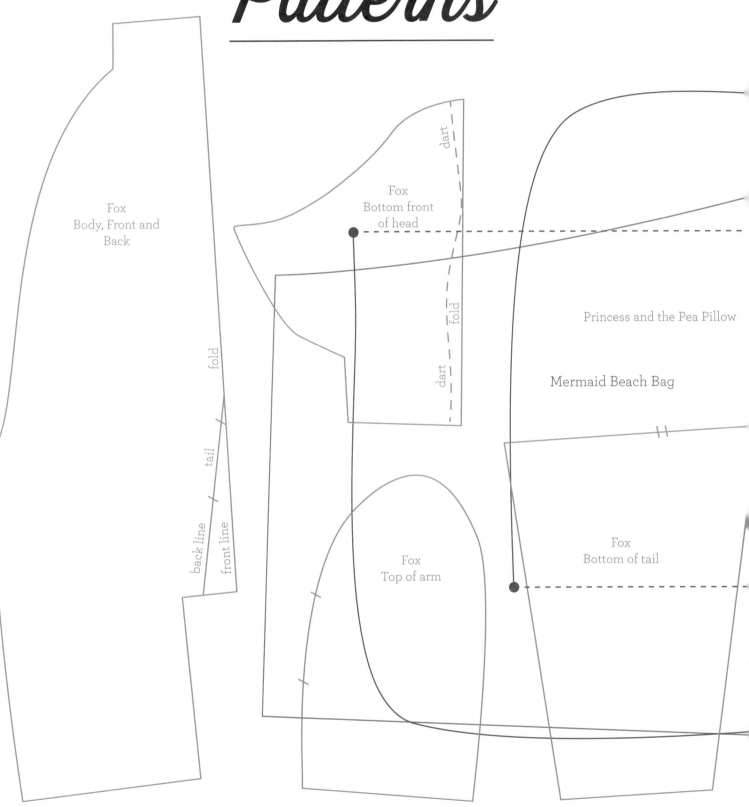

Fox
Body, Front and
Back

fold

tail

back line

front line

Fox
Bottom front
of head

dart

fold

dart

Princess and the Pea Pillow

Mermaid Beach Bag

Fox
Top of arm

Fox
Bottom of tail

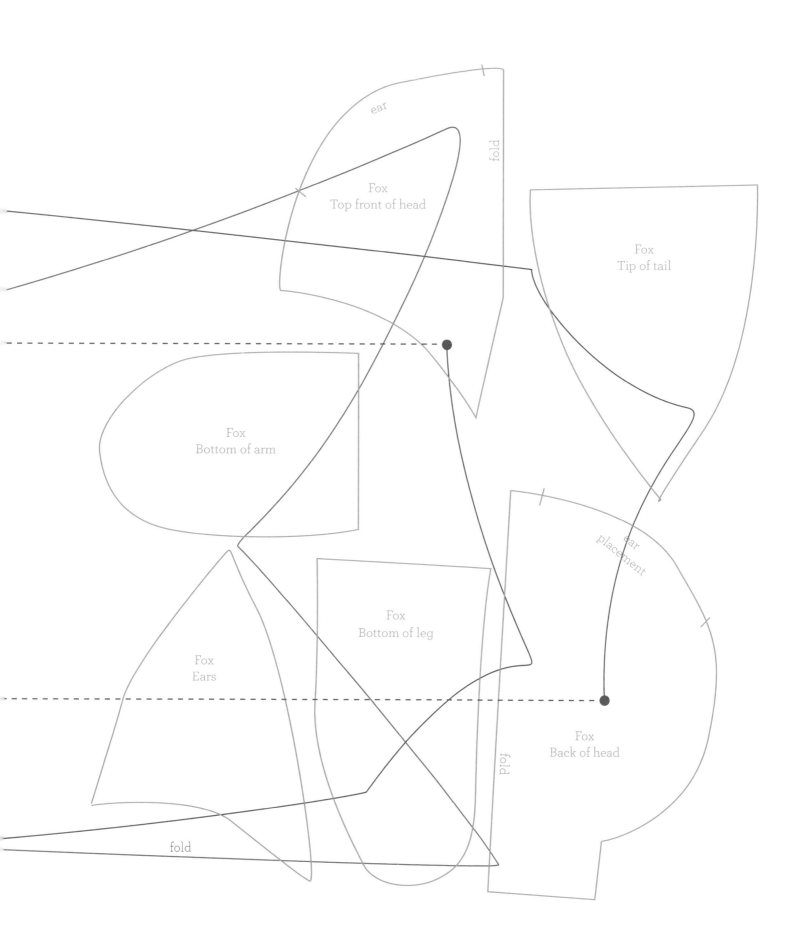

ear

Fox
Top front of head

fold

Fox
Tip of tail

Fox
Bottom of arm

ear
placement

Fox
Bottom of leg

fold

Fox
Back of head

Fox
Ears

fold

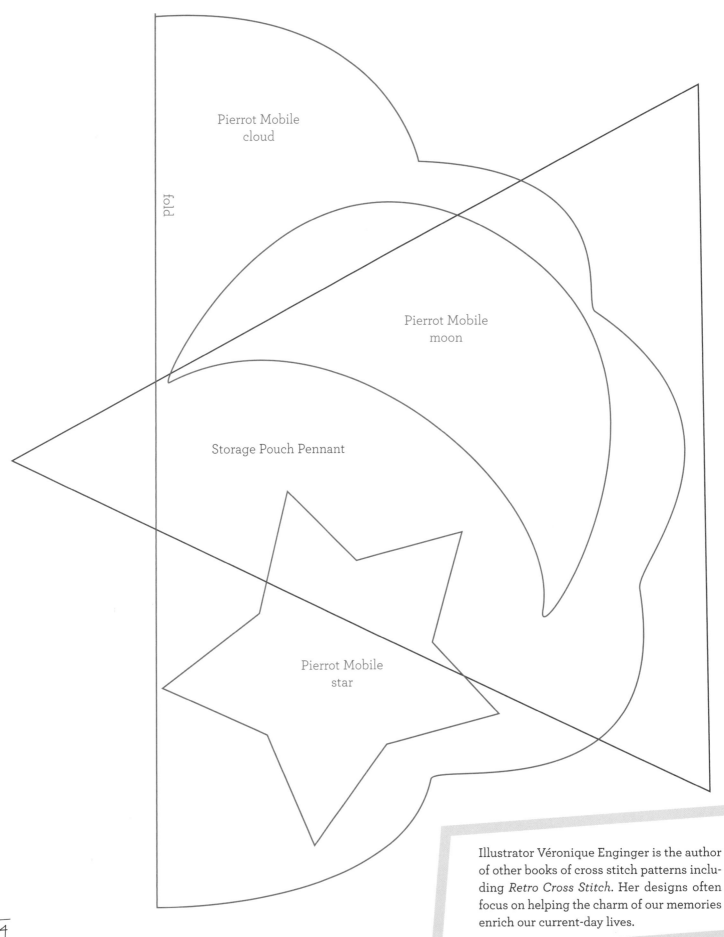

Pierrot Mobile
cloud

fold

Pierrot Mobile
moon

Storage Pouch Pennant

Pierrot Mobile
star

Illustrator Véronique Enginger is the author
of other books of cross stitch patterns inclu-
ding *Retro Cross Stitch*. Her designs often
focus on helping the charm of our memories
enrich our current-day lives.